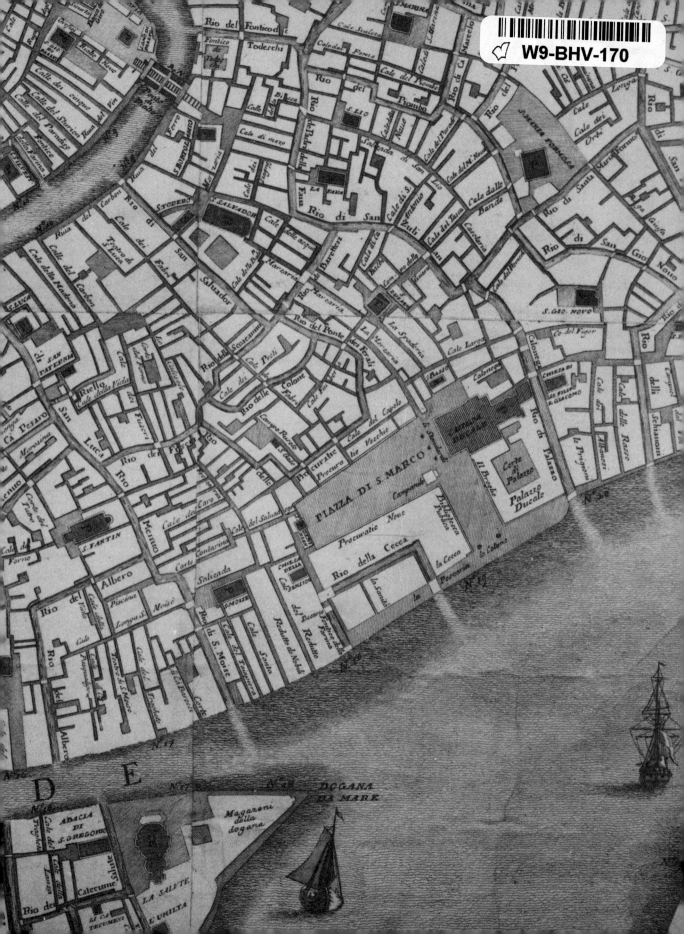

Canaletto and his patrons

Canaletto

and his patrons

J. G. Links

New York · New York University Press · 1977

Published in the United States by
New York University Press
Washington Square, New York, N.Y. 10003

Library of Congress Catalog Card Number: 76-39696
ISBN: 0-8147-4975-5

Made and printed in Great Britain by
The Garden City Press Limited
Letchworth, Hertfordshire SG6 1JS

Contents

List of plates

By Canaletto, oil on canvas, unless otherwise stated. Height before width, to the nearest centimetre. Numbers in brackets indicate catalogue numbers in W. G. Constable's *Canaletto*, revised edition, Clarendon Press, 1976. Titles of Canaletto's works generally follow those of that catalogue. Where no present owner is shown, originals are in private collections whose owners wish to remain anonymous, or the present owner is unknown.

Acknowledgements

The following illustrations are reproduced by the gracious permission of Her Majesty The Queen: plates I, 4, 35, 39, 44, 46, 48, 53, 54, 55, 59, 73, 75, 77, 78, 101, 103, 124, 135 and 136 (paintings); 67, 69, 70, 71, 74, 82 and 90 (drawings). I must also express my thanks to those in the Lord Chamberlain's Office and the Royal Library without whose co-operation this book would not have been possible.

I should also like to thank the following by whose courtesy the illustrations shown are reproduced: the Trustees of the National Gallery, London, plates VI, VII, IX, XI, 41–3, 50–2, 126, 129, 131, 133 and 134; the National Trust and Cheshire County Council, plates II–V; His Grace the Duke of Buccleuch, plate VIII; the Museum of Fine Arts, Boston, plate X; the Ashmolean Museum, Oxford, plates 1, 10 and 40; His Grace the Duke of Richmond, plates 26, 96–7 and 98–9; the Earl of Plymouth, plate 24; the Trustees of the Chatsworth Settlement, plates 29 and 30; the National Gallery of Art, Washington, plates 58 and 60 (gift of Mrs Barbara Hutton), plates 113 and 114 (collection of Mr and Mrs Paul Mellon); the Marquis of Tavistock and the Trustees of the Bedford Estates, plate 62; Staatliche Museen Preussischer Kulturbesitz Kupferstichkabinett Berlin-Dahlem, plates 65 and 104; the National Gallery of Canada, Ottawa, plate 66; Country Life and His Grace the Duke of Northumberland, plates 92 and 109; the Dulwich College Picture Gallery, plates 112 and 116; the Trustees of the Wallace Collection, London, plates 130 and 132; the British Library Board, endpapers.

Apologies are tendered to the owners of any pictures reproduced whom it has not been possible to trace. J. G. Links

Author's note

'S.' is generally used as an abbreviation for 'San' or 'Santa' (Saint) and 'SS.' for 'Santi' (Saints). A *campo* (plural *campi*) is a square (literally 'field') and a *scuola* (plural *scuole*) is a guild. Both are followed by *di*, *dei* or other word meaning 'of'. This is sometimes here omitted and always in the case of the Piazza di San Marco, referred to as the Piazza S. Marco or 'the Piazza' (the word *piazza* is not used for any other square in Venice, nor is 'Piazzetta', which is an extension of the Piazza). A *rio* (plural *rii*) is a canal, the word 'canal' being used only for the Grand Canal or the Cannaregio within the city. 'The Bacino' (basin or pool) is that part of the Lagoon between the island of S. Giorgio Maggiore and the Molo. 'The Molo' (quay) is the continuation of the Riva degli Schiavoni westward from the Doge's (or Ducal) Palace. A *calle* (plural *calli*) is a narrow street. A *campanile* is a belltower. The word 'clocktower' is used to describe the whole building (the 'Torre dell'-Orologio') facing the Piazzetta at the north-east end of the Piazza. Churches with 'Santa Maria' in their name are often abbreviated, e.g. 'the Salute', 'the Frari'. The Basilica di San Marco is so often referred to as St Mark's by English-speaking people that this usage is followed here.

The endpapers show the Venice of Canaletto's day as drawn in Lodovico Ughi's map of 1729. The principal subsequent alterations involve the widening of the Riva degli Schiavoni (1789); Napoleon's changes at the westward end of both the Molo and the Piazza (which included the destruction of the church of S. Geminiano); the demolition preceding the building of the railway station, the Piazzale Roma and the bridge linking Venice with the mainland; and, most recently, the replacement of the buildings immediately east of the Prison by the extension of the Danieli Hotel. With these exceptions most of Canaletto's views are easily recognized today although many buildings have of course been heavily restored or altered and two bridges have been built across the Grand Canal. The five most easterly arches of the Doge's Palace, blocked up in Canaletto's day after the fire of 1574, were opened in 1889; the Campanile in the Piazza was replaced by a replica after its fall in 1902 and several other *campanili* shown by Canaletto

have since fallen and not been replaced. Other major differences between Ughi's map and a modern one include the street leading from the Campo S. Bartolomeo (east of the Rialto Bridge), to the railway station, and the *rio* between the modern Piazzale Roma and the Grand Canal at the Palazzo Foscari; Canaletto's views are not much altered by these additions. Several *rii* shown by him have since become *calli;* such a street is generally called 'Rio Terra . . .'

Source notes will be found at the end of the book with a reference in each case to the relevant page and passage. Nothing except source notes is included in this section so that relatively few readers will wish to concern themselves with them; for this reason key figures or signs within the text have been omitted except in the case of footnotes which appear at the foot of the page.

With the exception of a few etchings Canaletto gave no titles to his work and descriptions vary widely among authors and cataloguers. The titles used in this book are those used by W. G. Constable in *Canaletto* (Clarendon Press, 1962, revised edition 1976). The abbreviations in these titles are not always consistent with those used in the text of this book.

I

Townscape painting

'. . . to make the splendours of Venice better known'

(*from the dedication of Carlevaris's etchings*)

When, in 1725, Stefano Conti asked his agent, Alessandro Marchesini, to order for him two more view paintings by Carlevaris he was advised against it. Conti was a successful textile merchant in Lucca who had started buying pictures from living artists twenty years earlier, when he was fifty years old. He never aspired to old masters and the gallery he built for his collection would arouse little interest to modern eyes. He patronized local artists where he could but he was, he realized, a provincial and he appointed Marchesini to advise him and to deal with artists on his behalf outside his home town. It was a wise appointment since Marchesini had proved an honest and energetic agent who knew well what was going on in the art world, limited though his own gifts as a practising artist were. He had been born in Verona, trained in Bologna and now lived in Venice, which may have accounted for the fact that, among the history paintings and still-lifes he had persuaded Conti to buy, were three views of Venice by Luca Carlevaris.

Once his gallery was finished and furnished with pictures after only some three years' collecting, Conti settled down to enjoy it and bought only three more pictures in the following twenty years. Then, when over seventy, he decided to make a few more additions and particularly to bring his Carlevaris views up to five. Pleased though he was to have his client back, Marchesini determined to keep him in touch with events and replied that, although Carlevaris (plate 1) was still active, he was getting old (he was sixty-two) and there was a new man who should be considered instead. The work of 'Sigr. Antonio Canale', Conti was told, was astounding everyone in Venice who saw it—'it is like that of Carlevaris, but you can see the sun shining in it'.

With these words Marchesini summed up the revolution that had taken place in view painting since Conti's original purchase. Carlevaris was the very founder of Venetian view painting. Of his predecessors in the art, or craft, which was all it had been in the seventeenth century, the only one who could have had any influence on later events was Gaspar van Wittel, called Vanvitelli, and it is by no means certain that he ever visited Venice, in spite of his attractive paintings of the

city. Carlevaris, on the other hand, had trudged over every bridge and into every *campo*. He had made laborious drawings of every church and palace of significance and then etched them and published 104 of the etchings in one volume when Canaletto was six years old. Then he had turned to painting and, hardly ever leaving the area of the Piazza S. Marco (plate 2) except to paint a festival on the Grand Canal, he had filled his pictures with lively studies of the endlessly varied human beings who lived in the city, visited it on business or pleasure or passed through it on their way elsewhere. Several of his set pieces were well enough composed to provide material, not only for Canaletto, but for Francesco Guardi almost a century later.

But you could not see the sun shining in his pictures. It was the shimmering play of water-reflected sunlight on brick or stone that enchanted the visitor to Venice and, if Carlevaris ever noticed such a thing, he was too dull a man or too lacking in technical equipment to be capable of recording it with pen, needle or brush. He had created a market that he was unable to satisfy. It seemed that Canaletto had been born at the right moment.

Carlevaris was by no means the first townscape painter. Jan van der Heyden had been born in Holland thirty years before him and devoted most of his painting career to the production of 200 pictures of streets and buildings, many of them of Amsterdam and half of them easily identifiable today. Then, suddenly, he gave up painting, leaving the Berckheyde brothers to follow the tradition he had founded, while he himself, still obsessed with streets and what went on in them, devoted the rest of his life to developing street lighting and ways of fighting street fires. The link between these Dutch townscape painters and Carlevaris was Gaspar van Wittel who was born near Utrecht twelve years before Carlevaris's birth and who outlived him. Van Wittel went to Rome as a young man and he took with him the ideas of seventeenth-century Holland; until his arrival the artists of Rome who were concerned with buildings at all regarded only the ruins of ancient ones as worthy of their attention.

Van Wittel, who soon became Vanvitelli, saw beauty and interest in the Rome of his own day, just as his immediate predecessors had found worthwhile subjects in the streets of the Dutch cities. He did not dwell, as they had done, on each brick and the mortar which bound them, but the light and the life of a Roman piazza was enough to move him to luminous, sunny and realistic pictures which it is sometimes hard to believe were painted in the seventeenth century. Two or three drawings of Venice, of astonishing freshness and topographical accuracy for their period, seem to establish that he must have been there in 1694 or 1695 although there is no documentary evidence of such a visit. They led to a handful of Venetian view paintings, certainly some and probably all, executed later in Rome.

It is tantalizing that Vanvitelli stayed so short a time in Venice. Its light, its

water and its shipping gave him something to get his teeth into and he would have been better employed there than in looking for picturesque views around Rome or Naples. So nearly do his Venice drawings and paintings strike home that there is a temptation to overrate him as an innovator and an observer. His drawing of the Piazzetta (plate 3) must, one feels, lead to some splendid painting. If it did, the painting has been lost. But Canaletto's painting of the scene half a century later (plate 4) has an almost uncanny resemblance to it. Vanvitelli's painting of the constellation of architecture which greets the visitor to Venice (plate 5) has an immediacy which makes one wonder that it could have been painted in the studio a dozen years after the artist had seen Venice for the only time in his life as was the case, so far as anyone can say. Vanvitelli proves to be little more than a portent of what was to come, although his memories of Venice certainly brought out the best in him. It must be remembered however that Canaletto could easily have seen Vanvitelli's work, and even have met the artist, while in Rome about 1720. Indeed, it is hard to believe that he had not done so when comparing Canaletto's work of the 1730s with Vanvitelli's much earlier painting. They have far more in common with each other than either has with the work of any of their contemporaries. Against this is the fact that during the 1720s Canaletto's painting was of an entirely different character; the light ground, blue skies and small figures associated with Vanvitelli came later.

There were other artists from the north who settled in Italy and who painted views but none of them played a serious part in the development of view painting. Ruinscape, not townscape, was the province of those in Rome, except for Vanvitelli. Joseph Heintz, or Heintzius, born in Augsburg *c.* 1600, spent more than fifty years in Venice and used the Venetian scene as background for some paintings of events and festivals; he was well regarded in Italy as a painter of serious subjects but he would not have regarded himself as a view painter had he heard the phrase. Johan Richter, from Stockholm, came much later and was a contemporary rather than a forerunner of Carlevaris. He was eighty when he died in Venice in 1745 and he had seen Carlevaris supplanted in fame by Canaletto and then Canaletto's own decline; although his views are often seen in Europe, particularly in Sweden, he achieved nothing original in them. Nor did Hendrick van Lint, whose views are mostly of places outside Venice; there is no firm evidence that he was ever in Venice, in spite of his paintings of the city, but he was working in Rome in the 1720s, when Canaletto was there, and the two artists may well have met. If there was a northern influence on Canaletto, though, there is no need to look farther than Vanvitelli. In any case, although the north produced the first purely topographical painters in van der Heyden and the Berckheydes, it had no monopoly in topographical painting itself.

Artists have for long ensured that we know something of what their streets and

cities looked like. The eruption of Vesuvius in A.D. 79 preserved for us wall paintings which show the harbour of Stabiae in detail and which give us many glimpses of towns which were known to those who lived in Pompeii and Herculaneum. Ambrogio Lorenzetti's frescoes in the Palazzo Pubblico in Siena give an intimate picture of the city's streets in 1340. The Boucicaut Master, in a Book of Hours, shows us early fifteenth-century Paris from the heights of Montmartre with many identifiable buildings, some still standing, and the Limbourg brothers take us right inside the Ile de la Cité. Jean Fouquet shows us the Paris of some thirty years later in still greater detail. It is impossible to believe that the backgrounds of street scenes in some of the work of Robert Campin, Jan van Eyck or Roger van der Weyden existed only in their imagination. But, Venice is a work of art in itself and the forcing ground on which view painting finally developed into an art; it is therefore appropriate that Venice should have been the city to have dominated a series of paintings commissioned to celebrate miracles of a different sort.

They were the miracles of the Holy Cross which belonged to the Scuola di S. Giovanni Evangelista. This was one of the six most influential of the *scuole*, or guilds, of Venice, all of which were concerned with both the spiritual and material needs of their members (the emphasis on the one or the other varied between the different *scuole* and at different periods). The relic of the Cross belonging to the Scuola di S. Giovanni Evangelista had been brought to them as a gift from Constantinople and was venerated not only for its holy association but also for the miracles which had been attributed to it. At the end of the fifteenth century the *scuola* was at the height of its power and prosperity and desirous of celebrating the achievements of its precious relic. To this end it commissioned a series of paintings of some recent events which were to be housed in its splendid building, not far from the Frari church. The Cross remains in the building today, the building itself having been restored after many vicissitudes following the closing of all the *scuole* by Napoleon; the paintings, however, have been moved to the Academy of Fine Arts.

Two of the paintings were by Gentile Bellini, four by his assistants and one by Vittore Carpaccio. Carpaccio chose to show his Miracle taking place by the old wooden Rialto Bridge; Gentile Bellini placed one by S. Lorenzo (where the miracle had taken place, the Cross having fallen into the canal but remained floating) and the other in the Piazza S. Marco, where no miracle is taking place but a procession follows the Cross into St Mark's. Venice, even more than the miracles, is the subject of all the paintings but none commands attention in the same way as Gentile Bellini's *Piazza* (plate 6). It is a topographical work of enduring interest, quite apart from its artistic quality.

We appear to be standing at the western end of the Piazza, in front of what was then the church of S. Geminiano but is now the entrance to the palace Napoleon

built himself, which has since become the Correr Museum. The procession winds round the Piazza but our attention is diverted from it by the surprising resemblance to the Piazza as it is now. There have been changes, notably in that the Procuratie Nuove, on the right, have not yet been built; the Byzantine Ospizio Orseolo is there instead and joins on to the Campanile which was not then free standing. However, the Campanile itself does not dominate the scene, as it does in fact, nor does it mask the entrance to the Doge's Palace. The main façade of St Mark's, too, stands symmetrically facing us whereas nothing is symmetrical in the Piazza.

All becomes clear if we move to the left side of the Piazza, beside the Procuratie Vecchie, just in front of the Caffè Quadri. This was Gentile Bellini's chosen viewpoint and a well-chosen one. From here the St Mark's end of the Piazza presents an altogether more pleasing composition to the artist's eye: the Campanile is less obtrusive and St Mark's is seen *en face*, not at a slant. It would not do as the apparent viewpoint, which must show both sides of the Piazza and the procession as it would be seen from a central point, but the idea of adopting two (and, in fact, more than two) viewpoints, and deceiving the spectator into believing that only one had been used, did not apparently offend Gentile Bellini or his patrons, if they noticed the subterfuge.

Had Gentile Bellini created a precedent by putting composition before topographical accuracy? The answer is probably 'yes' but it is highly improbable that Gentile Bellini considered the priorities of the question for a moment or that the words 'topographical accuracy' existed in an artist's vocabulary at the time. Perspective and its rules had been discussed among artists and scientists for half a century and with mounting excitement. Almost a century earlier, Brunelleschi had chosen a topographical subject, the Piazza del Duomo in Florence, to demonstrate his discoveries in this field. The objects were to create the illusion of space, a third dimension in a two-dimensional picture, to make things 'seem to be in some cases receding and in others projecting' to quote the words of Vitruvius in the first century A.D. (he was hoping to create the illusion on the stage: to achieve such an object on a panel or canvas must have seemed like landing on the moon). There was much talk of Brunelleschi's discovery at the time: it was 'as if the real thing was seen'. The full effect was not realized, though, by just looking at the picture; for this you had to look (through a hole in its back, made for the purpose) at its reflection in a mirror. As the fifteenth century proceeded the rules were amended and, by Gentile Bellini's time, viewpoints, vanishing points and so on were thoroughly understood. There had been no mention of topographical accuracy, though. The artist's object was to create an illusion, not to tell the truth.

By Canaletto's time townscape paintings had had two centuries of development but the objects had not changed much. Canaletto's concern was to convey a sense of space and for that he had to understand the rules of linear perspective in all

their complexity. He must also convey a sense of being in a particular place and for that the buildings in his pictures must appear to the spectator as they had appeared when he had stood before them. Above all he must carry conviction and for this he must resort to all the tricks that past artists had built into their repertoire. The sun would not shine in his pictures merely by letting it shine *on* them: much more was necessary. The smells and sounds, and even the sights, of Venice would not crowd back into the travellers' minds if the artist just painted what was before his eye (as every amateur photographer has learnt to his chagrin). If these objects were to be achieved the artist must create a work of art; such things as changes of viewpoint were mere technical resources like the materials used in grinding the paints, vital though a command of such techniques must be.

As has already been said, Canaletto had been born at the right moment, Carlevaris having created a market he was not thoroughly equipped to supply. The market was essentially a tourists' market; Venetians did not want pictures of their city and very few other Italians felt like Stefano Conti. Venice had been a tourist centre since the days of the Crusades when, having control of the ships that were to carry the Crusaders to the Holy Land, the Venetians ensured that they were seldom ready until their visitors had had an enforced stay enjoying, and paying for, all that the city had to offer. The Crusaders were followed by the pilgrims and the same techniques became more highly developed. At times Venice's whole fleet was turned over to serving the requirements of the pilgrims, and the shops in and around the Piazza must have seemed as well orientated to the visitors', as opposed to the residents', needs as they are today.

In the days of the Crusades and the pilgrimages the Venetians had many ways of growing rich besides looking after visitors. By Canaletto's time things had changed. For two centuries, since 1500, the power of Venice had been declining and now she had little left of her foreign influences and even her possessions on the mainland virtually ignored her. Art had survived longer than naval and mercantile expansion; her greatest artists flowered in the first half of the sixteenth century when the decline of the Republic was already well into its stride. But they left no successors of any consequence and the remorseless march to extinction continued, with but one pause, until 1797.

Pains were taken to conceal the true situation from the visitors who cooperated gladly in the deception. They wanted carnival and gaiety, gambling and courtesans, ceremonies and processions, and everything was done to ensure that they were provided with what they wanted. Very few commented on the decay that lay behind all this but tourists are not noted for their percipience. As for the Venetians, whereas they had always served their visitors well, they now dedicated themselves to making their city attractive to them: they had little else to do.

And there was a faint reflowering of Venice's ability to inspire great artists. A

Tiepolo can hardly occur in a vacuum and, although Tiepolo's contemporaries seem pale shadows beside the great Venetians of the Renaissance, they have some substantiality compared with their immediate predecessors. This was the pause in the march to doom. Thus, Canaletto did not look out on to an artistic desert, nor to a city which was as sombre as the situation merited. On the contrary, it was to all appearances an extremely gay city, thronged with visitors, many of wealth and position, and a few of intelligence too. With few exceptions they were enchanted by what they saw and did, and all doubtless longed to take home visual mementoes of the scenes which had given them such pleasure. This was a privilege reserved for the better off and, as Canaletto proceeded from recognition to success and from success to fame, it was a privilege enjoyed only by the very rich. In England, where Canaletto's work was most appreciated, it happened that great riches often went with a dukedom or lesser ennoblement. Some dukes were rich because they were dukes but, by a quirk of the social system of the period, some were dukes for no better reason than that they were rich. It may be that the presence of so many Canaletto paintings in ducal collections is accounted for by this rather than by his particular appeal to aristocratic taste.

2

Rome

'. . . he solemnly excommunicated the theatre'

A. M. Zanetti, *the younger*

Canaletto was certainly born near the Campo S. Lio in the parish of S. Leone, some 150 metres south-east of the Rialto Bridge, on 28 October 1697. The parish record establishes this, together with the facts that he was baptized Zuane (the Venetian form of the Italian Giovanni) Antonio, that his father was Bernardo Cesare Canal, painter, and his mother Artemisia, formerly Barbieri. By 8 March 1722 he had certainly painted 'the perspective and landscape' of two pictures showing imaginary tombs of English dignitaries. This is established by a letter from one Owen McSwiney in Venice to Lord March, who became the second Duke of Richmond the following year. The commission was shared with G. B. Cimaroli in some unspecified way.

Between these two dates there is no documentary evidence at all and for the first twenty-five years of Canaletto's life we have to rely on a few paragraphs in the works of eighteenth-century writers. Of the three concerned, Pierre-Jean Mariette had the advantage of being in direct communication with Canaletto and, probably, of having met him. He was a celebrated collector who was born three years before Canaletto and died a few years after him. He spent many years compiling an *Abecedario*, an ABC or dictionary, of artists which remained unpublished until the 1850s. Less than a page was devoted to Canaletto although the artist had sent Mariette a '*memoire*' in which his principal concern seems to have been to establish that he was entitled to call himself 'da Canal'. For this purpose Canaletto sent Mariette his genealogy and, although the date of the correspondence is not known, Canaletto certainly signed some of his last drawings in this way. The implication of noble birth was justified to the extent that Canaletto's great-grandfather had been granted the status of *cittadino originario*. This gave the family the right to use a coat of arms (which Canaletto quite frequently included in his works) and, in the highly class-conscious Venetian Republic, placed them one rung below the patrician nobility. Occasionally an 'e' was added to the name Canal, a matter of small consequence in an age when spelling mattered less than social status. The name of 'Canaletto', also spelt 'Canaleto' and, sometimes by

foreigners, 'Canaletti', was doubtless adopted to distinguish him from his father. It was used by McSwiney in his letter of 1722 but McSwiney also called him 'Canal'.

Canaletto told Mariette he had been born on 18 October 1697, which was ten days out. How much of the remainder of Mariette's brief note was contributed by the subject himself we do not know. Some comments certainly originated from Mariette himself such as the fact that he worked in the manner of 'Van Vytel; *mais je le crois supérieur*', some criticism of Canaletto's etchings (which were quite unjustified) and the specific statement that he made use of the camera obscura. The accuracy of this statement will be considered later but it would not have emanated from the artist himself.

Anton Maria Zanetti may also have known Canaletto. His elder cousin who bore exactly the same name certainly knew him (he knew everybody in the art world of Venice) and became the owner of unique examples of Canaletto's etchings which must have been given to him by the artist himself in the 1740s. The younger Zanetti included some 400 words on Canaletto's life and work in *Della Pittura Veneziana*, which was published shortly after the artist died in 1768. Brief as this 'biography' was, it concerned itself more with the work than with the life and tells us only that Canaletto was a theatrical painter, like his father, that 'he "solemnly excommunicated the theatre", to use his own words, about 1719 and went to Rome where he devoted himself entirely to painting views after nature'. We know this to be wrong from the printed libretti of two operas by Alessandro Scarlatti where the father and son are shown as having executed scenes for the works which were performed in 1720. Pellegrino Antonio Orlandi's note, which was published in 1753, in Canaletto's lifetime, is even briefer than the other two and tells us no more.

To sum up, all agree that Canaletto began by assisting his father as a scene painter and that he went to Rome when fairly young. The interesting question is what he did while there and this remains unanswered.

He certainly worked in the theatre while in Rome and did not 'devote himself entirely' to painting views after nature. Did he paint such views at all? It would be reasonable enough to assume that an artist who, at the age of twenty-eight, was 'astounding everyone in Venice' with his views had been producing something beyond theatrical scenery when he was twenty-two or twenty-three. Yet there is no painting which can be attributed to his Roman period with any certainty at all.

The near-certainty that such paintings exist tempts the scholar to see the hand of Canaletto in places where it may have been at work but where others are equally likely to have been responsible. For example, while Canaletto was in Rome, Marco Ricci was certainly painting real and imaginary landscapes in Venice, few of them signed and many of them the kind of picture one would have expected

from Canaletto, to judge from the earliest of his work that can be identified with certainty. Marco was the nephew of Sebastiano Ricci who was an immensely skilful and successful practitioner of that long-defunct branch of art known as history painting. Unlike Sebastiano, who leant heavily on his predecessor Veronese for inspiration, Marco was an originator; in fact he was the first Venetian landscape painter in that he used landscape as a subject in itself rather than as a background to something else. Joseph Smith, who had adopted Venice as the centre for his affairs and his collecting and of whom much will be heard, was a faithful patron of both Sebastiano and Marco and owned many paintings by both, as well as half a dozen done in collaboration. Since Smith later became Canaletto's principal patron, and both the Ricci were in Venice until their deaths several years after Canaletto's return there, there is good reason to believe that all three artists knew each other and Canaletto must certainly have known their work.

As soon as Canaletto's work becomes identifiable, that is to say with Stefano Conti's pictures and those of the same period, it follows a number of Marco Ricci's characteristics. Canaletto uses Marco's dark, reddish-brown ground for his canvases; he builds up his figures in much the same way and streaks on his high-lights to emphasize the drama of the scenes (both were accomplished scene painters). It is reasonable enough therefore to take some of Marco Ricci's more imaginative, undocumented works, of which there are so many, and assign them to those otherwise empty years of Canaletto's early twenties. Reasonable, but unfortunately not justifiable to the extent that their authorship remains anything more than a matter of opinion.

There is more to be said in favour of a very large capriccio painted with great skill in a manner which it is easy to associate with Canaletto (plate 7). This painting had as its companion another capriccio of the same size which bears the inscription on the back 'Io. Antonio Canal/1723'. The difficulty here is to associate it with what is known of the Canaletto of 1723. Moreover, the fact that the Library of Venice appears unmistakably in the right background of the picture illustrated makes it improbable, to say the least, that we have anything here to provide a clue as to what Canaletto was doing in Rome.

He may have painted *The Arch of Constantine* there (plate 8). Here again is the dark reddish ground and, except for the half obelisk and fountain in the left foreground, the subject is the same as one of some two dozen drawings which bear Canaletto's name and which can be associated with him without doubt. Whether these drawings are copies from a sketch-book of his, perhaps done for an engraver, or his own immature work is a matter of controversy but it is certain that Canaletto based a number of much later paintings of Rome either on these drawings or on their originals if they are copies. There is even an *Arch of Constantine* among these paintings, in this case dated as late as 1742. The present picture, though, is very much earlier and still shows the influence of Marco Ricci as far as

can be judged. A good case could be made out for its being the only known work done by Canaletto in Rome but it is more likely to be an early picture of Rome done by him in Venice very soon after his return. This does not mean that there is any proof that Canaletto painted it at all. Indeed there is no proof of anything he did in Rome except paint scenery or of anything he did in Venice until Owen McSwiney appears on the scene.

3
Stefano Conti's commission

'You can see the sun shining'

Marchesini to Conti

Canaletto was in Rome by 1720 and back in Venice by March 1722. By 1725 he had, therefore, had three years to earn the reputation which led to Marchesini's recommendation that Stefano Conti should turn to him rather than to Carlevaris for his view paintings. Hardly anything is known of the origins of his work during those three years whereas the progress of Conti's commission can be followed step by step. It even provided the artist's own description of his paintings in the only letters by him to have survived.

Conti was indeed the model patron for art historians. He insisted that every artist favoured by a commission from him should provide a full description of the subject and a written guarantee that the picture was an original work together with its date of execution and a receipt for the fee paid. In addition, where the work was proceeding outside his native Lucca, Conti demanded frequent progress reports from his agent, in this case Alessandro Marchesini who, it will be remembered, had recommended Canaletto as the new man who let the sun into his pictures. When Conti died at the age of eighty-five, fourteen years after Canaletto's work for him was finished, he expressed the hope that his collection should be preserved intact, as have so many collectors before and after him. The hope was not realized but a diligent secretary had copied his correspondence into a notebook which still exists. Canaletto's own letters have been passed with the paintings to their various owners ever since.

Once Marchesini's advice had been accepted he was entrusted with the negotiations and was surprised that Canaletto should demand thirty zecchini a picture. This represented about fourteen pounds sterling which hardly sounds excessive for a metre-high painting by an artist whose work was already astounding everyone in Venice. However, the true value of money, even in comparatively recent times, is notoriously difficult to arrive at. On the one hand, the richest family in Venice, the Foscarini, were said to have an income equivalent to £15,000 sterling a year and this was the cost of enrolment into the Venetian nobility a few years earlier (Conti's father had been accepted into the Lucchese nobility a century

before but the cost is not recorded). On the other hand, it was said that a man could just subsist in Venice on seven pounds sterling a year. Transactions were recorded in ducats, both 'current' and silver, as well as zecchini, the value of the ducat being lower; one also comes across lire (livres), scudi and soldi, of descending value, the soldo being worth about a farthing. For simplicity, money is here converted into zecchini (sequins), two of which were worth rather less than a pound sterling, or into sterling.

That Marchesini was right in considering Canaletto's price too high in 1725 is confirmed by the fact that five years later, when Canaletto was almost at the height of his fame, the Howard family were paying only £18 sterling for a pair of his pictures which Joseph Smith had shipped to England and in which he doubtless included his commission (it is true they were only half the height of the Conti paintings). In any case, Marchesini persuaded Canaletto to reduce his price by a third on the assurance that a present might be expected if the work was satisfactory.

This was in July and by 4 August Marchesini was able to tell Conti that work had begun on 'two of the finest views that have ever been seen'. The viewpoint was 'precisely on the spot' where Stefano Conti's son, Giovanni Angelo, had been lodged on a recent visit to Venice (or at any rate his entourage: it is not clear whether Giovanni Angelo stayed in the same lodgings).

It was true that Canaletto had agreed to paint the pictures and that he had signed a receipt for ten sequins as a deposit on the forty sequins to be paid for the pair 'leaving to the favourable cognizance of the said gentleman the difference between twenty and twenty-five' which he had expected. It was not true, though, that work had started. Meanwhile Giovanni Angelo was able to report to his father that he had seen one of Canaletto's views in the Palazzo Sagredo and this stimulated Stefano's enthusiasm enough for him to increase his order immediately from two to four pictures.

It was not surprising that Stefano Conti should be impressed by Canaletto having earned the patronage of Zaccaria Sagredo. The Sagredo family were one of the most ancient and distinguished in Venice and Zaccaria's uncle, Niccoló, had been Doge during his lifetime. That was in 1675 and Zaccaria was now an old man with the reputation of being by far the most distinguished and influential patron in Venice. He had been collecting art of every kind throughout his life as only a rich bachelor can and, as well as old masters from earlier collectors, he bought paintings from living artists such as Crespi and Piazzetta. He had only another four years to live and, like Conti and so many other collectors, desired nothing more than that his collection should remain intact for as long as possible after his death. As in almost all similar cases before and since, his wish for this kind of immortality was frustrated; his nephew Gherardo and his servant Tomaso bore the burden of safeguarding another man's treasures for a time but their successors spent more than twenty-five years dispersing what Zaccaria had devoted his life

to bringing together. The Canaletto judged worthy to join this great collection cannot be identified; this is a pity since the artist was never to find a patron of greater connoisseurship. Nor was there ever a period in his life when the influence of a discriminating patron was more necessary to his development.

With the doubling of Stefano Conti's commission, Marchesini had to confess that the original pair of pictures had not in fact been started. Canaletto 'would begin work' on them at once, though, and would consider the subjects of the second pair. One of the first pair (plate 9) was to show the Rialto Bridge as it would be seen from a point in the middle of the Grand Canal—in fact, from several points but this would not be immediately apparent. The other (plate 13) purported to show the view from the bridge in the opposite direction.

Work was still 'about to begin' on 18 August when Marchesini tried to pacify Conti's impatience by reporting that the ambassador to the ('Holy Roman') Emperor had bought one of Canaletto's paintings. This was said to be a view of SS. Giovanni e Paolo which had been exhibited outside the Scuola di S. Rocco. Canaletto was later to make this annual exhibition familiar to almost everyone through his masterpiece now in the National Gallery, London (plate VI). Unlike the regular exhibitions in the Piazza S. Marco, where artists could show their work to enhance their reputation but were not allowed to sell anything, the feast-day of St Roch provided a useful market-place where artists could offer their wares for sale. The Doge in his state robes of gold led a procession into the then unfinished church of S. Rocco (on the right) to hear mass and then visited the Scuola with its precious cycle of paintings by Tintoretto.

Canaletto has shown only one work in his picture which might conceivably be his own and certainly there is no SS. Giovanni e Paolo on display. The Emperor's painting might possibly be the version of the subject which is now in Dresden (plate 11) which was certainly painted at about this time and which belonged to the King of Saxony by 1754. This is a magical picture, perhaps showing Canaletto at the peak of this phase of his career, when his technical equipment had caught up with his imagination which was still itself allowed full rein. But the probabilities are against the idea. One of Stefano Conti's second pair of paintings proved to be of this very subject (plate 12) and it shows every evidence of being a step towards the realization of the Dresden work rather than the reverse. We must conclude that the Emperor's purchase has been lost or destroyed, together with another, larger Canaletto which Marchesini reported he had bought on the same day. Stefano Conti may have suffered annoying delay in the completion of his commission but he must have felt his judgement in accepting Marchesini's recommendation vindicated by finding himself in the same company as Sagredo and the Emperor.

At last, in September, Canaletto really did start on the paintings but Conti was warned that difficulties were to be expected over the expense of finding the blue

pigment which was one of the principal colours he used and a long-lasting type of green. He was also warned that he must not expect 'anything too grandiose' in the pictures. Weekly progress reports continued and the selection of frames was soon under discussion.

The second pair were being discussed before the end of September and it was suggested that they should be larger and that they should show the area at the end of the Grand Canal, now occupied by the railway station. Conti seems to have agreed that one of these, showing the whole course of the Canal from S. Chiara to the church of the Scalzi, would be acceptable but he wanted all four to be the same size and he had his own ideas about the fourth picture.

While the artist's and patron's views about the subjects of the second pair were being relayed by Marchesini, Canaletto made a startling remark. According to Marchesini, he said he was not painting from imagination in the studio, as was Carlevaris's practice, 'but this he always does on the spot and paints everything from reality'. 'Truly this is a marvel', added Marchesini, and it truly was—if it was a fact. It was no slip of the tongue on Canaletto's part; on 13 October he told Marchesini that Conti's proposal for the fourth subject was impracticable. 'He paints on the spot', Marchesini reported, 'instead of at home as S. Lucca (Carlevaris) does and, wishing to do this, a fixed spot is required and a permanent one, of which there is no possibility' as Conti would realize if his own idea of a subject were adopted. Canaletto would choose another which would match it for fineness of view.

What did Canaletto mean? That he set up a metre-high canvas at his viewpoint on a studio easel (for the portable easel did not exist) surrounded by his paint bladders (for the collapsible tin tube was more than a century away) and set down on canvas what he saw before him? It is hard to believe that Canaletto expected his patron to credit such a thing but Marchesini insists twice that that was what had been said.

Unless Canaletto was prepared to say almost anything to excuse his delay, or to create a *stupore* (marvel) in Marchesini's eyes, we can only assume that he used the verb *dipingere* to mean depicting in any form and to include making the on-the-spot sketches which anyone, including Carlevaris, would have needed before starting work in his studio. By a freak chance a drawing has survived which must be accepted as the sketch for the view of the Rialto Bridge by even the most sceptical (and it is advisable to regard all apparent relationships between Canaletto's drawings, paintings and etchings with considerable scepticism). The evidence in this case is circumstantial but massive. The sketch (plate 10) which is now in the Ashmolean Museum, Oxford, shows the scene as painted from the same viewpoint, a viewpoint not attainable today except from the water. However, an engraving and a painting of the same scene from a slightly different viewpoint establish that there used to be a quay in just the spot required. No other painting

of the scene, and there are at least half a dozen, is from exactly the same viewpoint and in no other painting than Conti's do the details in the bottom left-hand corner of the sketch appear. In the bottom right-hand corner of the sketch Canaletto has written *Sole* and this is precisely where the sun strikes the water in the painting. Across the top of the sketch, Canaletto has written *Vedute del ponte di rialto in facza Carbon*. He can hardly have been in danger of forgetting the subject so it must be assumed that he gave away, or sold, the sketch and identified it for the new owner. The statement that Canaletto *painted* in the open air, although made in almost every biographical note on him, must therefore be treated with great reserve, if not dismissed altogether. Another point intrudes, although it is purely speculative. Later on, Canaletto was to be said to have made free use of the camera obscura for his paintings. The evidence will be considered later and found to be far from reliable. Could the story have originated from his claim to follow the unheard-of practice of painting in the open air? Why, the Venetians may have asked one another, should he have done such a thing unless he needed a camera obscura before putting brush to canvas?

Certainly Canaletto needed some excuse for his continued failure to complete his commission. In November Conti was being assured that all would be well in ten days and Marchesini added, perhaps tactlessly, that there was talk of Canaletto being employed by the French Ambassador (foreshadowing further delay?). But at last the first pair were finished and Marchesini was able to write that all who had seen them, including other painters, agreed they were the most beautiful they had ever seen; he only hoped the remaining two would be as good. Just before this, on 25 November, Canaletto provided the receipt and description insisted upon by Conti for all his commissions. After giving the size, he went on

in the first representing the Bridge of the Rialto on the side looking towards the *Fontico de Todeschi* which is opposite the palace of the Camerlengi Magistrates and other Magistracies besides, looking down upon the Vegetable Market where they land all kinds of vegetables and fruits to be shared amongst the dealers in the City. In the middle of the Canal is painted a *Peotta nobile* [a sailing gondola presumably belonging to a nobleman] with figures in it and four gondoliers going at full speed and close to it a gondola with the livery of the Emperor's Ambassador (Plate 9).

The second picture was then described as continuing along the same canal with 'what are called *le Fabriche* [the Buildings] up to the fish markets, the Palazzo Pesaro and in the distance the Campanile of S. Marcuola. On the other side of the Canal but near at hand is the Palazzo di Casa Grimani and in succession other palaces, namely Rezzonico, Sagredo and many others.'* The price of thirty sequins was then specified and even the type of sequin and, subject to this, Canaletto

*The order should have been reversed. The palace on the right beyond the one with the colonnade was Zaccaria Sagredo's. Some distance beyond that is the Palazzo Fontana, then occupied by Count Rezzonico (later Pope Clement XIII). Farther away still is the palace then called Grimani della Vida, celebrated for its façade frescoed by Titian.

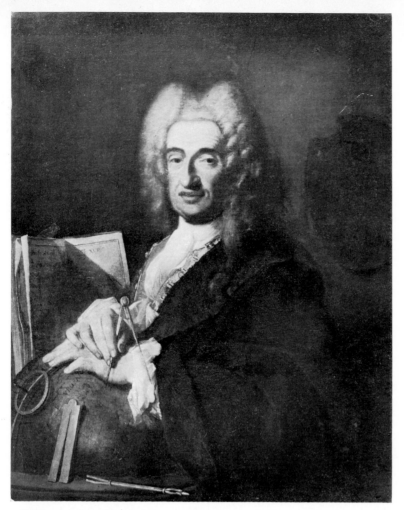

1 B. Nazzari, *Luca Carlevaris*. 90 × 74cm

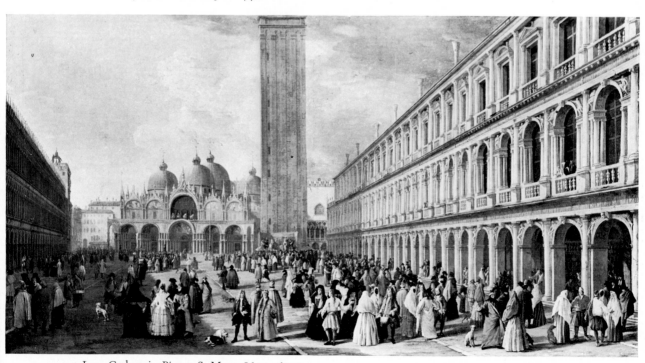

2 Luca Carlevaris, *Piazza S. Marco*. 86 × 162cm

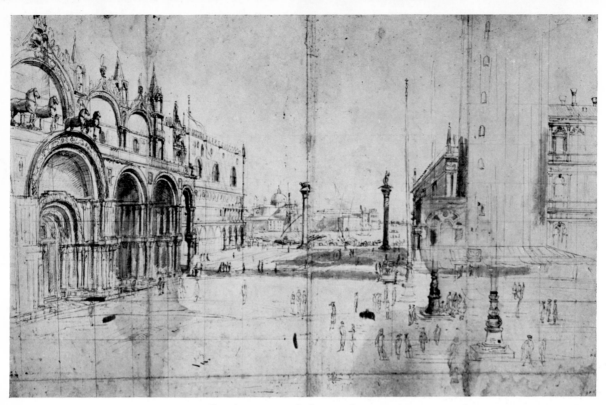

3 Gaspare Vanvitelli, *The Piazzetta: looking South.* 47 × 77cm

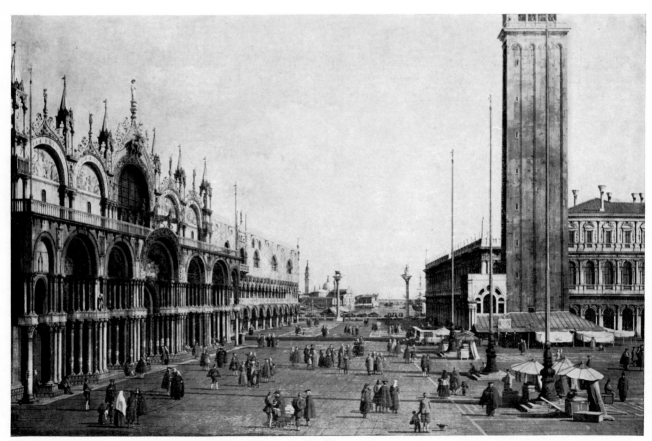

4 *The Piazzetta: looking South.* 170 × 132cm

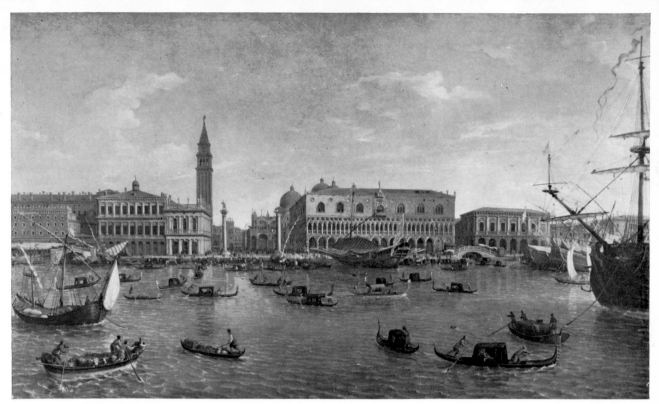

5 Gaspare Vanvitelli, *The Bacino and the Molo*. 98 × 174cm

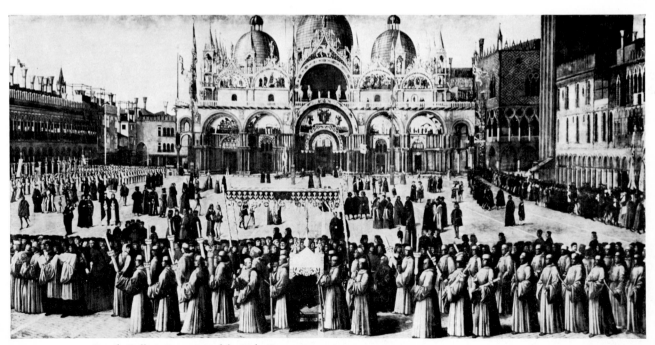

6 Gentile Bellini, *Procession of the Holy Cross*. 355 × 747cm

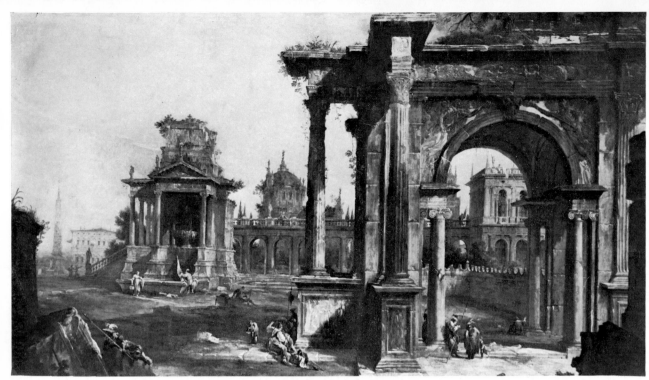

7 Attributed to Canaletto, *Architectural capriccio*. 178 × 320cm

8 Attributed to Canaletto, *Rome: Arch of Constantine*. 113 × 148cm

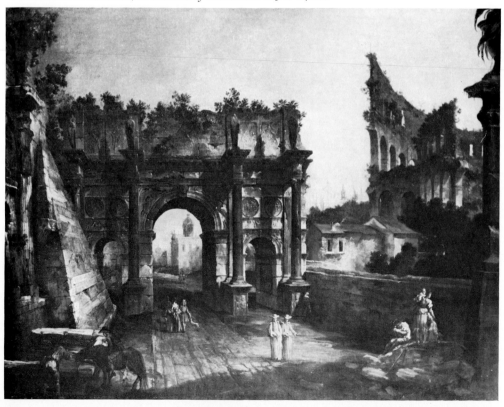

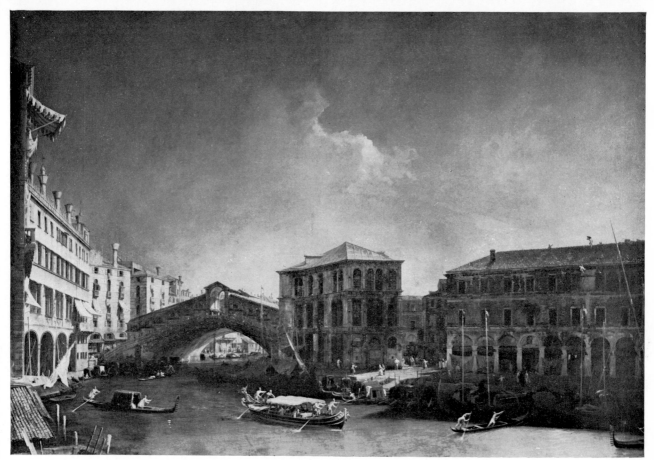

9 *Grand Canal: the Rialto Bridge from the North.* 91 × 134cm

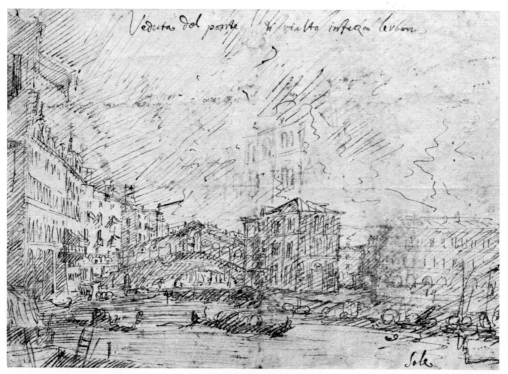

10 *Grand Canal: the Rialto Bridge from the North.* 14 × 20cm

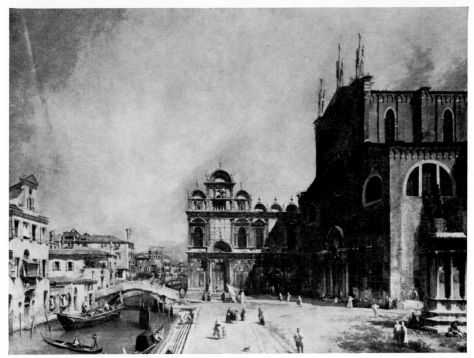

11 *SS. Giovanni e Paolo aud the Scuola di S. Marco.* 125 × 165cm

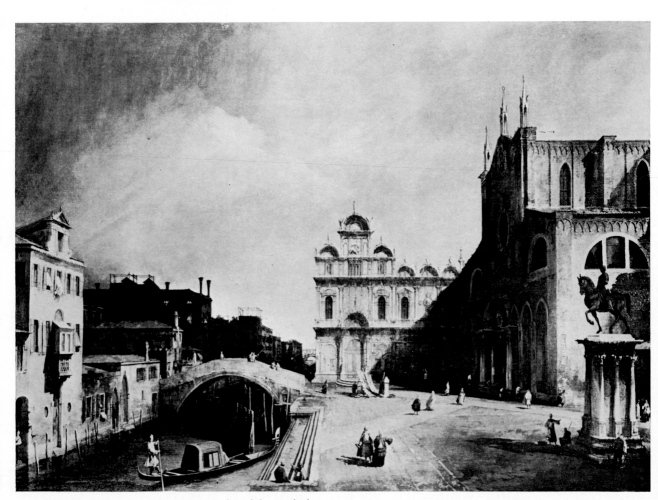

12 *SS. Giovanni e Paolo and the Scuola di S. Marco.* 91 × 136cm

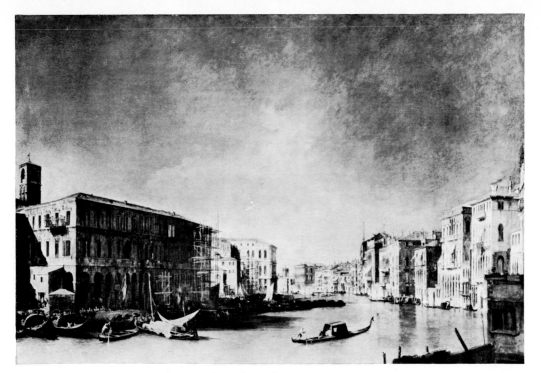

13 *Grand Canal: looking North from near the Rialto Bridge.* 90 × 132cm

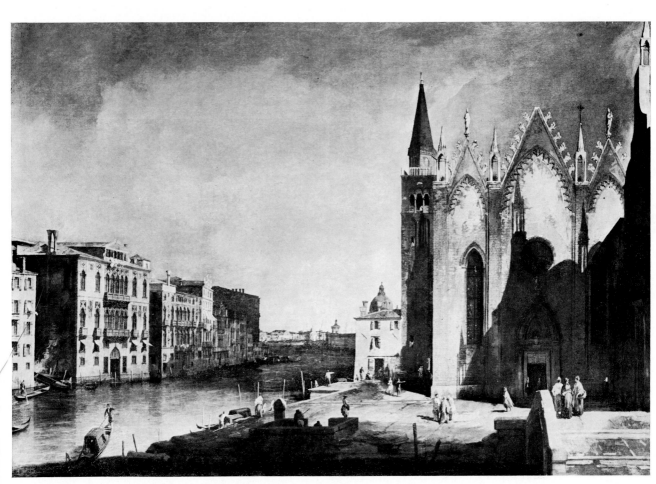

14 *Grand Canal: from S. Maria della Carità to the Bacino.* 90 × 132cm

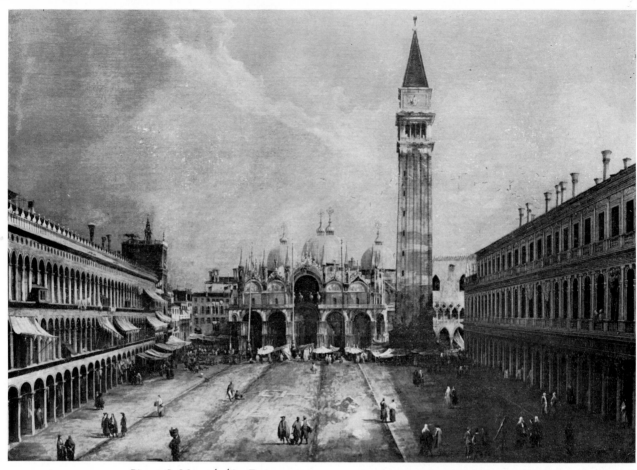

15 *Piazza S. Marco: looking East.* 142 × 205cm

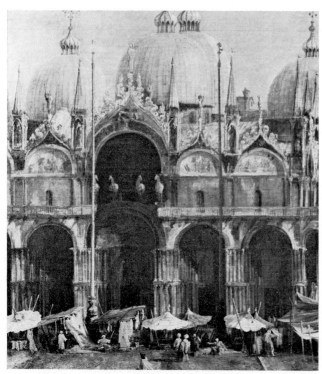

16 Detail of plate 15

17 Detail of plate 15

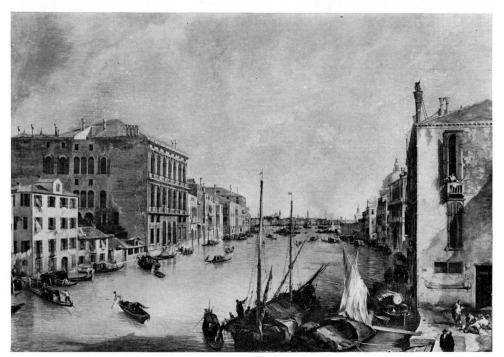

18 *Grand Canal: looking East from the Campo S. Vio.* 142 × 214cm

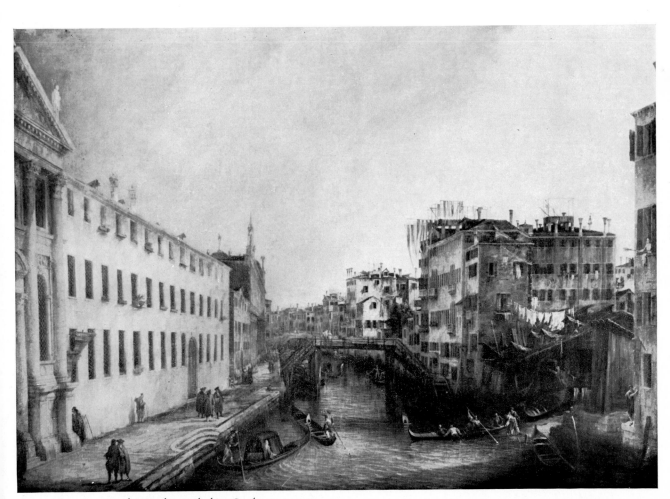

19 *Rio dei Mendicanti: looking South.* 143 × 200cm

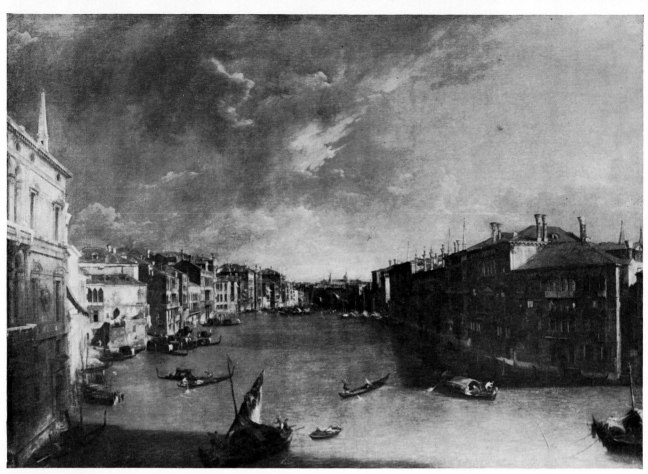

20 *Grand Canal: looking North-East from the Palazzo Balbi to the Rialto Bridge.* 144 × 207cm

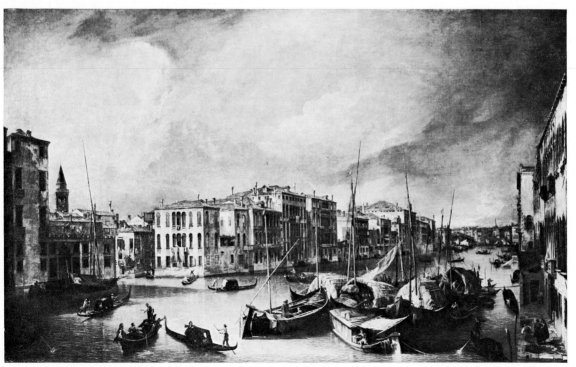

21 *Grand Canal: looking North-East from near the Palazzo Corner-Spinelli to the Rialto Bridge.* 146 × 234cm

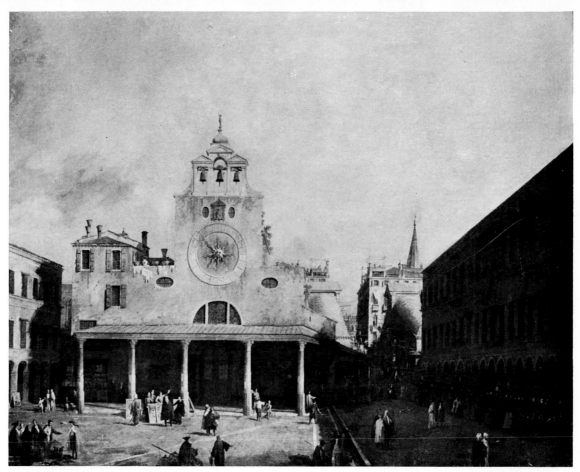

22 *S. Giacomo di Rialto.* 95 × 117cm

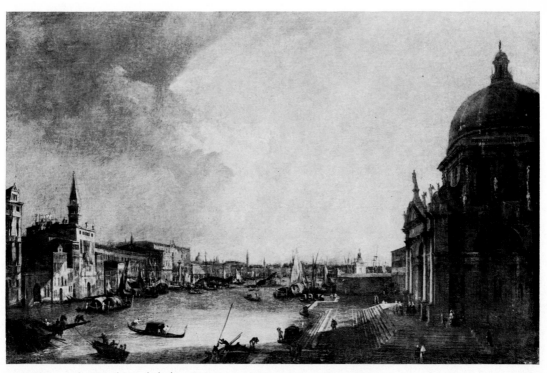

23 *Entrance to the Grand Canal: looking East.* 65 × 98cm

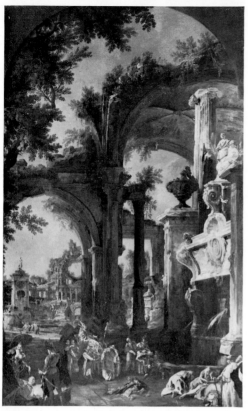

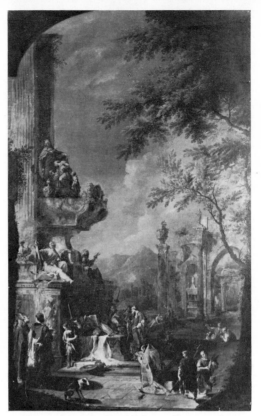

24 *Capriccio: tomb of Lord Somers, with ruins and landscape.* 280 × 142cm

25 *Capriccio; tomb of Archbishop Tillotson with ruins and landscape.* 218 × 138cm

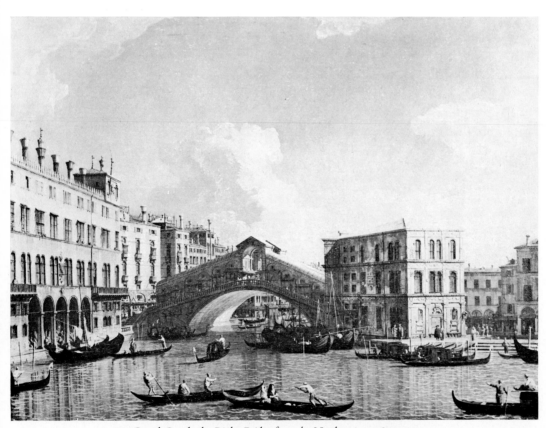

26 *Grand Canal: the Rialto Bridge from the North.* 46 × 58cm

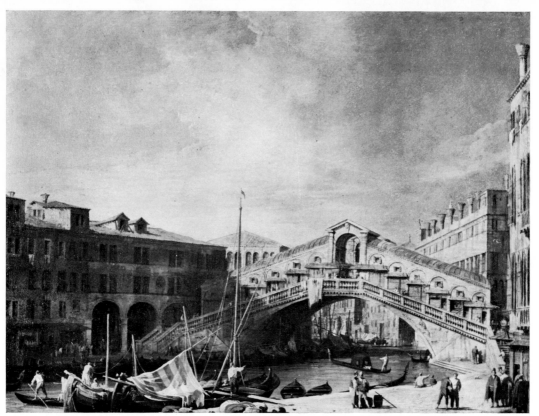

27 *Grand Canal: the Rialto Bridge from the South.* 45 × 62cm

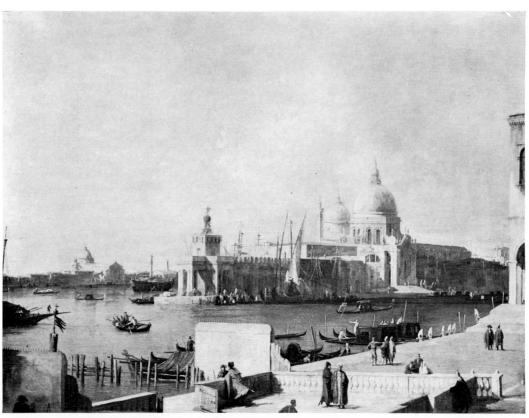

28 *Entrance to the Grand Canal: from the West end of the Molo.* 45 × 60cm

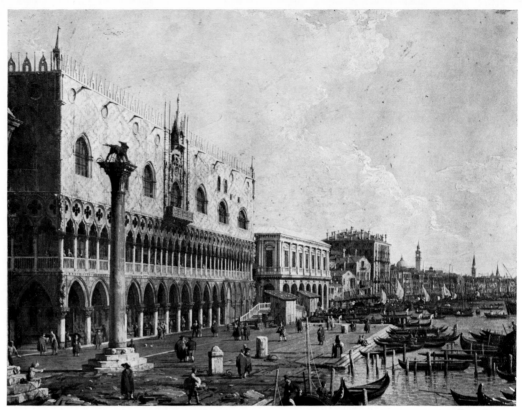

29 *Riva degli Schiavoni: looking East.* 46 × 62cm

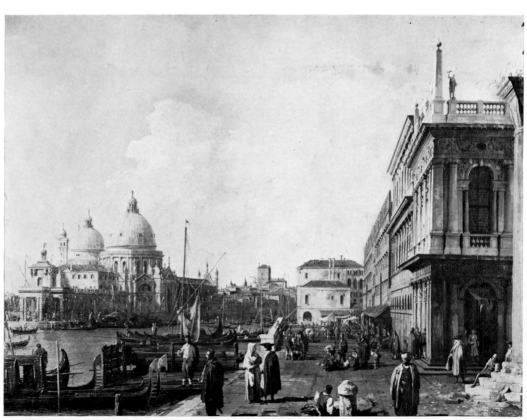

30 *Entrance to the Grand Canal: from the Piazzetta.* 46 × 61cm

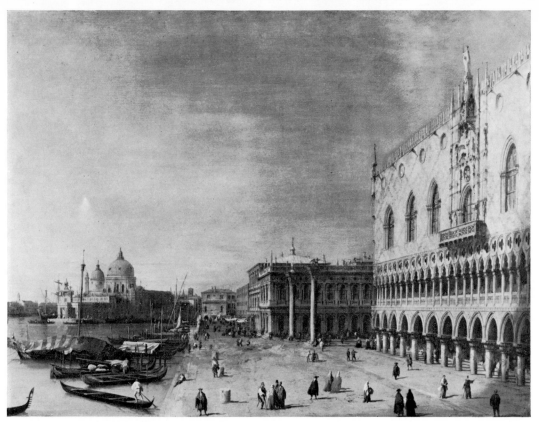

31 *The Molo, looking West: Ducal Palace Right.* 43 × 58cm

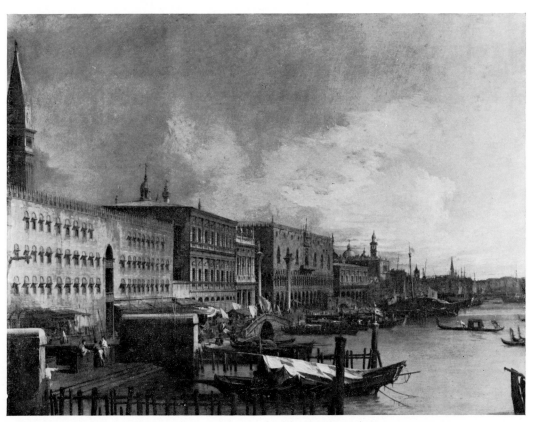

32 *Riva degli Schiavoni: looking East from near the Mouth of the Grand Canal.* 43 × 58cm

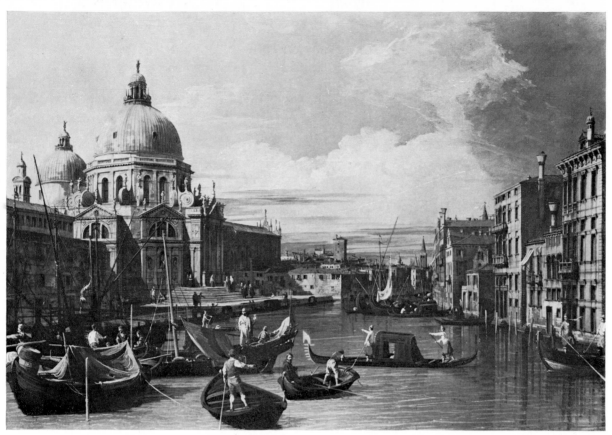

33 *Entrance to the Grand Canal: looking West.* 49 × 72cm

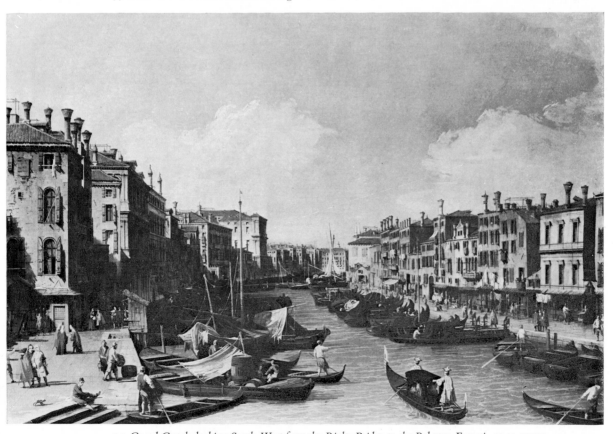

34 *Grand Canal: looking South-West from the Rialto Bridge to the Palazzo Foscari.* 49 × 72cm

agreed to paint two more pictures for the same price and to certify them as required. A postscript followed the signature reminding those concerned that he expected something more by way of a present.

On 22 December Canaletto acknowledged a deposit of ten sequins from Marchesini in respect of the second pair of paintings and Marchesini's letters to Conti continue in much the same vein. He had just written that the artist hoped they would turn out to be fine views, particularly the one of the S. Croce area; this must have been the picture which was to show the Grand Canal from S. Chiara to the Scalzi church. For the other, Canaletto was going to try to arrange accommodation on the balcony of the Casa Businello 'right next to the one' which Conti had himself occupied.

In the event Conti received neither subject although some years later Canaletto did paint a superb picture of the northern district which had been so much discussed (plate 50). He very probably did use the balcony of the Casa Businello, too, for later pictures of the Rialto Bridge from the south, or opposite side to that of Conti's first pair. His second pair, though, proved to be quite different.

It was to be six months before they were to be finished, six months of excuses for delay (the quality of the priming 'betrayed' the artist), requests for an additional present (they were involving more work than the first pair) and endeavours by Marchesini to placate his patron in the hope that Canaletto's moods would be humoured. He was, Conti was warned, '*un poco soffistico, e dilicato*'. Difficult, perhaps, and touchy; Marchesini was by no means the last agent to have problems in explaining the kind of man Canaletto was to his principal.

Stefano Conti was persuaded into patience and duly rewarded by news on 4 May 1726 that the pictures were ready. This was far from accurate but they were certainly well in hand and by 24 May one of them really was ready. The subject can hardly have surprised Conti himself but it does surprise the reader of the correspondence because it turned out to be a painting of 'the Church of SS. Giovanni e Paolo with the *campo* and the equestrian statue of General Bartolommeo of Bergamo and various other figures, namely a Counsellor in a red robe going into church, another of a dominican friar and various other small figures' (plate 12). The words are those of Canaletto in his certificate; Marchesini added that houses, bridges and boats were included, together with the Scuola S. Marco.

Marchesini was right to repair the omission by Canaletto of any mention of the Scuola S. Marco, both artistically and historically. The attractive *trompe-l'oeil* façade, by the Lombardo family, of what is now the principal hospital of Venice dominates the scene, the façade of SS. Giovanni e Paolo being seen sideways on and in deep shadow. Historically, the Scuola provided the justification for the equestrian statue being placed in the *campo* at all. Bartolomeo Colleoni was a leading *condottiero* whose generalship and army were at the disposal of those willing to pay for them. He died in 1475, having served Venice well; the

3—C * *

Republic's confidence in him was such that he warned it on his death-bed never to give another general such power, adding, 'I could have done you much harm'. He bequeathed most of his fortune back to the Republic, stipulating only that he and his horse should be commemorated by a statue in the Piazza S. Marco. This was unthinkable to the Venetians who were nevertheless reluctant to forego the money at a time when it was badly needed. The State conscience, always a pliable instrument, was salved by erecting the statue in what might have been (but never was) called the Campo S. Marco, since the *scuola* of that name occupied it as well as the great Gothic church which in fact provided its name.

Canaletto's demand for a present came as soon as the SS. Giovanni e Paolo painting was finished, at the end of May, and ten sequins were sent to him. Less than five pounds sterling seems a small sum but perhaps it was the mark of appreciation he wanted. At any rate, Marchesini reported that he had observed 'the highest satisfaction' in the artist. Another month saw the completion of the fourth, and last, picture (plate 14).

Canaletto described it as a view of

the Church of the Patri della Caritá Rochetini with its *campo* where I have disposed many small figures amongst which, in a little group of three figures in the centre of the *campo*, are two priests of the same Order who are discoursing with a learned man in a violet coloured robe. On the horizon at the farther end of the canal is part of the Riva degli Schiavoni. The Cupola which is seen is the principal one of the Church of the Salute, the lower part of which continues as far as the Dogana di Mare [marine customs house].

The name 'Rochetini' has long ceased to be attached to the Church of the Caritá which was itself suppressed by Napoleon and later, together with its adjoining *scuola*, became the home of the Academy of Fine Arts. The *campanile* fell in 1744 but most of the buildings remain in one form or another. It is interesting to compare the picture with the sideways view of the church in '*The Stonemason's Yard*' (plate 41).

Stefano Conti's commission had been executed and nothing remained to be done but to frame the pictures and deliver them. These were problems for Marchesini and Conti himself, not Canaletto, but the customs officials ensured that they were not easily surmounted. Another artist commissioned by Conti ingeniously changed the title of one of his works so that it could claim to be a 'sacred' picture, attracting less duty than a 'profane' one, but, appealing though the idea would have been to all concerned, this seems an unlikely device in the case of this particular group of pictures.

Stefano Conti's stipulation that his pictures must be original works was almost certainly honoured, if it meant that they must not be copies of others. As already suggested, his *SS. Giovanni e Paolo* seems to have been the stepping stone to the

miraculous version owned by the King of Saxony rather than the reverse. We may never know what the version bought at the S. Rocco exhibition looked like. Only one other version of the subject by Canaletto is known although his nephew, Bernardo Bellotto, painted it several times at least a dozen years later.

The labour Canaletto had devoted to composing the remaining three pictures was well rewarded by others, if not by Stefano Conti himself. All three became stock subjects, painted by Canaletto for other patrons (in the case of the first pair, at least a dozen times), then engraved, and copied by countless imitators. Stefano Conti (or perhaps Marchesini deserved the credit) had proved the model patron, not only in his insistence on business-like documentation, but in allowing the artist a free hand in both subject and method of painting. Canaletto was nearly, although not quite, at the peak of his powers and Conti allowed him to scale that peak within a short time. He was soon to be dragged down by well-meaning friends and patrons but throughout his career he showed occasional flashes of the qualities which had astounded everyone in Venice in 1725.

4

Pictures for palaces

'It makes everyone marvel'

Marchesini on a Canaletto view

The reputation which led to Canaletto's commission from Stefano Conti was earned by pictures of which only a handful survive and only four of these can be identified with any certainty. The rest of the handful show the characteristics of the Conti set, soon to be completely abandoned, but it is impossible to be sure whether they came before or after them. Another characteristic they share happens to be inaccessibility: they have either made only brief public appearances, like the Conti pictures, or are off the main paths of the average gallery visitor. It is unlikely that Zaccaria Sagredo's commission will ever be identified, even if it has survived, and no more can be said about the Imperial Ambassador's *SS. Giovanni e Paolo* than that it *may* be the one now in Dresden. We do not even know the first owner of the only four paintings which can almost certainly be said to have come before Conti's and which must therefore have done so much to make Canaletto known as a view painter.

They have always been associated with the names of the Princes of Liechtenstein and they belonged to that family for nearly 200 years. There could scarcely be a more illustrious provenance than the collection which was begun by Prince Charles Eusebius, son of the first Prince, in the mid-seventeenth century and for which his grandson, Prince John Adam, built two palaces in Vienna. By that time a picture had to be what the reigning Prince called *mondane* (and we should call erotic) if it was to enter the collection, but the eye of the Liechtensteins for quality can be attested by the spectacular sales of masterpieces from the collection which have taken place during the present century. Prince Joseph Wenceslas, who was born in 1696, was said by family tradition to have bought the pictures from Canaletto. He reigned from 1712 until his death in 1772, with a thirty-year break during which three other Princes successively took over, and towards the end of his life a complete catalogue of the collection was published. No works by Canaletto were mentioned although, when his successor Prince Francis Joseph I issued another catalogue thirteen years later, in 1780, there were fourteen Canalettos. These were much smaller than the four great paintings we are dis-

cussing which are therefore left without any recorded history that can be relied upon. They could well have belonged originally to Zaccaria Sagredo whose heirs took many years to disperse his collection. It is not impossible that the British Consul Joseph Smith himself had a hand in selling them to the Liechtenstein family; he is known to have been handling pictures from the Sagredo collection in 1751–2. Such guesses, attractive though they may be, are worth no more than the tradition that Prince Joseph Wenceslas bought the paintings from Canaletto direct—which, of course, might be perfectly true.

The four pictures (plates 15–20) were clearly painted within the same fairly short period and as a set. One of them, *The Piazza S. Marco* (plate 15), can be dated as before 1723 and this must date the others reasonably closely. The date for the Piazza picture depends on the well-recorded repaving with the geometrical design which appears in all Canaletto's other pictures and which can be seen today. Before 1723, when this repaving took place, the floor of the Piazza consisted of a series of wide cambered bands, with furrows between them for drainage, as shown in the picture. The new white marble lines can be seen on the extreme right so that the work has just begun. If confirmation were needed of the Piazza's appearance before 1723 it can be found in several paintings by Carlevaris and in one of them, now lost, he also showed the repaving in progress.

There is a possibility that another of the set, *The Grand Canal from the Campo S. Vio* (plate 18) was painted as early as 1719 since this shows scaffolding on the church of the Salute which might have been used for repairs known to have taken place in that year. Whether there is anything in the theory or not, this must be the first of what was to become a long series of pictures painted from the same spot and in which Canaletto seems to have been at pains to record the most minute topographical changes.

Five other pictures must have been painted about the time of Stefano Conti's and those of the Prince of Liechtenstein, that is to say before 1726. These belonged to the King of Saxony in Canaletto's lifetime, but not until many years after they were painted, and are all still in Dresden. One of them, the *SS Giovanni e Paolo* which may have been bought by the Imperial Ambassador at the S. Rocco exhibition has already been referred to; another was a smaller version of one of the Liechtenstein group. Each of the remaining three (plates 21–23) is Canaletto's first version of his subject, in one case the only version.

These thirteen pictures are all that survive of Canaletto's early period of view painting with any certainty. There are some replicas which suggest that he may not have been above taking orders for exact copies of his work but, where every brush stroke is followed, might also suggest the presence of a talented imitator. Another dozen pictures of no great merit but with similar characteristics might be added, some of them in too poor a condition to mean very much, but the total still remains small for four or five years' work on the part of a man who seems to

have been busy all the time. He may have employed himself on work of a different kind, some of which may have survived unrecognized, and some of his pictures must of course have perished in the course of 250 years. Whatever the reason, we are left with less than two dozen pictures to represent Canaletto's formative years and by which to judge as best we may what sort of artist he would have been had he been left alone.

He was still above all a man of the theatre. *The Piazza S. Marco* (plate 15) heightens the dramatic intensity of a scene which is still more theatrical than real to most of us. In spite of the drama there is an effect of serenity. The deep shadows emphasize the midday sun catching the heads of the figures on the right and the bronze horses of St Mark's emerging from their mysterious cavern in the centre background. As Ruskin wrote (not of this painting, which he never saw), 'the vast tower of St Mark seems to lift itself visibly forth from the level field of chequered stones'—the chequered stones which are just appearing for the first time on the right of the picture.

Perhaps even more theatrical is the view from S. Angelo, *The Grand Canal: looking North-East from near the Palazzo Corner-Spinelli to the Rialto Bridge* (plate 21). Virtually every palace, together with the *campanile* of S. Polo, can be seen today from the S. Angelo water-bus stop in the same position as they appear in the painting. Yet the scene in Canaletto's picture has hardly any relationship to the facts as they are. The palaces in the background run in a straight line, side by side, yet Canaletto has massed them to form a central group quite separated from the Palazzo Barbarigo della Terrazza and the entrance to the Rio di S. Polo on the left and the glimpse of the Rialto Bridge area in the distance on the right. The group of large barges in the foreground dominate the scene instead of being incidental to it, as such barges generally are on the Grand Canal. A spectacular storm is about to break yet the sun breaks through the clouds where relief is needed to ease the tension. The figures in the right foreground could be nowhere else; it seems to be for them that the whole scene exists. It is hard to believe the painting resulted from days or weeks of studio work, as it must have; the impression is rather one of the opening and closing of an eye and the fusion of memory with imagination.

What led Canaletto to choose the *Rio dei Mendicanti* (plate 19) as the subject of one of the four Liechtenstein pictures? He had scarcely begun to cover the celebrated monuments of Venice or the innumerable views which the Grand Canal offers throughout its length. The bridge over the canal in the background is the one which is seen from the opposite direction in the paintings of *SS. Giovanni e Paolo* (plates 11–12) but from this viewpoint it forms no part of the tourist's Venice. The wall of S. Lazzaro dei Mendicanti on the left offers little temptation to the artist but he must have been captivated by the boatyard on the right (it can just be seen,

beyond the second bridge, in the *SS. Giovanni e Paolo* paintings), the peeling walls and the washing hanging out to dry. He had been painting noble buildings of marble and brick: here he brought nobility to a scene of shabbiness and squalor.

There is none of the meticulous, brick by brick, painting that was soon to emerge—perhaps after he had seen the work of the Dutch painters in Smith's house. The brush moves freely in these early pictures, sometimes with a ragged touch. The paint is laid on a dark red ground which sometimes shows through. The figures are generally thin, with small heads, and nearly always moving; most of them wear something red or blue. There is always cloud in the sky and the water tends to be green. Foreshortening and shadows are often exaggerated, to heighten the sense of drama, yet the general effect is subdued. All this is in complete contrast to the bright paintings on a white ground, the harder lines and small, static figures which were so soon to come.

These were big pictures, too, painted for men with palaces or galleries rather than for Englishmen with manor-houses or houses in London squares. The Liechtenstein set are two metres wide, as are two of those now in Dresden; even those painted for Stefano Conti's gallery in provincial Lucca are almost a metre and a half. Seventy to eighty centimetres became the preferred width for the Joseph Smith type of Canaletto. Those painted for McSwiney, who introduced Canaletto to the English market, were even smaller. The painter of these pictures, the Canaletto we know so well, was on the point of making his appearance.

5

The first English patrons

'He has more work than he can doe . . .'

Owen McSwiney

Canaletto's first recorded commission came, as we have already noted, in 1722 from Owen McSwiney (also spelt Swiny or Swinny and with or without a 'Mc' or 'Mac'). He was a persuasive but unfortunate Irishman who had tried his hand at acting, play-writing and, in 1706, the precarious life of an impresario in London. There his successes did not compensate for his failures which finally overwhelmed him and drove him into bankruptcy and the escape to the Continent which so often followed. This was in 1711 and by 1721 he seems to have re-established himself to the extent that he was securing operas and singers in Italy for London impresarios and buying works of art for Lord March.

Lord March was a great catch for anyone trying to establish a reputation as consultant and buying agent, particularly as his father, the first Duke of Richmond, was evidently approaching the end of his life of debauchery. The Duke's mother had been Louise de Keroualle, who came from a poor but noble Breton family, and his father Charles II, who seemed willing to give this particular mistress almost anything she wanted. Within three years of their son's birth the King had made Louise Duchess of Portsmouth and the child himself the youngest duke to be created before or since. The Duke was said to have inherited his father's looks, grace and charm but from his mother a fatal flaw of self-indulgence which ruined him. In 1719, when his own son, Lord March, was only eighteen, the Duke married him off to the thirteen-year-old daughter of the first Earl Cadogan to settle a gambling debt and immediately sent him to the Continent with his tutor, Tom Hill. While abroad he was 'sett up' for two constituencies for Parliament and later secured both. At the end of 1721 the young man's mother was writing to him that she noted he 'had thoughts of seeing Venise once more' but, she added, 'I hope you will not keepe Mr Burges company too much, for I hear he is a violent drinker which is that has killed all our English youths'. Presumably it was drink generally which had had this effect on English youth, not only that supplied by Elizaeus Burges, a generally respected Englishman living in Venice who was Secretary-Resident between 1719 and 1722 and again from 1728 to his death in

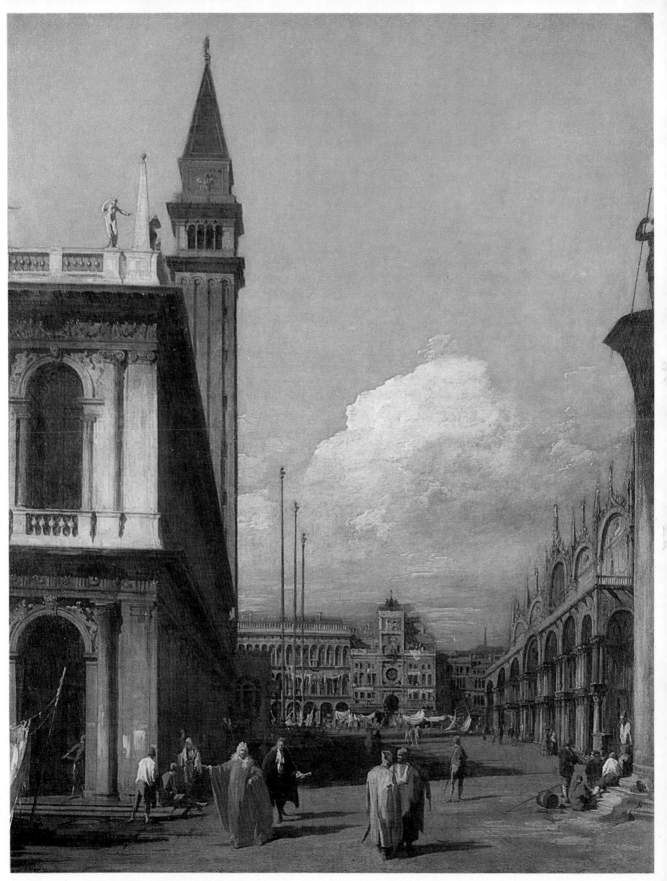

1 *The Piazzetta, looking North.* 170 × 130cm

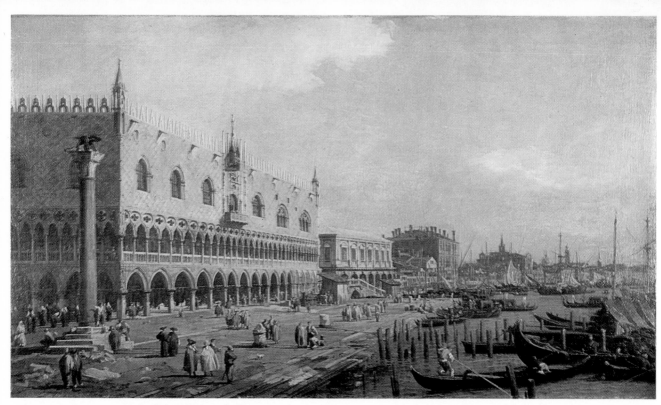

II *Riva degli Schiavoni: looking East.* 58 × 102cm

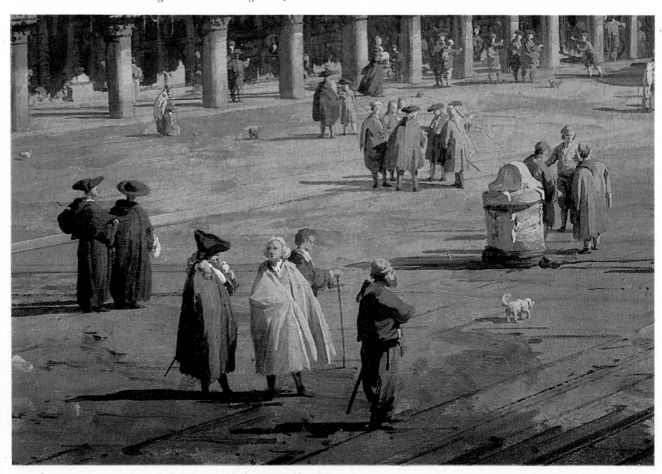

III *Riva degli Schiavoni: looking East.* (detail)

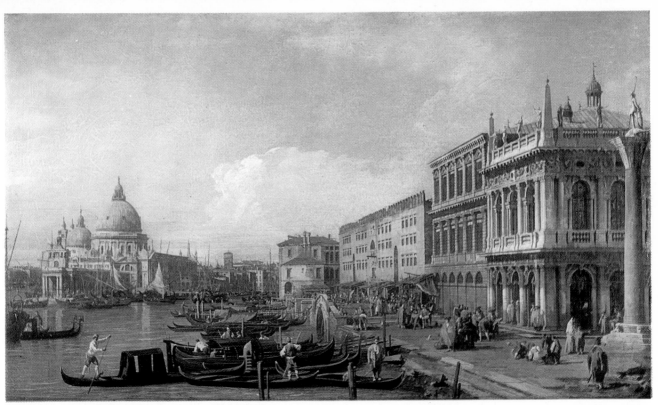

IV *The Molo: looking West.* 58 × 102cm

V *The Molo: looking West.* (detail)

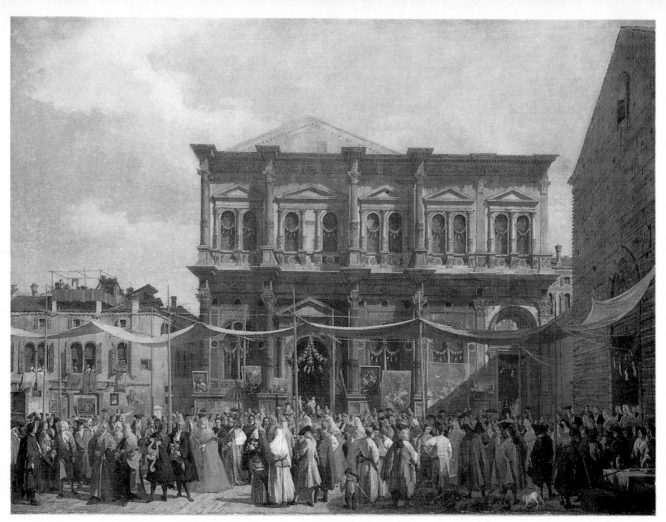

VI *The Doge visiting the Church and Scuola di S. Rocco.* 148 × 199cm

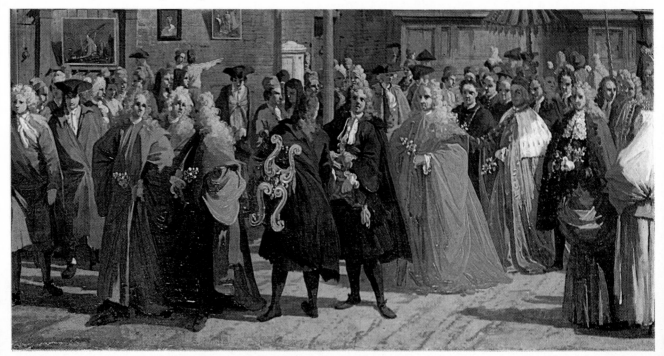

VII *The Doge visiting the Church and Scuola di S. Rocco.* (detail)

1736. Another English resident, Joseph Smith, coveted his post, which was senior to that of Consul.

The story went that after three years on the Continent Lord March returned to England and, asking the name of a beautiful girl he saw at the theatre, was told she was his wife. Whether this was true or not his unpropitious marriage proved highly successful in the event. A year after his return he inherited the dukedom Charles II had given his father and, from all accounts, graced it to the end of his life. Meanwhile, immediately after his return to England, McSwiney is found proposing to commission a series of allegorical tomb paintings which it was hoped Lord March would buy.

They were to commemorate the great men who had recently done so much for England's successes in various fields. The painters were to come from Venice and Bologna and were to include such established figures as Sebastiano and Marco Ricci, together with artists at the outset of their careers such as Cimaroli, Pittoni and Canaletto. By 8 March 1722 the last three were at work on the tomb of Lord Somers (plate 24) the Lord Chancellor who had died only five years earlier, and Canaletto and Cimaroli had already finished 'the perspective and landscpe' of Bishop Tillotson's tomb (plate 25); in this case J. B. Pittoni was to replace G. B. Piazzetta as figure painter.

The progress of McSwiney's 'strange and fanciful' scheme, as a contemporary described it, has been well documented but the part played by Canaletto was too small, and too difficult to identify, to justify dwelling on it. McSwiney himself, though, cannot be passed over and it is worth noting that G. P. Zanotti, the writer just quoted, described him as 'this amateur with as sound a knowledge of good pictures, books and antiquities as it is possible to have'. He was an insignificant figure in the world of affairs compared with Joseph Smith (with whom he lived for a time and where he learned what he knew of accountancy) but he was handling works of art for Englishmen long before Smith entered that field. Nevertheless, McSwiney worked closely with Smith while he lived in Venice and remained on friendly terms with him after McSwiney's return to England in about 1733. Twenty-four years after the tomb commission, it was to McSwiney that Smith wrote in London recommending Canaletto to the Duke of Richmond who evidently still trusted his old adviser. It would be wrong to dismiss Mc-Swiney as the Irish adventurer he often appears to be.

Although Bishop Tillotson's tomb painting required only Pittoni's figures to complete it, according to McSwiney's letter to Lord March of 8 March 1722, it had still not been sent to England by 28 November 1727 when he wrote that it would be leaving with two others which almost completed the project. Much had happened to Canaletto's career during those five years and McSwiney had evidently persuaded the Duke, as he had now become, to buy a pair of his pictures, following the example of an unidentifiable friend called Southwell. For a moment

some light is thrown on Canaletto's activities in a letter which seems to echo some of Marchesini's difficulties over Conti's commission. After dealing with the tomb paintings, McSwiney continues:

The pieces which Mr Southwell has, (of Canals painting) were done for me, and they cost me 70 sequens. The fellow is whimsical and vary's his prices every day: and he that has a mind to have any of his work, must not seem to be too fond of it, for he'l be yᵉ worse treated for it, both in the price and the painting too. He has more work than he can doe, in any reasonable time, and well: but by the assistance of a particular friend of his, I get once in two months a piece sketch'd out and a little time after finished by force of bribery.

I send yʳ Grace by Captain Robinson (Commandʳ of the Tokeley Gally) who sails from hence tomorrow, *Two of the Finest pieces*, I think he ever painted and of the same size with Mr Southwells little ones (which is a size he excells in) and are done upon copper plates: *They cost me two and twenty sequeens* each. They'l be delivered to yʳ Grace by Mr John Smith, as soon as they arrive in London . . .

I shall have a view of the Rialto Bridge, done by Canal in twenty days, and I have bespoke another view of Venice for by and by, his Excellence lyes in painting things which fall imediately under his eye.

The four pieces of Canal come to *88 sequeens* and the Rosalba etc. to 24 which comes to about *Fifty six Guineas sterling* and if your Grace will permit me to charge four Guineas more for the Freight, and expences in packing 'em up and sending 'em on board wᵗʰ ye Customs etc. and some former expenses of the same nature, the same will amount to six guineas wᶜʰ I'll draw for as at twice as yʳ Grace desires.

Full though this letter is of information (and of problems), the parts most often quoted are those derogatory to Canaletto. They seem quite unjustified. The artist did not like refusing commissions, busy though he was; if pressed too hard he was liable to skimp his work. He was in demand and able to charge twenty-two sequins for a small painting compared with the same price he had charged Stefano Conti for his large ones (still less than the portraitist Rosalba Carriera was charging for one of her pastels). He resisted the efforts of buying agents such as McSwiney (and Marchesini before him) to beat him down in price. None of this does Canaletto any discredit, nor would his patrons, whether principal or agent, have thought better of him had he sold his pictures for less than the market price.

He was able to produce a picture every two months for McSwiney, who was but one in the queue of buyers. One wonders what has become of all these pictures. Above all one wonders who McSwiney's 'particular friend' was who was able to advance McSwiney's place in the queue. In the absence of a scrap of evidence that Canaletto had a relationship with anyone not already mentioned the suggestion that this friend was Joseph Smith is irresistible, although Smith has generally been considered as having entered Canaletto's life a year or two later.

The 'John Smith' in London to whom the pictures were being consigned was Joseph Smith's brother. Relations between McSwiney and the two brothers were evidently good and there was no hint of rivalry. McSwiney's remuneration for his efforts on the Duke's behalf seems meagre enough in any case—six guineas to

cover freight, packing and whatever commission may have been payable, since it is unlikely Canaletto would himself have allowed a commission.

The two 'copper plates' are referred to in later letters. On 5 December they '. . . are very fine: I told you in my last Lettr that I forwarded 'em, to Mr John Smith, in London'. On 13 February of the following year, 'I hope you'l like [three tomb paintings, including the Bishop Tillotson at last] as well as the small ones done by Canaletto, which I sent above two months ago, on board Captain Robinson'. Again, on 27 February, 'In a few days after you receive this, in all probability Captn Robinson will be arrived, He has two pictures done for yr Grace by Canaletto'. Finally, on 30 July, 'I long to hear how you like [the tombs] as likewise ye copper plates by Canaletto, wch you recd before'.

This is the last mention of the paintings but we have the best possible evidence of their safe arrival—they are still hanging on the wall in Goodwood House. They are *The Rialto Bridge from the North* (plate 26) and *The Grand Canal: looking North from the Rialto Bridge*, the same subjects in fact as Stefano Conti's first pair but so totally different in style that it is hard to believe that only two years separates the two pairs of pictures.

There was to be another *Rialto Bridge*, but from the opposite side. On 16 January 1728, in a letter dealing with other matters, McSwiney writes '. . . Canaletto has, just, finished the piece of the Rialto Bridge, and as soon as it's companion is done, I'll forward 'em to you wth [another Rosalba]'. On 13 February he repeats '. . .the other two pieces of Canaletto, I'll send, by the first opportunity'. Five months later, in the letter of 30 July in which he 'longed to hear' what the Duke thought of the pictures already sent, he added, 'I wait for ye companion (to a copper plate) which Canaletto is now, about, for you: as soon as I get it, out of his hands, I'll forward 'em to you'. They had still not arrived by October of the following year, although the Duke had evidently paid for them as requested in 1727, and on 1 October 1729 McSwiney wrote, 'The remaining two copper plates of Canaletto . . . I acknowledge to have recd ye value of several months agoe. *Canaletto* promises me to let me have 'em on my return from Rome, which will be about the middle of January'.

This is the last to be heard of the second pair in the correspondence preserved by the Duke of Richmond and we must assume from it that 'the piece of the Rialto Bridge' which had been finished almost two years earlier was being held by Canaletto, not by McSwiney, awaiting completion of the companion picture.

However, it was not the last to be heard of the Duke's pictures. On 27 September 1730 McSwiney wrote to John Conduitt from Milan in reply to a letter 'sent me by my friend Mr Smith'. Conduitt was married to Sir Isaac Newton's niece and had inherited the post of Master of the Mint from Newton who had only recently died. He had been corresponding with McSwiney over a tomb painting in memory of the great man and must have referred to an order he had placed

with Joseph Smith for two or more Canalettos. McSwiney, after discussing the Newton 'Monument', ended as follows:

I'm glad you have given ye commission to Mr Smith for yr pictures of Canaletto, & I hope you'l like 'em when they are done; I am, it may be, a little too delicate in my choice, for of Twenty pieces I see of him, I don't like eighteen & I have seen several, sent to London yt I wou'd not give house room too, nor Two pistols [less than two pounds sterling] each. He's a covetous, greedy fellow & because he's in reputation people are glad to get anything at his own price.

Tis above three years yt he has Two copper plates in his hands, for ye D. of Richmond & I thought it wrong to sett him at work on new work till he had delivered wt he has been obliged to do so long since.

The Two copper plates of the D. of Richmd Two of Mr Southwell & Two of Sir Wm Morice are in his buon gusto—nay compare these with any other you know & you'l soon discern ye difference.

As with the earlier letter the derogatory words 'a covetous, greedy fellow' have been quoted and have stuck but there is much more of interest in the letter than that. We know from it that McSwiney had stopped buying from Canaletto but that Smith was going on. We know that the Duke had still not received his second pair and it is possible that he got tired of waiting and cancelled his commission. There seems very little doubt that the pair were sold in the end to the Earl of Leicester, whose descendant still owns them, perhaps by McSwiney, perhaps by the Duke of Richmond himself for one reason or another. The present Earl of Leicester's two pictures are on copper, of the same size as all the others and one of them shows *The Rialto Bridge* (plate 27) as promised (but from the south, that is to say from the side discussed with Stefano Conti although no view from that side was in fact executed). The other is *The Grand Canal: looking East from the Campo S. Vio*, Canaletto's third version of this scene. The first, for the Prince of Liechtenstein (plate 18) had been a metre and a half high; the second, bought by the King of Saxony, less than half the height and width; Lord Leicester's pair are only 46 × 62cm.

McSwiney's letter to John Conduitt tells us nothing more of Mr Southwell, the first buyer of small 'copper plates', but there seems to be every probability that his pair ended by becoming the property of the Dukes of Devonshire at some unknown date and that they are the pictures now hanging at Chatsworth, Derbyshire. They are a *Riva degli Schiavoni: looking East* and *The Entrance to the Grand Canal: from the Piazzetta* (plates 29–30) and if they were Mr Southwell's they were almost certainly the first of often repeated pairs showing the views in opposite directions from approximately the same position on the Molo. As well as being on copper, they are much the same size as the Richmond and Leicester pairs and, in the painting of the figures and the architecture, Canaletto never did better. The paint is thicker than in the others of the series, with a quite deep impasto in parts, particularly on the boats. Their condition is admirable and one

wonders why Canaletto so soon abandoned the use of copper as a support. Possibly because of the expense or difficulties of supply he never returned to it after the end of the 1720s.

John Conduitt's own pair may also have been on copper although they cannot be identified. An *Entrance to the Grand Canal: from the West End of the Molo* (plate 28) on copper appeared for the first time at a sale in Vienna in 1938 and might well be one of them, the size corresponding with the others.

The reference to Sir William Morice in McSwiney's letter is of great interest. A year earlier, on 26 November 1729, Joseph Smith referred to him in a letter to Samuel Hill, of whom more will be heard, as having 'bought all Swiny's monumental pieces and was a fortunate hitt for him'. He had not in fact bought all twenty-four of the tomb paintings which McSwiney had commissioned; the Duke of Richmond had bought at least ten. Nevertheless it must indeed have been a 'fortunate hitt' to find a purchaser for the remainder and McSwiney was by this time making arrangements for the paintings to be engraved so the strange project seems to have been a success.

Sir William Morice was the grandson of another Sir William, a theologian who supported Charles II and was well rewarded. Another of the first Sir William's grandsons, Humphrey, became Governor of the Bank of England but was discovered after his death in 1731 to have been forging bills and embezzling trust funds. The story ends happily, however, for by 1760 the embezzler's son, another Humphrey, had inherited his second cousin Sir William's estates and was being recommended to Sir Horace Mann in Florence by Horace Walpole as 'of vast wealth'. He also evidently inherited Sir William's two 'copper plates' which had been noted by Walpole, when visiting his house, as 'good' and which he kept until his death in 1786 when they were sold. The second Earl of Ashburnham was the buyer and they stayed in the family until 1953 when they were sold. One, (plate 31) shows *The Molo, looking West: Ducal Palace Right;* the other (plate 32) *The Riva degli Schiavoni: looking East* (but from much nearer the mouth of the Grand Canal than in the case of the Devonshire version).

We have thus reached 1730 and Joseph Smith has taken over from Owen McSwiney, who was soon afterwards to return to England for good. It is not difficult to assess Smith's influence on Canaletto. What was McSwiney's, if any?

All we know of his purchases are seven out of the eight 'copper plates' he refers to (Sir William Morice's pair did not go through him and their whereabouts is in any case unknown). These mark a fundamental change in Canaletto's style, a change from large, dark pictures which turned Venice into a series of stage sets to smaller, cooler paintings with an emphasis on topographical accuracy. The first have a dramatic intensity which can only have come from an emotional

involvement with the subject; the second, for all their immense skill and originality, foreshadow the cold assessment by the commercial artist of what the customer wanted.

The clue, perhaps, is to be found in McSwiney's words 'his Excellence lyes in painting things which fall immediately under his eye'. From all the evidence available to us, that is to say the known paintings of the early period, the words have no relation to the kind of picture Canaletto was painting. Yet it would be a fair description of the pictures McSwiney commissioned. Was it McSwiney who decided where Canaletto's excellence lay and who directed it into the channels he thought most beneficial for himself, his principals and the artist? Or had Canaletto himself made the decision by 1727? By 1730 McSwiney claimed to like only two out of every twenty paintings he saw but it is between these two dates, as we shall shortly see, that Canaletto was producing some of his finest work. With the exception of one group, none of it was for Smith and McSwiney's 'copper plates' vary from the somewhat perfunctory Richmond pair of the Rialto to the splendid Molo pair now at Chatsworth. The probability is that Canaletto was still at that stage developing his 'new' style and could have been influenced for better or worse by his patrons. Smith's influence proved lasting and wholly bad; McSwiney's was temporary but, had it lasted, he might have found a way to effect a happier transition.

6

The end of the beginning

'The Merchant of Venice'

Horace Walpole on Joseph Smith

The words Horace Walpole used many years later to describe Joseph Smith were intended as a sneer but apart from this there was no reason why Smith himself should have taken them amiss had he ever heard them. He was *the* merchant of Venice at a time when the great merchants of that city founded by business men had long left it to decay. He was also one of the greatest art patrons of his day and by far the greatest patron of living Venetian artists. Yet he does not seem to have been an easy man to love.

He was a generation older than Canaletto, having been born about 1674, and went to live in Venice in his mid-twenties as an apprentice to a general merchant called Thomas Williams. Some ten years later he married Katherine Tofts who had retired to Venice from the London opera stage after a short but successful career; she had the advantage of taking with her a considerable fortune but the disadvantage of already being intermittently insane (the insanity became progressively worse but they lived some kind of life together until Smith was eighty, when she died and he immediately remarried). Very little is known of Smith's early business activities but by 1722 he was sufficiently well-established for McSwiney to be writing that he had learned something of accountancy through living in Smith's house. McSwiney was by this time relying on Smith's organization to ship works of art to his patrons in England and also using him as a banker to advance payment until the English buyers were ready to settle their accounts. By 1730 Smith was spending part of the year in a newly decorated house on the mainland at Mogliano. He had acquired it through granting a mortgage which he was confident the owner would be unable to redeem but he was clearly by now a man of considerable substance. He had for a number of years been collecting the works of contemporary artists, particularly those of Sebastiano Ricci, then the leading painter in Venice, of his nephew, Marco Ricci, of Rosalba Carriera, the pastel portraitist, and of some whose reputations have not survived. In addition to the newly acquired house at Mogliano he lived in the Palazzo Balbi, near the Rialto Bridge, where he had settled on his

arrival in Venice, and he was turning his attention to old masters, gems and, perhaps above all, books. His personal character emerges to some extent in his dealings with Canaletto—but not very much. He remains an enigmatic man whose misfortune it was to rub people up the wrong way, particularly people who were at the time recording their prejudices for posterity. Horace Walpole's gibes tell more of the writer than of Smith himself. Lady Mary Wortly Montague was unable to accept graciously a service he rendered her and vowed she would never accept another. He was pompous yet obsequious, self-seeking yet generous, a would-be scholar yet superficial. The words of a Venetian poet, although written much later, should also be remembered: 'a man as remarkable for his rare talents, his goodness and sweetness of temperament as for the love which he feels for the fine arts'.

McSwiney refers to Smith many times in correspondence from 1722 onwards but the first documented reference to Smith and Canaletto does not appear until as late as 17 July 1730 in a letter from Smith to Samuel Hill of Staffordshire, England. Hill's nephew, Samuel Egerton, had been apprenticed to Smith in Venice for more than a year, doubtless in recognition of the fact that Hill was an important buyer of art for which he used all Smith's services. After promising to pass on to young Egerton the good news that his mother (Hill's sister) was re-covering from an illness, and referring to pictures already sent to England, Smith refers to Ughi's newly published plan of Venice which forms the end-papers of this book. 'Tell me how you like it' he writes and continues:

I take it to be a compleat performance both in the exactness with which every smallest street and canal is laid down, as well as the engraving. The author will not sell 'em for less than 2 chequeens [sequins, almost one pound sterling] a price none butt strangers think the work deserves and indeed 'tis just so with everything else of worth which Italy now produces. At last I've got Canal under articles to finish your 2 pieces within a twelvemonth: he's so much follow'd and all are so ready to pay him his own price for his work (and which he values himself as much as anybody) that he would be thought in this to have obliged me, nor is it the first time I have been glad to submitt to a painter's impertinence to serve myself and friends, for besides that resentment is lost upon them, a rupture with such as are excellent in their profession resolves 'em either not to work for you at all, or which is worse, one gets from them only slight and labour'd productions, and so our taste and generosity is censured—tho' both unjustly . . .

There is every sign that Smith is making Canaletto out to be even more difficult and dilatory than he no doubt was. Twelve months for a pair of pictures only sixty centimetres high sounds quite unreasonable and, as might be expected, Smith's blandishments were able to reduce the delay. The nephew, Samuel Egerton, was commissioned to tell his uncle on 15 December 1730 that Smith 'had att last prevailed with Canal to lay aside all other business till he had finished the 2 pictures you order'd when you was last here, and they'll now come home in about 15 days more'. Hill, it seems, had been to Venice where he probably met

Canaletto and certainly met Smith with whom he had made arrangements for his nephew to be apprenticed—he was no believer in the Grand Tour for young men and had warned Egerton's mother against the folly of 'sending out boys who only expose themselves and their country without getting any good'.

The pictures arrived, although we do not know when, and within a few years Samuel Egerton was to find himself heir to his family estates on the death of his elder brother at the age of twenty-eight. When Samuel Hill died he inherited his estate too, so that the pictures went to the Egerton seat, Tatton Hall, Cheshire, where they have remained ever since. The house, with a famous garden, and its entire contents were left to the nation by the last of the Egertons in 1958.

One of Hill's pictures shows *The Riva degli Schiavoni: looking East* (plates II–III) from a slightly more distant viewpoint than the first version, now at Chatsworth. The other, *The Molo: looking West* (plates IV–V) is in the opposite direction but also from a more distant viewpoint than the Chatsworth version and from a point over the water. They are larger than the Chatsworth pictures, a metre wide against sixty-two centimetres, and the paint is thinner although there is still considerable impasto. The figures are more loosely painted and there is an air of greater assurance; with a few other paintings of the same kind they represent the peak of Canaletto's achievement as a topographical artist.

In the same year, 1730, two more paintings can be identified, the last to be dated with certainty for at least ten years. An Irish bishop of the ancient Howard family had inherited the estate of one of their many branches in 1728 from his brother. We can but guess how he fell into the net of Joseph Smith but he preserved a scrap of paper of great interest which escaped destruction by his son, who became Viscount Wicklow, and his grandson, who became Earl Wicklow, and which was finally copied out and placed in the family archive. The bishop had evidently ordered two Canalettos from Smith who had had them framed, seen them through the Customs and delivered them to Ireland. Someone made a note of the details which read:

Aug 22 1730 Recd two pictures of Canaletti from Venice

	£	s	d
Pd Mr Smith Mercht 35 Venn. Zecni	18	7	11
Freight	0	11	0
Custom	2	0	0
Charges		8	0
Frames	1	14	0
	23	0	11

So Canaletto's price had not gone up in the three years since McSwiney had bought the 'copperplates' for Mr Southwell. Bishop Howard's pictures were in fact rather larger than the earlier ones so he might have been expected to pay more. True, McSwiney had managed to get the Duke of Richmond's pair for twenty-two sequins each, against the thirty-five sequins charged to Mr Southwell, but the Duke was a very important patron, capable of introducing the artist to a vast, untapped market, and McSwiney would not have hesitated to point this out to Canaletto.*

But the Howard pictures were no bargain. They showed *The Entrance to the Grand Canal: looking West* (plate 33) and *The Grand Canal: looking South-West from near the Rialto Bridge* (plate 34), both for the first time. If Samuel Hill's and Bishop Howard's pictures were the only ones Canaletto painted in 1730, instead of being merely the only ones there is documentary evidence of for that year, we would not hesitate to say that Hill's were the last of the transitionary phase and Howard's the first of the straight commercial product. As it is, there must have been many unidentifiable pictures painted in that year, a few as muted in colour, soft in outline and perceptive in their figure-painting as Hill's and many as bright, brisk and prosaic as Howard's. For the first time in the Howard pair Canaletto seems to have used a ruler to ensure the straightness of his lines and for the first time the figures seem to have been drawn from stock instead of leaving the impression that those were the people who happened to be standing at those points at the time and no others. And, for a topographical artist as experienced as he already was, he made a surprising perspective blunder. His canvas (46.5 × 72.5cm) was not wide enough for its height and in both paintings the buildings on either side of the Grand Canal are far too close to each other. Canaletto must have been conscious of the cramped effect of the pictures since in the versions he painted for Smith himself, probably very shortly afterwards, he used a wider and less high canvas and maintained much the same proportions in all later versions (of which there were many). It is impossible to believe that these pictures were painted after other versions which sit comfortably on their canvases, hard though it is to put the work of the period into any kind of chronological order.

There can be no question that Smith had entered Canaletto's life well before the letter to Samuel Hill of July 1730, the first documentary evidence of the relationship; the only question is how long before. The evidence, even if one dismisses the reference to 'a particular friend' of 1727 (p. 26) is contained in six large

*The only other recorded price of the period is in a letter of A. M. Zanetti to a Cav. Gaburri, dated 24 July 1728. He refers to a small painting for which Zanetti had paid Canaletto fifteen sequins on Gaburri's behalf 'after having kept back with great difficulty one of the sixteen sequins which he persisted in claiming, pretending that even at the higher price he was doing me a favour'. However small the painting, which cannot be identified, less than £8 sterling could hardly be a high price for the work of an established artist; Canaletto evidently had some tight-fisted people to deal with and the greed was not all on one side.

paintings of the Piazza area which Smith must have bought from Canaletto within a year or two of the Conti commission in 1726 (plates I and 35–39). The implication is that they were being painted at much the same time as the Duke of Richmond's pair and of Mr Southwell's which, although unidentifiable, we know to be similar in style to the Duke's. This is a very difficult implication to accept but there is no alternative. Smith's pictures are very large (131 × 171cm) and must have occupied much of Canaletto's time—we already know he was not a fast worker at this period. Even had they been begun immediately after the Conti commission, and even had there been no other work to be done, they could scarcely have been finished before Mr Southwell's. There is topographical evidence in one (plate 39) of a date before 1728: the *campanile* of S. Giorgio Maggiore appears with the straight-sided steeple which was dismantled and replaced by an onion-shaped one between June 1726 and the end of 1728. Topographical evidence is not needed, though. The pictures have the dark ground, the dramatic foreshortening and the freedom of touch of all the known early works and they lack the blue skies on a white ground, the hard lines and the small static figures of nearly all the later ones. Canaletto was almost at the peak of his ability to combine reality with poetry and drama. This does not mean that they are the finest pictures he ever painted; two or three which had come earlier, for instance plates 15 and 19, reveal Venice with even greater clarity to some eyes and there were others being painted at about the same time in which Canaletto seemed able to fuse the lyric quality which was gradually deserting him with the technical mastery which he had only just achieved.

'The Stonemason's Yard' (plates 41–43) for example; nothing is known of its history before 1808 by which time it had become the property of Sir George Beaumont. Sir George contributed as much as anyone to the foundation of the National Gallery as it is today and was one of those rare art lovers who are prepared to give their treasures to the cause they are wedded to during their lifetime rather than at their death (for this we may forgive him for repainting part of the sky of the picture himself instead of leaving it to later, more expert hands). 'The Stonemason's Yard' must certainly have been painted after Stefano Conti's pictures and almost as certainly before Bishop Howard's, in other words between 1726 and 1730. This can be said with fair confidence on the grounds that before 1726 Canaletto was incapable of producing so complete a masterpiece and after 1730 he was developing an entirely different technique. But one cannot be sure. He *might* have reverted to his old style for once after he had acquired confidence in his ability to work in the way his new patrons wanted. *Dolo on the Brenta* (plate 40) suggests at least the possibility that this is what he did. In style it is fairly close to 'The Stonemason's Yard' and there is some, although not much, topographical evidence to support a date pre-1730. Such a date, though, would require Canaletto to have gone to the Brenta canal area on the mainland at a very

busy and critical moment of his career, paint one picture and return without leaving any other evidence of his visit. A more comfortable supposition is that the painting was part of the outcome of a long visit Canaletto made to the mainland in the early 1740s which resulted in many drawings and provided material for his etchings and later paintings. It seems plausible enough that he should also have indulged in an experimental reversion to his earlier style which so suited this particular subject, however heterodoxical the suggestion may be.

To admit such a likelihood in the case of '*The Stonemason's Yard*' would be going too far. It is Canaletto at his finest, the Canaletto that might have been perpetuated but for the pressures of the English dukes and their representatives in Venice, and it must be assumed to have come out of the studio at much the same time as the Duke of Richmond's 'copperplates', however incomprehensible such a confusion of endeavour may appear. Thousands of words have been written about the picture and thousands of people have stood before it while lecturers have done their best to assess its significance. Yet there is hardly anything to be said. It shows the Campo S. Vidal in the foreground, the houses on the right still readily identifiable. In spite of the title which has attached itself to the painting it is more likely that some kind of building operation is being finished than that there was ever a stonemason's yard on the site—possibly the work was connected with the rebuilding of the church of S. Vidal, which is behind the spectator. Across the Grand Canal are the church and *scuola* of the Carità (Charity), now housing the Academy of Fine Arts. The *campanile* fell in 1744, destroying the small house in front of it; the shadow thrown by both these buildings on the church show precisely how far away from it they stood. The light falls on the various textures of wood, stone, brick and stucco revealing the individuality of each. The shadows unobtrusively give the picture coherence in a way that must have been considered by the artist although there is no trace that they are there for any reason other than that they *were* there. This noble picture moved Ruskin to confess, on coming out of the National Gallery in 1887, that he now admired Canaletto 'after all'— that is, after the 'determined depreciation' with which, to use his own words, he had for so long pursued him. Even then it was primarily the fact that Canaletto's pigments endured that brought about the recantation. Ruskin was in fact incapable of recognizing a Canaletto: of the only three works he mentions specifically, one (in the Louvre) proved to be a Marieschi, another (in the Academy, Venice) a Bellotto and the third (in the Manfrini collection, Venice) of so little consequence that it has been allowed to disappear without trace. On the other hand Whistler, whom Ruskin attacked as bitterly but who was still alive to answer back, considered '*The Stonemason's Yard*' worthy of Velasquez. In the late nineteenth century no higher praise was possible and Whistler added: 'Canaletto could paint a white house against a white cloud and to do that you have to be great.'

7

The beginning of the end

'He works only for an English merchant'

Count Tessin

Once Smith had secured the pictures he wanted for himself from Canaletto he seems to have lost no time in setting the artist to work in producing those he intended to sell. Many attempts have been made to explain the relationship between the two, often to the discredit of both. By 1736 Count Tessin, a Swedish diplomat, was writing home to Stockholm saying that Canaletto was 'engaged for four years to work only for an English merchant named Smitt', and later still Horace Walpole, who thoroughly disliked Smith when he met him in 1741, wrote that Smith had engaged Canaletto 'to work for him for many years at a very low price & sold his works to the English at much higher rates'. There is no evidence to support either story and no reason why either should be believed. In spite of the many paintings in the disposal of which Smith's hand can be established or presumed, there were a number in which he clearly played no part— some of the artist's finest work.

Smith was much too shrewd a business man to want to bind an artist to work for him unwillingly when he could get all he needed from him by an informal relationship; nor would he have made the cardinal error of a good broker by acting covertly as a dealer. Smith's 1730 letter to Samuel Hill should be remembered. 'He's so much follow'd,' he had written, 'and all are so ready to pay him his own price for his work (and which he values himself as much as anybody) that he would be thought in this to have obliged me, nor is it the first time I have been glad to submitt to a painter's impertinence to serve myself and friends.' The exasperation that shows through these words gives them a ring of truth, anxious though Smith no doubt was to give the impression that he, and he alone, could extract work from this tiresome artist. They certainly do not give an impression of a master-servant relationship, nor was there any reason for Canaletto to sell his work for less than what he knew perfectly well was the market price.

Yet these two difficult men maintained a close relationship for at least twenty years and, so far as one can judge, until Canaletto's death another twenty later. It must be assumed that it was profitable to both parties and it was clearly to Smith's

advantage that he should be known as a useful intermediary for those wanting to acquire a Canaletto or a set of Canalettos. He was a banker and would naturally and properly make a profit on the financing of the transactions. He was a shipping agent and would charge for such services—even the purchase of frames. Above all, perhaps, he was a collector and the retention of Canaletto's confidence would give him the run of the studio and first choice of the artist's output. He may or he may not have charged a commission as buying agent in addition to his other charges but if he did so it would not be to his discredit.

What was there in it for Canaletto? Many artists have preferred, and still prefer, to deal through a professional agent rather than direct with all their clients and there can be little doubt that Smith was active in promoting Canaletto's name among his wide acquaintanceship, particularly in England. Moreover he bought many more of the artist's paintings than anyone else; as for Canaletto's drawings, Smith owned, and the Royal collection now owns, as many as exist throughout the world elsewhere. Finally, Canaletto's trust in his patron was to prove entirely justified. The time was to come, much later, when the world was no longer 'ready to pay him his own price for his work' and, when that time came, Smith was to prove a friend in need.

The loose partnership, which is perhaps the best description of the probable relationship between the two men, began with the commissioning of a dozen small (48 × 80cm) paintings which provided a tour of the Grand Canal, beginning at the Rialto Bridge (plates 44–45), proceeding down the Canal as far as the Salute (plates 46–47), turning round to look up the Canal once, and then returning to the Rialto Bridge. From there the spectator went by five stages up as far as S. Chiara (plate 48), then a sufficiently fashionable district to house the English Resident, Elizaeus Burges against whom the young Lord March had been warned by his mother as 'a violent drinker', now given over to the railway station and garages.

An immediate difficulty presents itself in dating. In the same letter of 1730 to Samuel Hill already quoted there was a passage which read, 'The prints of the views and pictures of Venice will now soon be finished. I've told you there is only a limited number to be drawn off, so if you want any for friends, speak in time.' This certainly gives the impression that the paintings themselves were well in hand and that they would soon be engraved. It was doubtless the impression Smith wanted to give in order to make the project known as soon as possible but it is extremely unlikely that more than two or three of the paintings had yet been begun. The first one of all for reasons already given (p. 34), must surely have been painted after Bishop Howard's version of the same subject and this was not delivered until July 1730 (we do not know when it was *painted*: possibly well before). The engravings were not in fact ready for another five years, by which

time two larger and more important pictures had been added to the Grand Canal series. These were two celebrated paintings of festival scenes (plates 53–54) and the project might well have been spread over the whole five years, interrupted as it doubtless was by many other commissions. Nothing more can be added with any authority to the question of date, except that one of the festival pictures shows the arms of Doge Carlo Ruzzini who reigned from 1732 to 1735. Nor is it a matter of great importance; no real pattern of development can be discerned in the 1730–40 decade when Canaletto's work included both masterpieces and pot-boilers.

The paintings were copied by Antonio Visentini, whose drawings for them still exist in the British Museum and the Correr Museum, Venice, and published as etchings by Smith through the publishing firm of G. B. Pasquali in 1735. Publishing was another of Smith's activities and he virtually owned this celebrated house so it may be assumed that if the prints had been ready before 1735 they would have been published. Visentini may not have been 'owned' by Smith but he was almost a member of his staff. He had been born in 1688 and was an 'artist' in the eighteenth-century sense of the word—that is to say, he painted wall decorations and easel pictures, reconstructed and designed houses, including both of Smith's, and drew bookplates and ornamental designs for printers, principally, as would be expected, for G. B. Pasquali. Much later, in 1746, Visentini collaborated with Francesco Zuccarelli in a series of capriccio views of English subjects which can still be seen at Windsor Castle.

The fourteen etchings were published under the title *Prospectus Magni Canalis* and, following the title-page, there was a portrait of Canaletto together with one of Visentini (plate 49). Canaletto's portrait bears the words 'Origine Civis/Venetus', literally a native citizen of Venice. This was a status granted on proof that the applicant was not descended from artisans, an acknowledgement, in effect, that he was a gentleman although not a nobleman (the nobility, although bearing no titles, were a recognized class). The portrait is the only authentic one of Canaletto which exists and he appears to be in his mid-thirties, which is as it should be. Visentini is clearly of inferior social status. He is described merely as *Venetus* and he wears a cap as opposed to Canaletto's wig; a craftsman rather than an artist. But his self-portrait is more convincing than G. B. Piazzetta's formal portrait of Canaletto.

Visentini was certainly not capable in his etchings of breathing life into paintings which lacked it in the original and there was not very much to inspire him in Canaletto's work. The dozen Grand Canal paintings included versions of several subjects which Canaletto had already painted, in no case adding anything in feeling or observation to what he had said before. The additional subjects followed much the same formula—plenty of incident on the Canal, but a sense that the groups had been worked out in the studio rather than captured and recorded from nature; sensitivity to the textures of buildings which Canaletto was incapable of

stifling, however commercial his work became; water painted to a recipe and skies varying only in the placing and shape of the invariable light, summer clouds. The two festival paintings which closed the series were half as big again, both in height and width, and on a grander scale in every way. The *Regatta on the Grand Canal* (plate 53) was a shameless following of Carlevaris's composition of twenty-five years earlier but the scene is drenched in sunlight whereas Carlevaris portrayed the King of Denmark's Regatta under the stormy sky which may well have told the truth of the occasion. *The Bucintoro at the Molo on Ascension Day* (plate 54) was, curiously enough, never painted by Carlevaris so Canaletto had to design his own composition; if this was not the first of many versions of the subject it was certainly one of the first. Canaletto was clearly in his element in showing the scene when the Bucintoro (the Doge's state barge) returns from the Lido where a gold ring has been thrown into the Adriatic to mark the marriage between Venice and the sea. The ceremony had taken place for centuries but by this time it was being conducted with an eye to the tourist trade. For the Venetians themselves the Ascension Day market on the Molo seems to have been an important part of the event; the title-page to Visentini's engravings refers to the addition to the Grand Canal pictures of 'Nautical contest and Venetian market' and the engraving itself is titled 'Bucintoro and Venetian market'.

Smith would have expected to sell copies of Visentini's engravings to many tourists who could not afford to order Canaletto paintings but they would also have served another purpose. Here, in effect, was a catalogue of subjects from which English or other foreign buyers unable to visit Venice in person could take their pick. Those who did get to Venice were more fortunate. As the title-page made clear the original paintings were *in Aedibus Josephi Smith Angli*, in the house of Joseph Smith, Englishman, and the number of versions still in existence speak to the fact that many accepted the invitation to see and buy or to order from the engravings. Needless to say the publication of the engravings was an open invitation to the copyists and imitators, an invitation that was accepted enthusiastically for many decades after 1735.

In 1742 Smith published a new edition of *Prospectus Magni Canalis*. The first part was exactly the same as in the 1735 edition except that the plates were described as 'elegantly recut' and the new date was substituted for 1735; enough copies had evidently been sold to necessitate recutting. A second title-page was added drawing the reader's attention to the fact that the book now contained three parts. The second and third parts each consisted of twelve engravings. The second provided another ten Grand Canal views followed by a pair taken in opposite directions from the Molo which were new versions of Samuel Hill's pair; the third showed ten churches with their *campi*, followed by two views of the Piazza S. Marco in opposite directions. As in the case of the first series, the final pair in each part reproduced a painting which was very much larger than the others.

By 1742 Canaletto's circumstances had changed and the days when he was 'so much follow'd and all [were] so ready to pay him his own price' for his work were over. The paintings themselves, though, are simply a continuation of the series which was begun with the first painting reproduced in the first edition. They were still described on the title-page as 'in the house of Joseph Smith, Englishman' although it is probable that, by the time the book was published, all except one of the second and third series had been sold. This single exception, a *SS. Giovanni e Paolo and the Colleoni Monument* (plate 55), remained in Smith's own collection, together with the fourteen paintings reproduced in the first edition, until the whole collection was sold to George III almost thirty years later.

Why Smith should have kept these fifteen paintings and sold the others cannot be answered but there can be little doubt that he either owned all thirty-eight or that he kept them in his house to sell on Canaletto's behalf; another possibility is that he had bought the pictures for clients and kept them long enough for Visentini to copy and engrave them. Whatever the precise arrangements may have been there is a strong presumption, not only that the original of any picture engraved in *Prospectus Magni Canalis* passed through Smith's hands, but that the same applied to all other pictures of the group to which it belonged.

Smith was without doubt handling Canaletto's work on a very large scale but he was by no means handling all of it. Inexplicably, it was the masterpieces which seemed to elude him. No more is known, for example, of the history of *The Doge visiting the Church and Scuola di S. Rocco* (plate VI) than of '*The Stonemason's Yard*' yet there is no reason to suppose that Smith had anything to do with either. The date of the *S. Rocco* has been much discussed but never placed before 1730 or after 1735, in other words during the very years when Canaletto was producing small views of little consequence for Smith and his customers. The *S. Rocco*, on the other hand, is two metres high and the work of a master who, if he could design and paint such a picture might surely have achieved almost anything. 'Festival pictures' too often imply a stiff-jointedness, emphasized by their constant repetition, whereas the *S. Rocco* has an immediacy and freshness which perhaps explain why Canaletto never attempted another version.

The Grand Canal: looking South-West with S. Simeone Piccolo (plates 50–52) is by contrast a conventional view-painting, although two metres wide and therefore large enough to allow the artist to avoid the suggestion of neatness and prettiness inseparable from most of the 'series' views. Hanging as it does in the company of '*The Stonemason's Yard*' and *S. Rocco* in the National Gallery, London, its exceptional quality is apt to be overlooked. The shabby palaces, the paint peeling from their façades, are given the same loving care for the portrayal of textures as the newly rebuilt church of S. Simeone Piccolo, its marble steps only just completed and the workmen's hut still there. There are no endlessly repeated squiggles to

represent water; the buildings are reflected in the smooth surface of the Canal which nevertheless has a depth which invites the eye to peer down into it. The sense of distance in the meticulously painted background beckons the onlooker to board the *sandolo* in the foreground and demand to be rowed along this magical canal and explore its delights. From the condition of the church steps, the picture must have been painted well after 1735 and it may well be Canaletto's last important view of the Grand Canal.

Even groups of pictures which by-passed Smith seem at any rate to have included examples of the highest quality, although the quality may not have been sustained throughout. *The Rialto Bridge from the North* was an oft-repeated subject but the finest version was unquestionably the one engraved for Joseph Baudin and published by him in 1736 (plate 56). It was one of a set of six, another group of six being published in 1739. Nothing is known of the source of the originals except that wherever they have appeared they prove to have all the marks of a much earlier period than 1736. *The Piazza S. Marco: looking North* (plate 57) is another example of this group. Its subdued colours, like those of *The Rialto Bridge*, the cool tones and the superb quality of paint in the architecture and the figures all indicate a date very close to 1730, when Canaletto had reached his full powers and before he was painting to a formula prescribed by Smith.

Even more difficult to explain is the origin of a group of seventeen paintings which used to hang at Castle Howard, seat of the Earls of Carlisle, before the house was destroyed by fire and the pictures either destroyed with it or soon afterwards dispersed. The family tradition was that the fourth Earl bought the set from Canaletto himself between 1734 and 1745 but this was certainly not true of many of them, which were below even Smith's required standard and would not have been sold by Canaletto as his own work. Two of the pictures, on the other hand, have the very rare distinction, before the 1740s, of bearing Canaletto's initials *A.C.F.* or *A.C.F.* [*fecit*] and are fine examples of infrequently repeated subjects, *The Piazza S. Marco: looking South-East* (plate 58) and *The Entrance to the Grand Canal from the Molo* (plate 60). Canaletto would have been proud to sell these direct to an English milord and even more so in the case of *The Bacino di S. Marco: looking East* (plate X). This must be one of the finest achievements of his career and surely his most endearing portrayal of the constellation of architecture, the multifarious shipping and the shimmering light which every visitor to Venice of the eighteenth century must have carried in his mind's eye for the rest of his life.

Most perplexing of all the non-Smith paintings are two which belonged to George III and are still in the Royal collection but which were never owned by Smith. *S. Cristoforo, S. Michele, and Murano from the Fondamente Nuove* (plate 59) has been seen by one of Canaletto's most distinguished scholars as the most beautiful of all the Canalettos in the Royal collection and by another as of such 'sketchy technique and feeble draughtsmanship' as to make it probably the work

of someone who was copying Canaletto's style, or perhaps a lost painting by him. Canalettos which are radically different from his run-of-the-mill style are quite apt to move those who see them in different ways but seldom to such an extent as in this case. The picture's companion, apparently by the same hand, is so clumsy as to make the suggestion of a copy or a lost original the most plausible one to account for the S. *Cristoforo*.

To sum up these early years of the 1730s it might be said that to avoid Smith's hand certainly did not ensure a masterpiece for the buyer but it does seem to have improved his chances. Against this, it could not have been very easy for the buyer to avoid the importunate merchant of Venice, particularly if he was an English lord.

8

The English come to Canaletto

'In the House of the Englishman'

Title-page of Visentini's engravings

The early 1730s saw some very big fish arriving on the Venetian lagoon from England or from other parts of Italy, and Smith was generally ready to receive them and do what he could to be of service. Among them were the Earl and Countess of Essex and Lady Essex's brother, Lord John Russell, who were there in 1731 and who returned in 1734, this time with Lord Essex's close friend, the fourth Duke of Leeds. All ended by owning Canaletto paintings and in the case of Lady Essex there is correspondence from Smith claiming credit for pressing Canaletto to complete the commission she had placed with him. Unfortunately her son sold her six pictures in 1777 and they are now unidentifiable.

The Duke of Leeds seems to have bought eleven paintings altogether; at any rate this was the number sold by his descendant the tenth Duke in 1920. Two of them were engraved for the 1742 edition of *Prospectus Magni Canalis* and so were described as 'in the House of Joseph Smith, Englishman'. This is no doubt where they were while Visentini was copying them for the engraver although they would have been delivered long before publication of the book. The Duke often returned to Venice and may well have bought a Canaletto or two on each visit; the pictures do not look as if they had been painted as a single commission. They were larger than Smith generally liked to handle but otherwise characteristic of those he supplied to his clients—the tourist's Venice, abounding in interest, highly evocative of the Venetian light, but devoid of the lyric quality of the earlier work and of the sense of discovery of the first topographical pictures.

Lord John Russell was a greater catch for Smith than either Lady Essex or the Duke of Leeds, a more 'fortunate hitt' even than Sir William Morice had been for McSwiney when he relieved him of his remaining tomb paintings. Lord John had been sent on a tour of the Continent with his tutor in 1729 and his long visit was just about to end in 1731. Smith, who made it his business to know what was going on, would have realized that Lord John was more than just a younger brother of a duke. His brother, the third Duke of Bedford, was fast drinking himself to death and gambling away what was left of the family wealth and within a year Lord

John had returned home, married, inherited the dukedom and started on the career which was to make him the most distinguished of the Dukes of Bedford and, according to one of his descendants, 'certainly among the four richest men in England'.

It seems unlikely that he would have bought the twenty-four Canalettos which are now at Woburn Abbey in one set and he certainly did not do so during his 1731 visit since one of the festival pictures could not have been painted before 1735. He may well have been persuaded by Smith to buy one or two while in Venice and perhaps to place an order for delivery over a number of years. All that can be said with certainty is that he was in Venice in 1731, that he met Smith and allowed two of his pictures to be engraved in Smith's *Prospectus Magni Canalis*, and that twenty-four Canalettos spent half a century in Bedford House, London, until it was demolished and the pictures sent to Woburn Abbey. There they give delight to all who see them, ranged three high in an elegant dining-room with the table set to receive the Duke and Duchess and fourteen guests (plates 61–62). No one could question that Canaletto provided Henry Holland, the architect of Woburn Abbey, with the most felicitous interior decoration he could hope to have. The Canaletto of the Smith era would no doubt have been content with his work and the setting it was destined for; it is less certain how the pre-Smith Canaletto would have regarded it.

There was at least one other buyer of Canalettos almost on the scale of the Duke of Bedford. In the mid-nineteenth century Sir Robert Grenville Harvey became the owner of twenty-two paintings (plates 63–64) following a spectacular bankruptcy on the part of his relative the second Duke of Buckingham. Some ancestor of the Duke's, probably a statesman named George Grenville, had made the original purchase although nothing is known of the circumstances. Smith's part in the transaction is verified by the fact that no less than nine of the set were used for *Prospectus Magni Canalis*. In a sense this Harvey group, now dispersed, formed half a set of which the Woburn Abbey pictures made up the other half. The sizes are much the same and both groups are divided almost equally into Grand Canal scenes and views of churches with their *campi*. No subject occurs in both groups although there are a number of versions in existence of many of the subjects. There is a strong implication that all forty-six pictures spent the early part of their life in Smith's house (where indeed those engraved by Visentini were described on the title-page as being) and that while there they were used as models on which orders could be, and were, taken.

It would be wrong to see the 1730–40 decade, the Smith years, as a period of steady decline for Canaletto. It is true that much of his work became hard and mechanical and that constant repetition of the same view for different patrons tempted him to

work to a recipe and to seek various aids to increase his production. On the other hand, his skill in providing the kind of picture his clients wanted developed with the years. This was a record of a part of Venice on a sunny day, as it might be seen framed in the frosted glass of a camera obscura but capable of being removed from the instrument, enlarged and hung on a wall. It was to retain the illusion of movement as seen in the camera obscura and furthermore the illusion that every scene in Venice presents a balanced and harmonious design. As every amateur photographer knows this is far from being the case and the highest possible skill was required in the manipulation of the proportions of buildings, the fusion of the scenes from a series of viewpoints into an integrated whole with apparently only one viewpoint and, perhaps above all, in the unified fall of light and creation of atmosphere by imaginative shadows. Generally speaking every patron received an original work of art with its own character and individuality, however many versions of the same scene had been supplied to others. Replicas are rare indeed and, when they occur, slightly suspect; Canaletto himself was always able to move around the boats, market stalls and figures, as well as the sun and the clouds to change the fall of the shadows. The spectator may be looking at the same scene but it is on another day and other people have come to populate it. And the scene which he is so convinced reproduced what he saw was in fact the product of Canaletto's own imagination translated into oil and pigment on canvas in the seclusion of his studio.

Occasionally, as we have seen, a masterpiece burst out of what might have, but never did, become a strait-jacket. More than occasionally the pressure was too great and the imagination sagged. We shall never know though how much Canaletto was himself responsible for the product of such occasions. The extent of 'studio assistance' cannot be diagnosed by any exact science and opinions vary. As far as can be judged Canaletto reached the peak of his ability to produce the kind of picture Smith and his patrons wanted in about 1735 and the Harvey and Woburn Abbey series represent that period at its best. This is as would be expected since many other pictures were based on originals in those two series and for such orders increasing reliance was placed on Canaletto's automatic pilot.

Where, then, should the eighteenth-century traveller, still intoxicated by the spell of Venice and longing to refresh himself with his memories, have turned? It depended on what he wanted and the risks he was prepared to take. For decorative and evocative views to brighten the walls of his home he could rely on Smith in whose hands he could be sure of a certain standard of quality as well as authenticity. If he went to Canaletto himself he *might* land a *Bacino di S. Marco* but he might well find himself with replica-type versions of well-known subjects already rejected by Smith. By 1735 the days when he could hope to find a '*Stonemason's Yard*' were over so it was safer, if less adventurous, to trust Smith.

* * *

During these ten years of intense commercial activity on the part of Smith and Canaletto between 1730 and 1740, Smith held back nothing for his own collection except the original fourteen paintings used for the first edition of his book and the single picture from the second edition. Instead, he seems to have prevailed on Canaletto to take frequent respites from painting, busy though he must have been, and produce drawings of many of his subjects. None of these drawings was sold, even though there were often two or three versions, barely distinguishable from one another, and no one but Smith appears to have commissioned a drawing during the period. Yet Canaletto was a superb draughtsman whose fame would have been assured had he never painted a picture.

Many of the drawings appear to be preliminary sketches for paintings but close study generally shows them to have followed the painting and their purpose is often obscure. Canaletto did make preliminary sketches, of course, a few of which have survived such as the one used for Stefano Conti's *Rialto Bridge from the North* (plate 10). Moreover there are three sketch-books in existence, one of them intact in the Venice Academy and two from which the sketches have been removed, in which Canaletto's method of making his preliminary notes can be intimately studied. The Academy sketch-book's pages are for the most part occupied by a systematic stocking-up of material for a long series of pictures, many of them used for the Woburn Abbey group, some pictures requiring two or three pages each whereas others needed up to ten pages. As well as line drawings of the buildings noted, their names are recorded, the kind of shop identified and the colour and type of the material added—dull red with stains, for example, or old boarding. Other sketches contain detailed notes of a small section of Venice such as would be needed when the time came to compose a picture which included such a section. An interesting example of this occurs in two sketches he made of the Campo S. Basso (plates 65 and 68), the little *campo* on the north-east side of the Piazza, often called the Piazzetta dei Leoncini after the two pink-marbled lions, each with a child almost inevitably astride it.

Against every shop in this *campo* Canaletto has noted precisely the goods in which it deals and there are corrections following a comparison of the sketch with the subject itself—'wider', 'not so high' and so on. In due course a painting was commissioned, or executed and sold from stock, in this case *The Piazza S. Marco: the North-East Corner* (plate 66) which an Englishman, William Holbech, wanted as part of the decoration of his dining-room in Warwickshire, made by Italian workmen. (He bought a companion picture at the same time, looking across the Piazza in the opposite direction, and some years later, when Canaletto was in England, he commissioned two more Venice pictures of the same size to complete his room.) Holbech's pictures were very much larger than Smith was used to handling, 132 centimetres as opposed to the forty-seven centimetres high of the Woburn and Harvey groups, and perhaps for this reason they do not

appear to have passed through Smith's hands. However, Smith may well have seen the S. Basso painting and admired it, as well he may for it shows Canaletto at his best for the mid-1730s period, and commissioned a drawing of the same subject (plate 67). The drawing he received, now in the Royal collection with all his other 140 Canaletto drawings, shows no sign of being a preparatory drawing for a painting; it is, on the contrary, a finished drawing which could have been handed over directly to the engraver. One wonders why this should never have been done at the time, for Canaletto's own drawings would have made far more attractive engravings than Visentini's copies of his paintings. But one wonders why Smith, and apparently no one else, accumulated fifty drawings of Venice between 1730 and 1740 and kept them almost until the end of his life. Perhaps it was because he recognized that Canaletto could make the sun shine on paper with pen-and-ink almost as brightly as on canvas with his brush and Smith, a collector first and a dealer second, could not bear to part with them.

35 *Piazza S. Marco: looking East.* 133 × 170cm

36 Detail of plate 35

37 Detail of plate 35

38 Detail of plate I

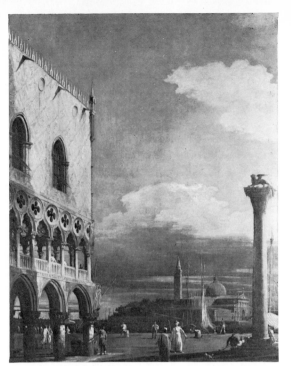

39 *The Piazzetta: looking South.* 170 × 132cm

40 *Dolo on the Brenta.* 61 × 95cm

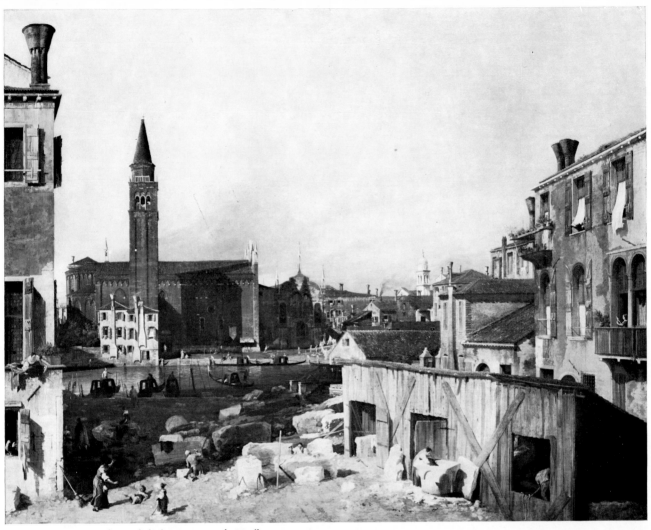

41 *Grand Canal: 'The Stonemason's Yard'.* 124 × 163cm

42 Detail of plate 41

43 Detail of plate 41

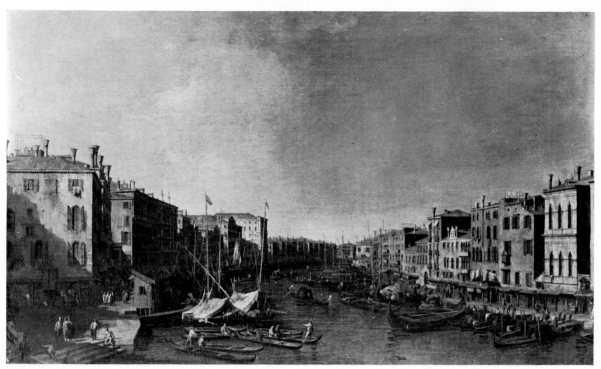

44 *Grand Canal: looking South-West from the Rialto Bridge to the Palazzo Foscari.* 47 × 78cm

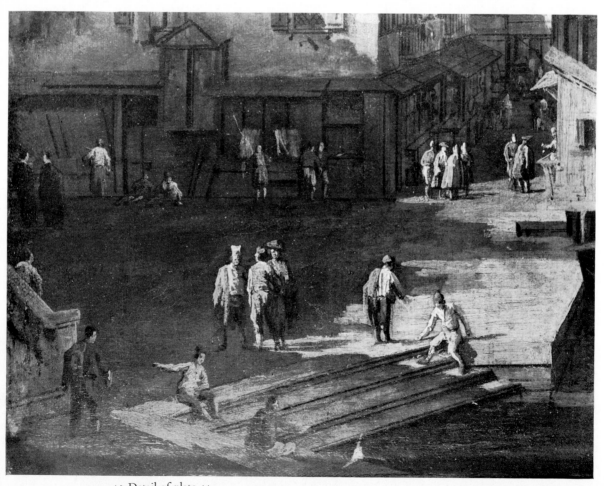

45 Detail of plate 44

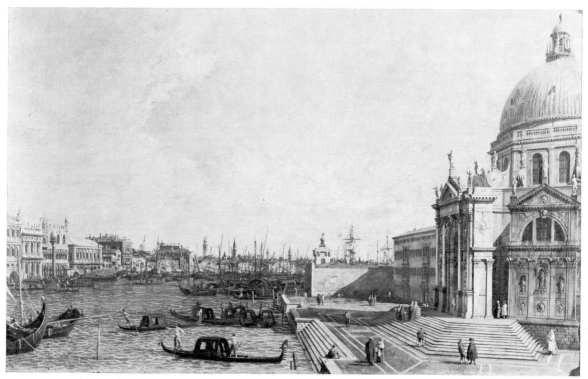

46 *Entrance to the Grand Canal: looking East.* 47 × 80cm

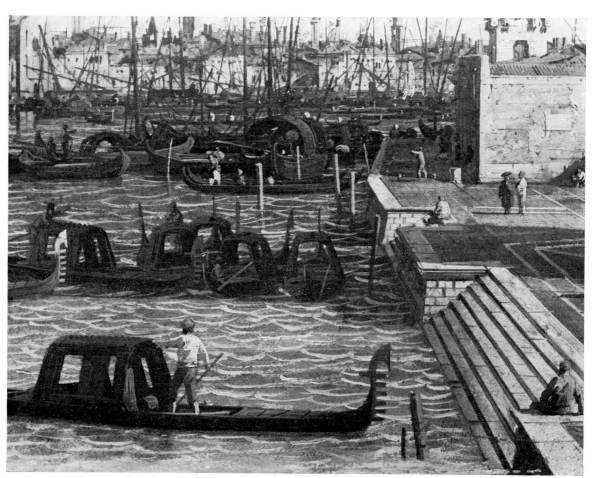

47 Detail of plate 46

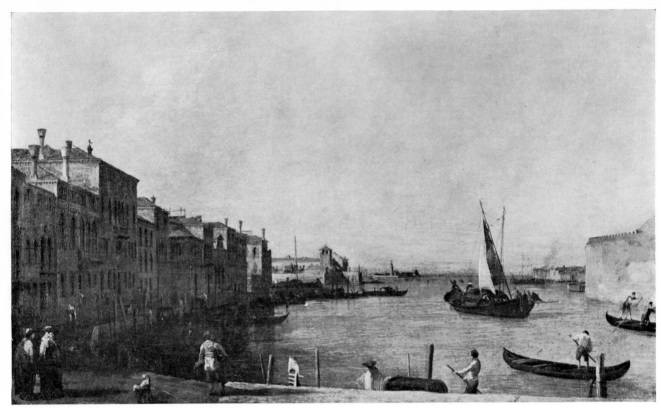

48 *Canale di S. Chiara: looking North-West from the Fondamenta della Croce to the Lagoon.* 46 × 81cm

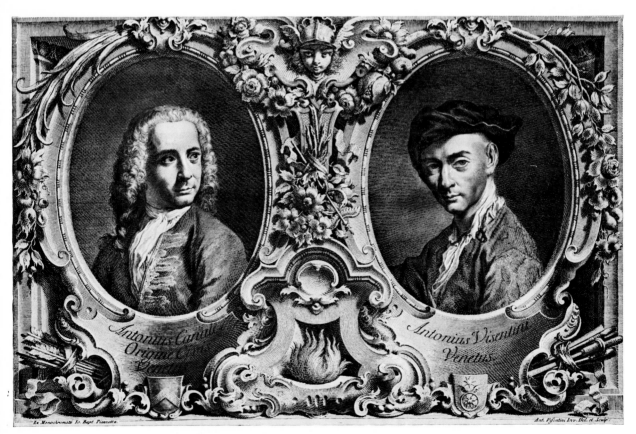

49 *Portraits of Canaletto and Visentini.*

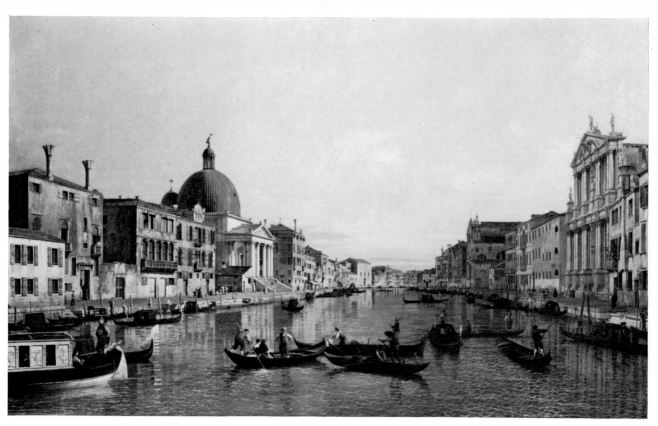

50 *Grand Canal: looking South-West from the Scalzi, with S. Simeone Piccolo.* 124 × 204cm

51 Detail of plate 50

52 Detail of plate 54

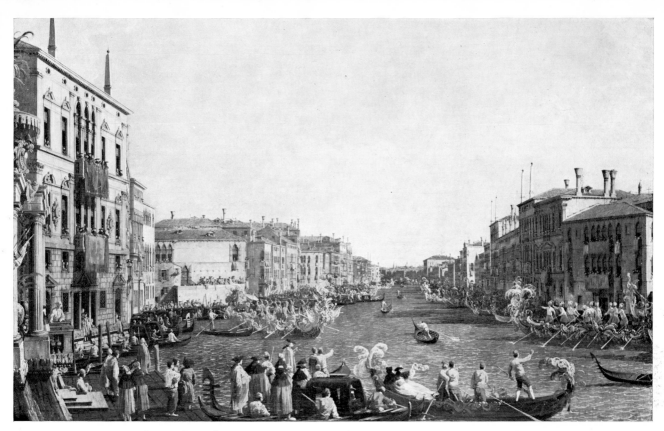

53 *Regatta on the Grand Canal.* 77 × 126cm

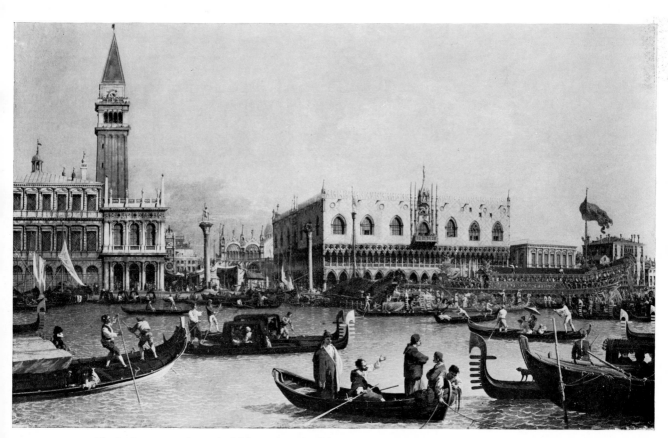

54 *The Bucintoro returning to the Molo on Ascension Day.* 77 × 126cm

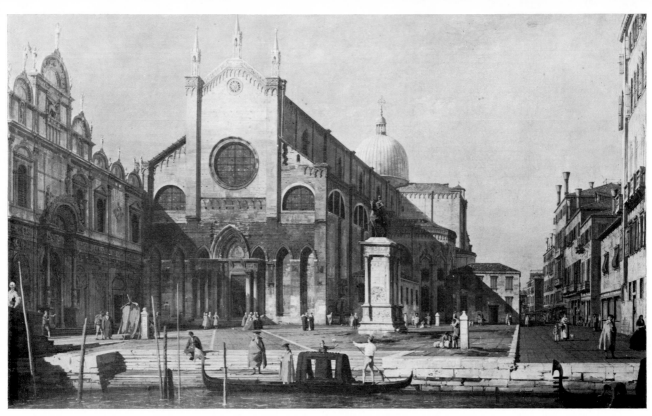

55 *SS. Giovannie e Paolo and the Monument to Bartolommeo Colleoni.* 46 × 78cm

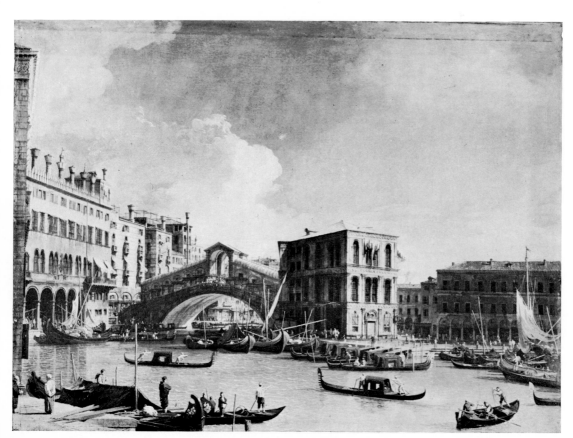

56 *The Rialto Bridge from the North.* 58 × 85cm

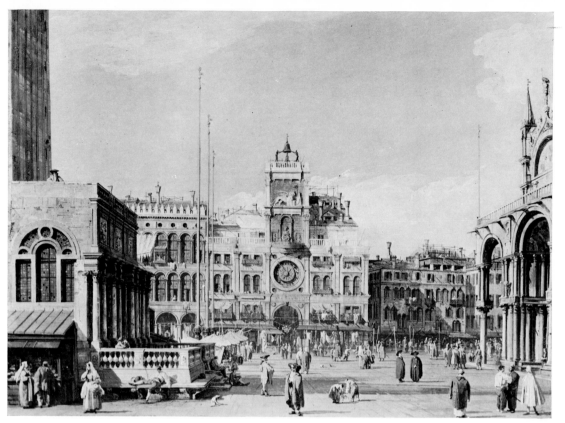

57 *Piazza S. Marco: looking North.* 53 × 70cm

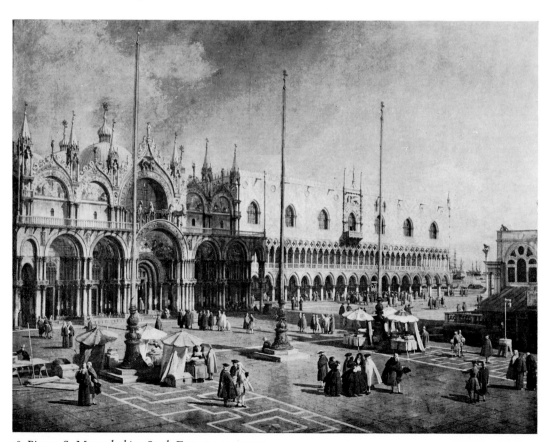

58 *Piazza S. Marco: looking South-East.* 114 × 153cm

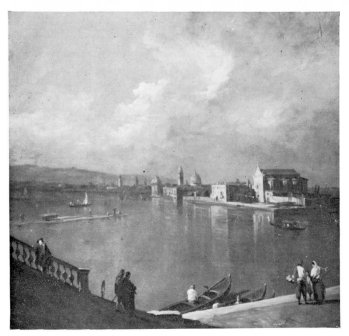

59 *S. Cristoforo, S. Michele, and Murano from the Fondamente Nuove.* 120 × 130cm

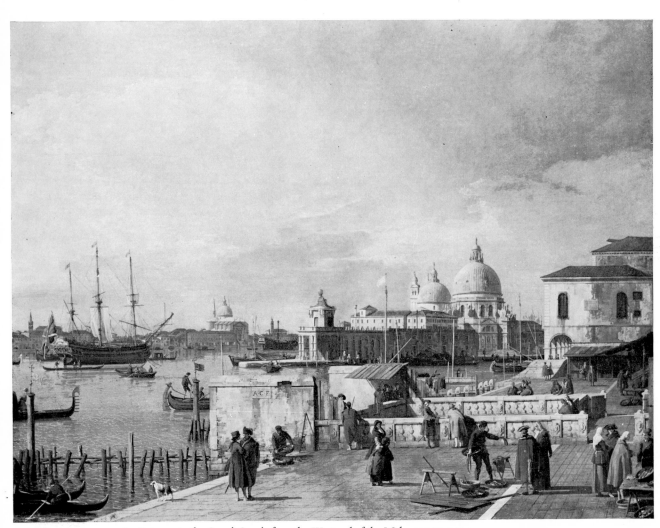

60 *Entrance to the Grand Canal: from the West end of the Molo.* 114 × 153cm

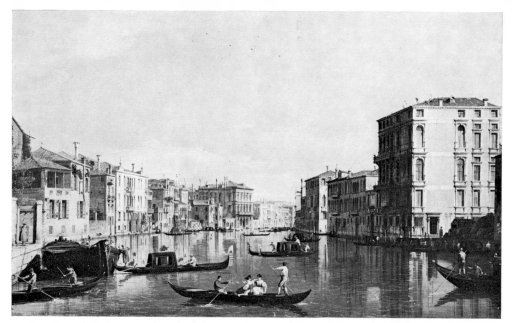

61 *Grand Canal: looking East from the Palazzo Bembo to the Palazzo Vendramin-Calergi.* 47 × 80cm

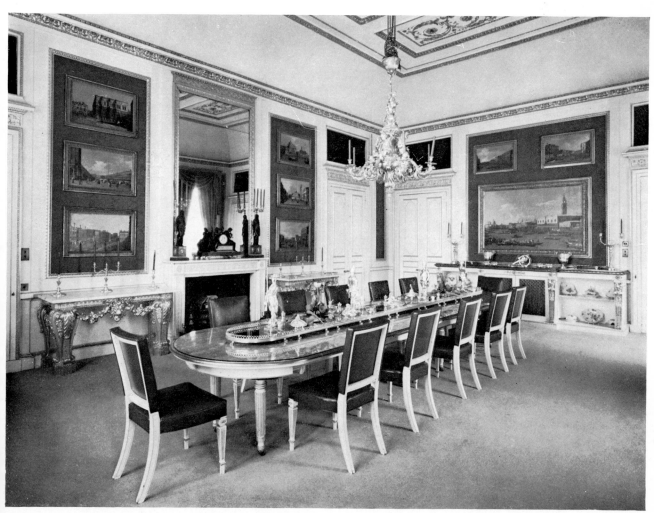

62 The 'Canaletto Room', Woburn Abbey

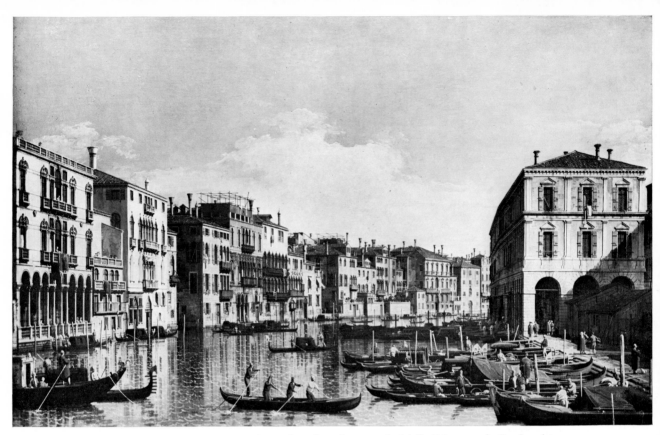

63 Grand Canal: looking South-East from the Palazzo Michiel dalle Colonne to the Fondaco dei Tedeschi. 47 × 77cm

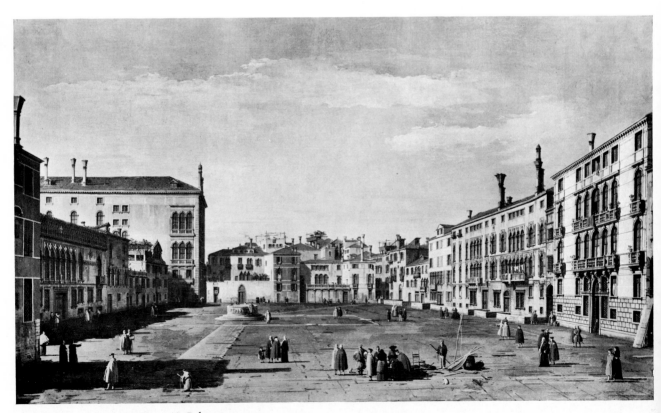

64 Campo S. Polo. 46 × 77cm

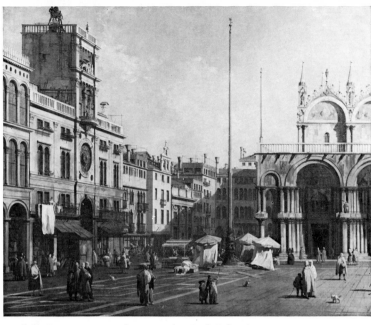

65 (*left*) *Campo S. Basso: houses on the North Side.* 43 × 29cm

66 (*above*) *Piazza S. Marco: the North-East Corner.* 132 × 165cm

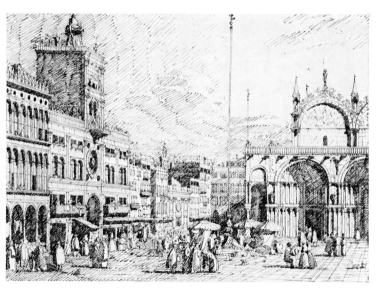

67 (*above*) *Piazza S. Marco: the North-East Corner.* 27 × 37cm

68 (*right*) *Campo S. Basso: the North Side with the Church.* 43 × 29cm

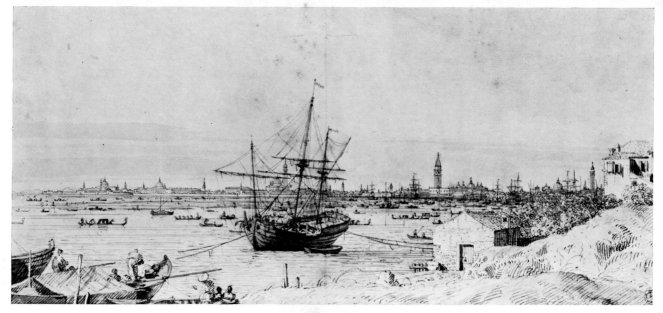

69 *View on S. Elena.* 16 × 35cm

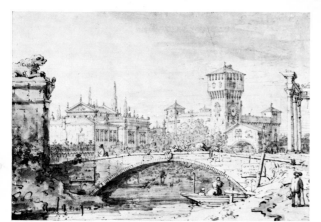

70 (*left*) *Capriccio: based on reminiscences of Padua.* 20 × 28cm

71 (*right*) *Courtyard and pavilion of a villa.* 21 × 34cm

9

Journey with a pupil

'The Delights of the Brenta'

Title of G. F. Costa's book of engravings

However much skill and care Canaletto put into the Venice drawings he gave or sold to Smith before 1740 he remained essentially a painter who also drew. However, at some time very soon after 1740 he seems to have locked up his studio and taken a sabbatical year from painting. As far as view paintings of Venice were concerned it proved to be very much more than a year and, except for a handful of paintings of an experimental kind, he abandoned the career in which he had been so celebrated for more than fifteen years.

This momentous step is generally attributed to the effects of the War of the Austrian Succession and the consequent falling-off in the number of foreign visitors to Venice. But before its effects had begun to be felt in 1742 there were signs that either Canaletto had grown tired of painting Venice views or that the market had at last been surfeited. Few artists can resist an importunate patron with a well-filled purse, and Canaletto in his early days at any rate does not seem to have been one of them, so the second explanation is more plausible. All the same, the zest with which he turned to his new type of work makes one wonder whether, if the change was forced on him, he did not accept the need for it with some sense of relief. Things might have been different if Smith had turned away from his old friend now that he could no longer profit from his work as in the past. He took no such course and, however difficult his own affairs might have been at this time, he was ready with new ideas and willing to take whatever resulted from them for his own collection. In the past Smith had taken most of the saleable work, only the masterpieces eluding him; now he was to take virtually everything and to direct its production more than he had ever done before.

It may have been a gradually forming desire in Canaletto's mind to see what Venice had to offer his pen besides the Molo, the Grand Canal and the churches that led to four exquisite drawings from near S. Elena, on the extreme east of the city (plate 69). These are not the works of a tired man, however tired he may have been of his studio, working on impressions formed outside it. Here his vision is as

5—C * *

fresh as when he had been a young man whereas he has mastered every technical device which enables him to convey with a few lines the stillness of the lagoon, the unique light reflected from the water and the miraculous city playing, for once, a secondary part in the far distance, or the sun falling on the walls of houses and *campanili*. The criss-cross of masts and long, horizontal lines recalls the Castle Howard *Bacino* now in Boston (plate X). This was probably the last great Venice view that Canaletto painted and the S. Elena drawings, possibly separated from it by only a small distance in time, are the first examples of the new vision which was to carry the artist to such heights in his etchings. Drawn for no purpose but to give pleasure, equally no doubt to Canaletto and to Smith, they stand alone with no other versions in pen, paint or engraving.

Nor was it a tired man who now left the city altogether and allowed his eye and his imagination to be seduced by the delights of Padua and the Brenta canal. Stimulated by the new subjects, by the temporary escape from his studio and, perhaps above all, by the prospect of exploring the possibilities of the etcher's needle for the first time, he showed that he was still at the height of his powers. The drawings and etchings which resulted from the journey to Padua and the Brenta can only be seen as two aspects of the same phase of Canaletto's career; both must have been in his mind at the same time.

There is not much evidence of date, and none as to the duration, of the journey, or journeys. One of the etchings bears a date MDCCXLI and a drawing for another '1742' so that, although they were not completed until 1744, they must have been begun by 1741. The etching with the MDCCXLI date is certainly, from its style, not one of the first so that a 1740 date becomes perfectly possible.

There are other indications. Bellotto must have been with his uncle from the first, and probably for the whole time. For practically every drawing by Canaletto there is a corresponding one by Bellotto and there is enough difference between the two versions to exclude the possibility that Bellotto was just copying the drawings after his uncle had returned to Venice. Indeed, it is arguable, and has been argued, that more than one of the drawings shows evidence of having been originally done as an exercise by Bellotto and then copied by Canaletto as a demonstration of how it could have been done better. Bellotto's presence is established beyond doubt.

Bellotto also produced some etchings based on what he had seen during this journey and it is worth noting that he signed them 'Bernardo Beloto' [or B.B.] 'detto Canaleto' [or Canaletto]. He later came to be known as Canaletto, and is so known today in Germany and in Poland, where he died, and it was often said that he used the name deliberately to cause confusion and exploit his uncle's reputation. It is clear, though, that he was using the name while still in intimate

contact with Canaletto and with his uncle's full approval, perhaps indeed at his instigation.

Canaletto derived far more from the visit than material for the two dozen drawings of Padua and the Brenta which became Smith's property on the return to Venice. Not that these drawings can be dismissed lightly: they have a freshness which is sadly lacking in his later drawings of Venice itself and it is apparent that he was deeply stirred by the variety of the unfamiliar scenes (plates 70–71). But the impressions which he was storing up in his mind during this period of spiritual refreshment served him for many capriccios in which he allowed his imagination to soar and which include some of his most engaging work. Very few of them can be dated and it may be remembered that modern scholars suggest that he began his career with this type of work. However, the 1740s were almost certainly the most fertile period for these imaginary compositions, some with identifiable buildings, others with traditional ruins, arches or temples, some of them deeply moving and others decorative in the best sense (plate 76).

Bellotto's name has been occurring with increasing frequency now that his apprenticeship was nearing its end. How long it had lasted can only be guessed at but he had certainly been in his uncle's studio for four or five years. He had been born in 1721, the second son of Canaletto's eldest sister, Fiorenza Domenica, and of Lorenzo Bellotto, of whom hardly anything is known. In, say, 1735 Canaletto was at his busiest, and perhaps at the height of his fame, so a boy of fourteen or fifteen with talent would have been warmly welcomed. It may be supposed that Canaletto's father, Bernardo Canal, lent a hand in the studio; he seems to have given up scene painting by this time and would have been useful, although view paintings which bear his name show no evidence of unusual gifts. The three generations of artists may well have comprised the entire 'studio', perhaps with occasional outside help; there is no evidence, either in contemporary gossip or in the works themselves, of a large staff of assistants. Weak passages in Canaletto's paintings may be accounted for by the presence of these few helpers or by moments of over-pressure on his resources. Outside the studio, there were plenty of artists who preferred to remain anonymous and who copied, as best they could, Canaletto's methods and Visentini's engravings. They also had Carlevaris's earlier engravings and those of various artists whose work was published by Domenico Lovisa in 1721. It is to those that the thousands of 'school' view paintings must be attributed rather than to the direct influence of Canaletto himself.

There is little difficulty in identifying the young Bellotto's drawings, even before the visit to the mainland, and they show him practising his craft much as one would expect. From copying Canaletto's drawings he went on to adding original touches to them, moving the viewpoint slightly and making the

consequent changes of perspective, and then making his own drawings from Canaletto's sketch-book.

There is not one painting of Venice which is certainly the work of Bellotto and there are less than twenty which have been attributed to him by any responsible critic. A few of these have been generally accepted; the remainder are often the subject of warm controversy of limited interest to any but specialists (but of addictive interest to them). The controversy, needless to say, centres only on the responsibility of Bellotto or Canaletto for the paintings. The thousands of pictures which show no trace of the work of either and which, if too poor to be associated with Canaletto's name, have often had to bear a Bellotto label, are not involved.

Certain characteristics do seem to be identifiable. A few paintings have more heavily contrasting shadows than one associates with Canaletto, whose delicate transition from light to shade contributes much to the peculiarly Venetian light with which his pictures are suffused. Bellotto's brush carried more paint than that of Canaletto who relied on a powdery, or foamy, consistency to achieve his effect of harmony; this heavy impasto is particularly noticeable in the figures. No one credits Bellotto with much originality in the way of composition during his Venice period; his uncle's paintings or drawings were there to be copied and copied they were, with alterations here and there to the figures, the viewpoint and the extent of view. An exception is perhaps the most controversial of all, the *Rio dei Mendicanti and the Scuola di S. Marco* (plate 72) in the Venice Academy. Most authorities now give this to Bellotto (thus leaving not a single Canaletto painting on view in his native city) but this is far from saying that it *is* by Bellotto. Perhaps the shadows are a little dark for Canaletto; perhaps there was a little more paint than usual on the artist's brush when the figures were painted. To regard Bellotto, though, as capable of composing and painting so accomplished a picture as this while still in his uncle's studio offends one's sense of reason and the clouds of doubt cannot be easily dispersed.

Guarienti, in his dictionary of painters, wrote of Bellotto that 'his scenes of Venice were so carefully and realistically done that it was exceedingly difficult to distinguish his work from his uncle's'. This was in 1753 and the words 'his scenes of Venice' must not be overlooked. By this time Bellotto had left Venice for ever and was painting dazzling views of Dresden for the King of Saxony, whose Court painter he had become. There was no question of confusing these with the work of Canaletto. Indeed, from the moment he left his uncle's studio Bellotto seemed able to develop his own style, to design his own compositions, to demonstrate, in fact, that he was an artist of high talent who had the immense advantage of a thorough grounding in his craft.

10

Bellotto, Rome, and Marieschi

'A bold, frank manner'

Smith on the Rome paintings

In either 1741 or 1742 Bellotto left Venice and set out for Rome. Probably on the way out, but possibly on the return journey, he stopped in Florence, of which six paintings survive, and in Lucca, of which there is one. Fifteen paintings of Rome exist, not all necessarily painted there, as well as a number of drawings. He is next heard of in August 1743 when it is recorded that he exhibited two pictures outside the Scuola S. Rocco at the annual exhibition there, just as his uncle had done almost twenty years earlier (p. 14). He was, however, certainly back by 1742 and in close collaboration with Canaletto—just how close poses an intriguing problem.

In 1742 Canaletto painted a group of five pictures of Rome for Smith (plates 73–74) and, for the first time in his career, added his signature and the date; a sixth was dated 1743. It must have been about the same time that he provided Smith with eleven drawings, also of Rome but based on a group of much earlier drawings rather than on paintings. These early drawings, or copies of them, are now in the British Museum. Whether Canaletto's own or not, they were certainly not drawn in his forties so they throw no light on the controversial question of whether he went with his nephew on the Rome journey. It would have been reasonable enough for him to have done so. He had not been to Rome for twenty years; there were few patrons demanding pictures of Venice and he does not seem to have had any wish to translate his drawings of Padua and the Brenta on to canvas. On the other hand, there is no trace of such a journey and Canaletto was sufficiently well known by this time to justify the expectation that, if he had gone, someone in Rome or Venice would have mentioned the fact.

In the absence of any evidence that Canaletto went to Rome a second time it must be assumed that he did not. Smith's Roman drawings provide no such evidence since they were all based on drawings made when Canaletto was a young man or, in some cases, on other artists' engravings. Nor do the paintings. Canaletto had the drawings and paintings which Bellotto had brought back, some of which were no doubt being produced in his own studio. They provided both the stimulus and the subjects but he seems to have seen Rome to some extent through

his nephew's eyes. It has been suggested that there was collaboration between the two men and even that Bellotto played the major part in the work. How then is Canaletto's signature to be accounted for? There is a remote possibility that it was a ruse to deceive Smith who apparently gave no encouragement to Bellotto although he must have known his favourite's nephew well. Since Smith was above all a collector of living artists' work this is an extraordinary fact. He would not have wanted Bellotto's pictures of Venice, which were but echoes of Canaletto's work, but he now had an ideal opportunity of acquiring original paintings resulting from the journey to Florence and Rome. The suggestion that he may have bought unknowingly what he would not buy knowingly may seem far-fetched but if it is rejected, as perhaps it should be, there remains the fact that Smith never owned a Bellotto of this or any other period.

Canaletto's new practice of signing and dating his paintings may have done little to clarify the pictures of Rome but it does place two other groups in their correct position. A group of four Venice paintings carry the dates 1743 or 1744 and enough of a series described as 'thirteen pieces over doors' are dated 1744 to make it certain that the whole series must have been painted in or around that year.

The overdoors, like almost everything of this period, were for Smith who wanted them to serve partly as a tribute to Palladio, whom he admired fervently. They were to represent 'some of the most admired Buildings at Venice, elegantly Historiz'd with Figures and adjacency to the Painter's Fancy' according to his own catalogue. The painter's fancy does not appear to have been caught by the commission. Palladio was several times ignored altogether and Canaletto's imagination often went no further than to place well-known elements of the Venetian scene in unaccustomed surroundings where they appear as embarrassed as the artist must have been. By this time Canaletto was using a twist or two of his brush to represent his figures, instead of the elaborately built-up studies of the past, and highlights were indicated by little dots of yellow or white. It was the beginning of a technique that he followed to the end of his life but gradually the twists became more expressive and within a few years he was able to convey an extraordinary degree of vitality to figures which, when looked at closely, seem to have been dropped on to the canvas almost carelessly. This stage had not been reached while the intended tribute to Palladio was being worked on and few of the figures show the Canalettesque tendency to leave the canvas and take on a life of their own. The painting of a bridge which Palladio had drawn for one of his 'four books of architecture' is perhaps the most interesting of the series (plate 75). Palladio had almost (but not quite) certainly visualized it in place of the old Rialto Bridge, which was overdue for replacement at the time, and Canaletto has shown it in that position. The thirteen paintings must have been sold to George III with the rest

of Smith's collection but, curiously enough, four of them later disappeared, two to reappear almost two centuries later.

Smith was certainly serving Canaletto well during these early years of the 1740s. Apart from encouraging him to turn for his subjects to the outskirts of Venice, then to the mainland, then to Rome and then to the 'Palladian' capriccios, he had, in 1742, published the second edition of *Prospectus Magni Canalis* ... with its additional twenty-four engravings. There is no ready explanation for the seven-year delay after the publication of the first series since the paintings must have been finished long before. It is possible, indeed, that the book might never have been published at all but for the appearance of Canaletto's first potential competitor since the death of Carlevaris. 'Appearance' is perhaps an ill-chosen word for Michele Marieschi; one thinks of him rather as a character in a play who is much spoken of but never seen on the stage in person.

Marieschi was born in Venice in 1710—thirteen years after Canaletto and ten before Bellotto. His father was a wood-carver who died when Michele was eleven and whose family were unable to pay the expenses of his funeral. Nothing is known of Michele until 1735 when two engravings by him appeared in a volume commemorating the funeral of the Queen of Poland at Fano, between Ravenna and Ancona. Between 1736 and 1741 his name appears among the Fraglie dei Pittori of Venice and there are records during those years of three purchases of paintings by him on behalf of Johann Matthias Schulenberg. Schulenberg was a professional soldier, born in 1661, who had fought for his native Saxony, for the Hungarians, the House of Savoy and for the Venetians against the Turks in defence of Corfu. He had retired to Venice, spending his old age between there and Verona, and had become a collector on a considerable scale (the only Canaletto he seems to have bought was a view of Corfu which has disappeared, if it ever existed). According to his inventory, Marshal Schulenberg paid 50 and 55 gold sequins each for two Venice views by Marieschi, a high price, making it reasonably certain that they were fairly large oil paintings. There is no evidence of any other painting by Marieschi who was said by his biographer, Orlandi, writing in 1753, to have been in Germany until about 1735, probably as a scene painter. Nothing is known of his sojourn in Germany, or indeed of his life in Venice except that he was married there in 1737 when his sponsor, Gaspare Diziani, testified that he had known both bride and bridegroom since childhood.

In 1741 an album of twenty-one etchings of Venice was published under the title *Magnificentiores Selectioresque Urbis Venetiarum Prospectus* ..., the title-page bearing a portrait of Marieschi by Angelo Trevisani and describing him as *Pictor et Architectus*.

The effect on Smith and Canaletto of this publication can only be guessed at—as must everything else about Marieschi since virtually all that is known about him

is contained in the two paragraphs above. A painting in Bristol bears the initials *M.M.* and if these stand for Michele Marieschi it is the only painting which can be attributed to him with certainty. All others, and there are hundreds, base their attribution on an apparent resemblance to the etchings. Two guesses seem justified —that Smith's issue of the second series of Visentini's engravings was influenced by the appearance on the scene of this new and talented artist and that Marieschi owed a great deal to the work of Canaletto. Some of his etchings are clearly based on earlier ones which had also been used by Canaletto, some on apparently original work by Canaletto and some (very few) seem to be conceived entirely by Marieschi. It has been suggested that the two artists worked together, and they must surely have known each other. There is no evidence at all, though, as to whether they were rivals or colleagues—or both, as is perfectly possible.

The title-page of Marieschi's book of etchings claims that they are 'for the most part' from pictures painted by himself but no painting has yet been identified which there is any good reason to believe is the original of one of the etchings; there are many which follow the etchings, which is hardly surprising bearing in mind the tendency of unimaginative but skilful painters to copy available subjects. Although he no doubt did paint, it is therefore as a draughtsman and etcher that Marieschi must be judged. The etchings suggest that he was attracted by the theatricality of a scene which he exaggerated by taking a close viewpoint, with its resulting steep foreshortening and 'wide angle', that he allowed fantasy to break out, as with his tree growing beside the canal (plate 88) or his imaginary design of the façade of S. Rocco (plate 89), and that he may well have turned to other artists for his figures which are curiously unrelated to their background.

These are the considerations which have doubtless led to the most striking attribution of a picture to Marieschi, the *Salute* (plate 87) which entered the Louvre as a Canaletto in 1818 and continued to carry that attribution for nearly 150 years. John Ruskin seized on this picture as the text for what he called his 'determined depreciation' of Canaletto and described it as a 'rascally Canaletto' adding that 'a man deserves chastisement for making the truth so contemptible'. It was an unfortunate choice but Ruskin seems never to have seen any of Canaletto's better works at the time he was campaigning against him or he would have doubted the attribution himself. The new attribution to Marieschi seems altogether more reasonable than the old, however tentative it must necessarily be in the light of present knowledge.

Canaletto had by now almost given up painting views of Venice and, for most of 1741, when Marieschi's book of etchings appeared, he had given up painting altogether and was on the mainland working on his drawings and etchings. Marieschi may have been painting hard before his book appeared; it seems more probable that the book made his reputation and that the commissions followed.

To judge by the number of surviving paintings which he apparently produced himself, he must then have been working on a scale as great as that of Canaletto in his heyday. The second edition of Visentini's etchings, perhaps hurriedly published by Smith from existing plates as a rejoinder to Marieschi's book, does not seem to have resulted in more commissions for Canaletto. Perhaps he did not want any more commissions for views for the moment; perhaps Marieschi had supplanted him in the public favour as he himself had supplanted Carlevaris nearly twenty years earlier. For whatever reason, Marieschi went on producing views and capriccios in considerable numbers for various unknown patrons while Canaletto remained preoccupied with his exploration of a new range of subject and confined to but one patron, Joseph Smith. First the drawings of S. Elena followed by those of Padua and the Brenta, then the drawings and paintings of Rome, then the 'overdoors' and, probably, a few other capriccios. In October 1743 he signed and dated two paintings of the Piazza area (plates 77–78) which were to be followed by a second pair the following year. The style differed from any Venice view he had yet produced in that he followed Marieschi's practice of placing his viewpoint close to his subject and taking in a wider angle than the eye could in fact encompass. All four paintings were to be copied in outline by Visentini and then engraved in a larger format than those of the *Prospectus Magni Canalis . . .* series.

Before the second pair of paintings was completed Marieschi was dead. He died in January 1744 (still called 1743 according to the Venetian year which ended in March) after an eight-day illness just after his thirty-third birthday and his biographers attributed his death to overwork. Thus he departs from the scene which, as a painter, he never really entered until years later. Forty-five years later a dispute arose over the attribution of two pictures said to be by Canaletto and a committee of Academy members was formed on which Francesco Guardi served. Their decision was that the correct description was 'school of Marieschi'. This is almost the first recorded mention of his name since his death and it was to be another century before it was to begin to join the catalogue of view painters with those of Carlevaris, Canaletto and Francesco Guardi. Were the Academicians, one wonders, basing their decision on the engravings or did they really know Marieschi paintings?

11

Fixing the camera image

'The eye is deceived...'

Orlandi in Abecedario

The paintings of the Piazzetta area which Canaletto signed and dated 1743 for Smith are in all likelihood his first Venice views for several years and his last until after 1756. The painting has become mechanical and mannered yet there is a sensitivity, particularly in the figures, which signals Canaletto out so unmistakably from the imitators who by this time were surrounding him. It had always been his practice to build up his picture from sketches made from a number of viewpoints: here he goes further and almost abandons any pretence of having seen what he was painting. *The Piazza S. Marco: looking West* (plate 77) may appear to have been painted from a balcony of the Doge's Palace but no series of attainable viewpoints would enable the buildings to be seen from the angles at which they are shown. To take in the view encompassed by *The Piazzetta: looking North* (plate 78) the spectator would have to retreat to the island of S. Giorgio Maggiore, from which the relationships of the buildings would of course be entirely different.

Canaletto was evidently experimenting with the possibilities of a type of view which has come to be known as 'wide angle' and which was a favourite device of Marieschi. Canaletto had himself never hesitated, when restrained by physical objects from attaining his desired viewpoint, to sweep them away in his imagination and picture himself where he wanted to be. The church of *S. Maria Zobenigo* stands in the narrowest of *calli* from which the top of the façade is invisible without craning the neck and from which the *campanile*, still marked by its stump after its fall in 1774, could never have been seen at the same time as the main door. In his painting (plate 79) Canaletto forgets these awkward facts and even manages a glimpse of the Grand Canal on the extreme left. The Piazzetta is no narrow *calle* but it is self-evident that no one can see the church of the Zitelle on the island of Giudecca, which appears on the left of *The Piazzetta: looking West, with the Library and Campanile* (plate 80), and the west end of the Piazza, which appears on the right, from the same viewpoint. Many other examples could be given of paintings and drawings of the 1730s where Canaletto has been forced to go closer

to his subject than he would have wished and so have needed to turn his head up and from side to side to see all he wanted, often to have changed his viewpoint as well. There was no more difficulty in composing a picture in the studio which concealed these manoeuvres than in raising the sky-line, and adjusting the vanishing points accordingly, so as to give the illusion that a picture had been painted from a non-existent high window or the top of a ship's mast—as in the cases of plates 28–32, to name only some blatant examples of the process.

The 1743-4 Smith paintings are another stage in Canaletto's experiments with wide angles, and in a series of drawings of the Piazza, also kept by Smith, he goes almost to the limit of capriciousness. Whereas the artist in plate 80 purports to be able to see the St Mark column and part of the Campanile at the same time, in plate 82 he sees from well to the left of the St Mark column to the south façade of St Mark's itself and the entire Campanile appears not very much right of centre.

There was nothing new in this type of picture. There are equally 'impossible' views in Carlevaris's book of engravings of 1703 and by the time Domenico Lovisa published another book of engraved views in 1721 called *Il gran teatro* . . . they had become conventional. Plate 81 is one of several examples from Lovisa's book.

In the case of Canaletto, though, and only in his case, the wide-angle drawings and paintings have often been used to establish his employment of the *camera ottica*, or camera obscura, as it is generally known in this country, or camera, as it will be called here (for it is nothing but a camera, as we know the instrument today, but without a film in it).

A. M. Zanetti, who was one of the three contemporary writers to leave some brief notes on Canaletto, included a passage which was not confirmed by the other two:

By his example [he wrote] *il Canal* taught the correct way of using the *camera ottica;* and how to understand the errors that occur in the picture when the artist follows too closely the lines of the perspective, and even more the aerial perspective, as it appears in the camera itself and does not know how to modify them where scientific accuracy offends against common sense. Those learned in this art will understand what I mean. [*Il Professore m'intendara.*]

One does not have to be very learned in the art to understand what Zanetti meant. He was referring to what is today often called the psychology of pictorial representation or the science of illusion, the subject of many books, articles and even exhibitions. He was referring to the beholder's share in the reading of visual images which leads to the fact that an artist who draws what he sees will often carry less conviction than if he draws what the beholder expects him to have seen. No one knew this better than Canaletto, even though he is unlikely to have read any of the books (of which there were already many in his day).

Zanetti's words are sometimes taken to mean that the camera image is a

distorted one but, provided it is kept in one position, this is not so. If its lens is moved round to obtain a panoramic effect or a wider angle there will be distortion to the extent that there will be more than one vanishing point, just as there will be if the head or the eyes are turned to right or left. It could be said moreover that the reduction of a three-dimensional scene to a two-dimensional screen, paper or canvas must itself produce distortion. The rules of linear perspective will help to 'modify the errors' to some extent but the successful transfer of a scene to a flat surface is the whole essence of topographical art and a part of most other forms of the graphic arts.

Zanetti did not mean that a camera image can change the relationship of various objects to one another, the 'perspective'. This depends exclusively on the viewpoint. A picture with a 'wide angle' or with steep foreshortening indicates that the artist has gone in unusually close to his subject (as did Vermeer, as a rule) irrespective of whether he has then used an instrument or not. If, on the other hand, the background seems to be almost on the same plane as the foreground, the figures and buildings in the distance to be larger than one would expect compared with those nearby, then the artist was unusually far from his subject when he drew it.

It may also be borne in mind that a lens can project an image only in the dark. It may be projected on to a white table in a darkened room, as in the case of the 'camera obscura' (dark room) which still survives as an attraction to visitors in a few towns. Engravings exist of contrivances of this nature which could be dismantled and re-erected elsewhere, but there is no evidence that they ever progressed beyond the drawing-board stage. Alternatively, the image may be projected on to a ground glass screen, or a piece of oiled paper, mounted in a small box; in this case, the 'chamber' in which it is to be seen must be darkened by a hood which isolates the viewer from the light which surrounds him.

No lens or combination of lenses could account for the 'anomalies' of the examples given if for no better reason than that there is no position which presents the view as depicted and so there is no point at which the lenses could be set up. A modern 'fish-eye' lens will encompass some, but by no means all, that they contain and it is not impossible that Canaletto should have sought inspiration for some of his compositions by seeing them reflected in the eighteenth-century equivalent of such a lens, a convex mirror. Even this is easier to accept than that he should have covered his head with a black cloth and moved some form of camera from side to side, and then up and down, to see the different aspects of a scene which presented itself equally well if he were to move his own head in the daylight.

In short, many drawings and paintings prove themselves *not* to have depended for their composition on the use of an instrument; there is no viewpoint or series of viewpoints from which such a view could have been seen. This by no means

proves that Canaletto never used an instrument, only that he did not use one in cases where he is often said to have done so. It would be hoping for too much to look for instances where he *must* have used a camera; such evidence could not exist within the picture itself (apart from Zanetti's warning that if it had existed Canaletto knew how to remove it). There are many cases where he *may* have used a camera and some where one might have expected him to do so. An example of these would be a diagrammatic sketch of a complicated sky-line where it might well be worth projecting the image on to a small piece of paper in order to record the relationships and shapes of numerous *campanili* and roofs. Normally one would expect these *aides-mémoires* to be thrown away when they had served their purpose but there is also the possibility that pencil lines which often underlie Canaletto's pen-and-ink sketches were made with the aid of a camera. These might have been inked over and detail added while the artist was still in front of his subject—but with the tiresome hood removed from his head.

It is a matter of small importance. Not without interest, just as it is of interest to know whether the artist used a goose or swan quill, or indeed anything which throws light on his methods of work. The fact, though, that no biography of Canaletto, however short, fails to mention his use of the camera obscura implies that his work was in some way influenced by it. Of this there is no evidence at all.

It must have been a heady experience to look for the first time at that screen and to see on its two-dimensional surface a three-dimensional scene, in colour, fully animated, reduced in size and neatly framed. It still is, to some extent, even though all the ambitions which fired the early observers have been realized within little more than a century—first to 'fix' the image so that it could be removed from its box and exposed to daylight, then to preserve its colours, then to animate it so that its movements were unfrozen, and finally to transmit it anywhere up to the distance of the moon or farther. Canaletto must have seemed to have achieved more towards the object of 'fixing' the camera image in colour than anyone else of his day. It is hardly to be wondered at if his contemporaries believed that the camera itself must have played a part, that one or two of them should have recorded their belief as a fact and that the record should in course of time have been accepted as if it were a fact.

We know that the same illusion of reality can be achieved both more readily and effectively by other means—but this was known nearly three centuries before Canaletto was born. When Brunelleschi demonstrated his theory of mathematical perspective by exhibiting a painting of the Piazza del Duomo in Florence his biographer wrote that it was 'as if the real thing was seen: and I have had it in my hand and can give testimony'. Nevertheless, it must have been easier to believe a celebrated patron and writer such as Francesco Algarotti when he wrote, in 1764, that 'the best modern painters among the Italians have availed themselves greatly

of this contrivance [the *camera ottica*] nor is it possible they should have otherwise represented things so much to the life'. They may have overlooked the fact that Algarotti was pressing the contrivance on the 'young painter', that the only 'modern painter' he mentioned by name (Spagnoletto of Bologna) would really have had no use for the camera, and that, although by that time he had known Canaletto for twenty years, he did not mention his name in connection with it. It *was* possible, we know, for Canaletto to 'represent things so much to the life' by use of the well-understood rules of perspective, his own eyes and his immense talent for illusion rather than the camera. Algarotti was deluded as McSwiney and so many others had been and were to be.

12

Canaletto goes to the English

'No doubt he will give the same satisfaction'

Vertue

Some time after 6 June 1744 Canaletto's etchings were published. The date cannot be earlier because the series is dedicated on the title-page (plate 83) 'as a sign of esteem and homage' to Smith who is described as 'His Britannic Majesty's Consul', a post he had attained, after many years of hoping, only on that date. Nothing more is known about the publication and it may well be that they were never published in the sense we understand the word today but made available to friends of the artist and his patrons. The existence of a title-page implies that the etchings were intended to form a book but, from the way in which they were printed, it seems more likely that buyers were expected to mount them separately. Thirteen of the etchings occupy a full page each; twelve were printed four to a page and there was a page with two more of the same, small size. Ten of the etchings were 'prese da i Luoghi' (taken from the places themselves) in the words of the title-page; the remainder were more or less imaginary views, the 'altre ideate' of the title-page, and the influence of the visit to the mainland is apparent in most of them.

The etchings are an almost incredible achievement for a man who had never practised the art in his life and who turned to it at a moment when his paintings had become mechanical and unimaginative. The imaginary towns (plates 84–85) beckon the beholder to enter them; heat and sunlight are portrayed with the etcher's needle almost as effectively as with the painter's brush (plate 86). No man could have had a greater tribute from the artist he had befriended for so long than Smith received in the dedication to him of these small masterpieces.

On 23 April 1745 the Campanile was struck by lightning and scaffolding was erected to carry a cradle from which men could repair the damage. Smith was immediately ready with another commission and Canaletto drew the scene for him in pen and wash (plate 90). But his days in Venice were drawing to a close. Nothing is recorded of his activities during the following twelve months and it can be concluded they were few and unprofitable. His father had died the previous

year; there had been family quarrels over property they owned in the S. Lio district where Canaletto lived. It was a bad period in every way.

Francesco Algarotti was in Venice at the time, buying works of art for the King of Saxony, and one of Canaletto's greatest disappointments must have been to be virtually ignored by this important figure in the world of art patronage. Algarotti did own a capriccio of a Palladian bridge similar to Smith's overdoor but he is generally thought to have bought this after Canaletto's return to Venice ten years later. There was no question of his replacing Smith as Canaletto's patron at a time when Smith's appointment as Consul had made it impossible for him to be as active in affairs as in the past.

In the circumstances it was far from surprising that Canaletto's thoughts, doubtless encouraged by Smith, turned to England. He also received encouragement from Jacopo Amigoni, a Neapolitan resident in Venice, who had spent ten years in England where, after turning from history- to portrait-painting he met with considerable financial success. Canaletto had the advantage over Amigoni of already having numerous well-satisfied English patrons who might well be interested in portraits of their magnificent houses or of the city in which they also spent much time. Owen McSwiney, who had given him his first commissions for English patrons, had returned to England in the 1730s and Smith himself could be relied upon for introductions.

It was later said by George Vertue, an engraver and collector whose generally reliable 'notebooks' are an important source for the art gossip of London, that Canaletto 'Had made himself easy in his fortune and had brought the most part to putt into Stocks here for better security, or for better interest than abroad'. This sounds like the Canaletto of old talking in the hope of making himself sound important. Whatever he may have wanted his patrons to think, Canaletto left Venice because there was not enough work for him there and he believed he would find more in the country in which he was already well known.

In 1746 the invaluable Vertue recorded:

Latter end of May, came to London from Venice the Famous Painter of Views Cannalletti of Venice the multitude of his works done abroad for English noblemen and Gentlemen has procured great reputation & his great merrit and excellence in that way, he is much esteemed and no doubt but what his Views and works he doth here will give the same satisfaction—tho' many persons already have so many of his paintings.

The sting was in the tail and no one was more aware of the situation than Smith. He had already made sure that everyone he knew likely to buy a Canaletto had as many as they had money, wall-space and wish for. Canaletto would have to find a new market and where better to start than with the Duke of Richmond, the first of his English patrons, who owned but two of his pictures and those two painted

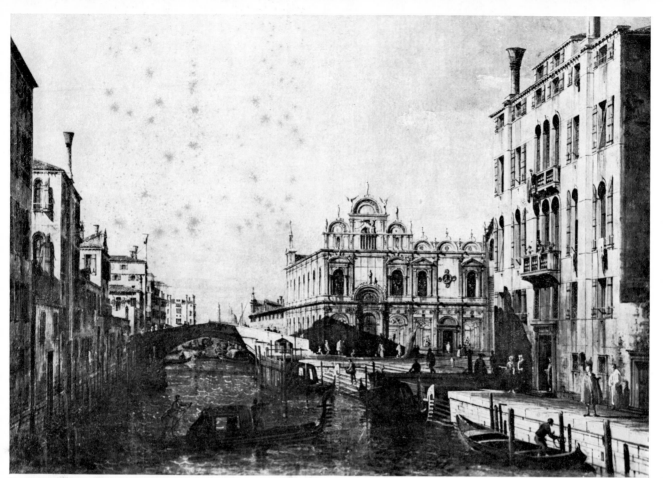

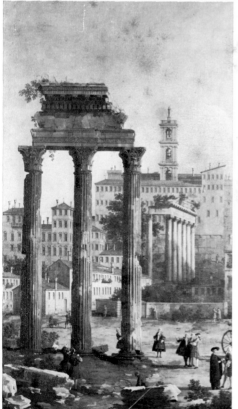

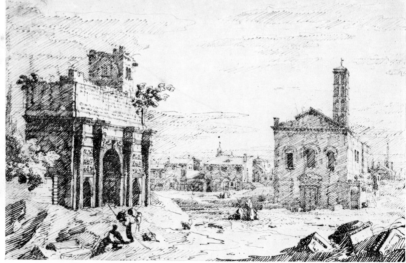

72 (*top*) *Rio dei Mendicanti and the Scuola di S. Marco.* 39 × 69cm

73 (*left*) *Ruins of the Forum, looking towards the Capitol.* 188 × 104cm

74 (*above right*) *The Arch of Septimius Severus and the Church of S. Adriano.*
9 × 15cm

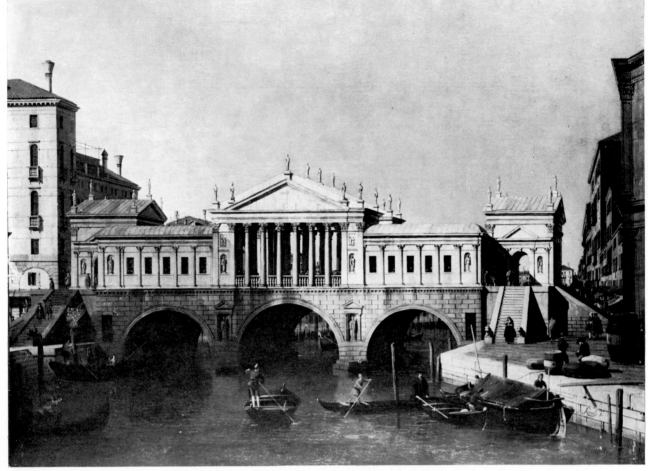

75 *Capriccio: a Palladian design for the Rialto Bridge.* 90 × 130cm

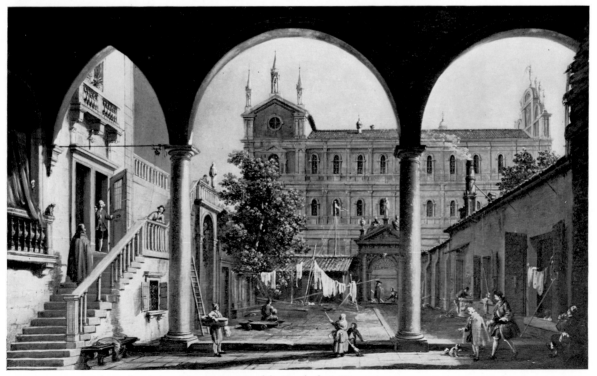

76 *Capriccio: with reminiscences of the Scuola di S. Marco.* 47 × 77cm

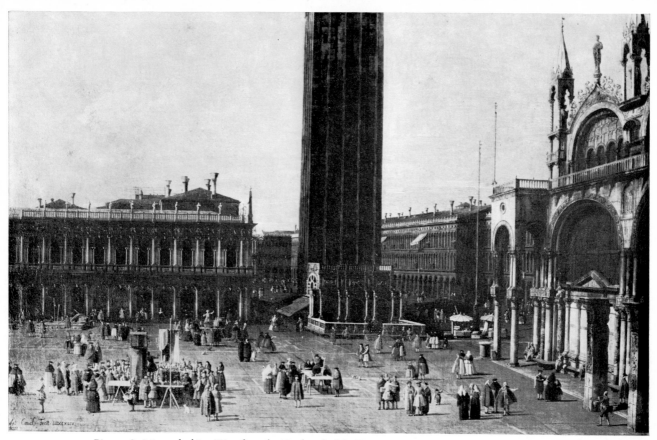

77 *Piazza S. Marco: looking West from the North end of the Piazzetta.* 77 × 120cm

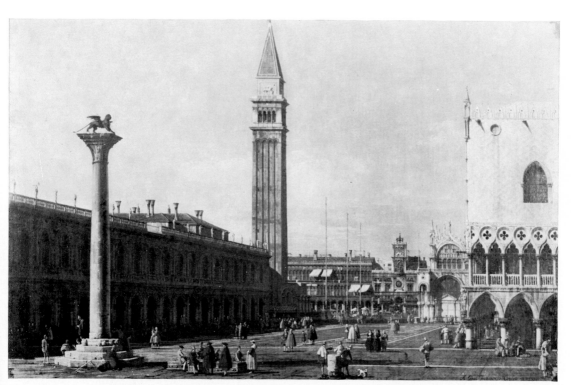

78 *The Piazza: looking North.* 58 × 94cm

79 *S. Maria Zobenigo.* 47 × 78cm

80 *The Piazzetta: looking West, with the Library.* 147 × 77cm

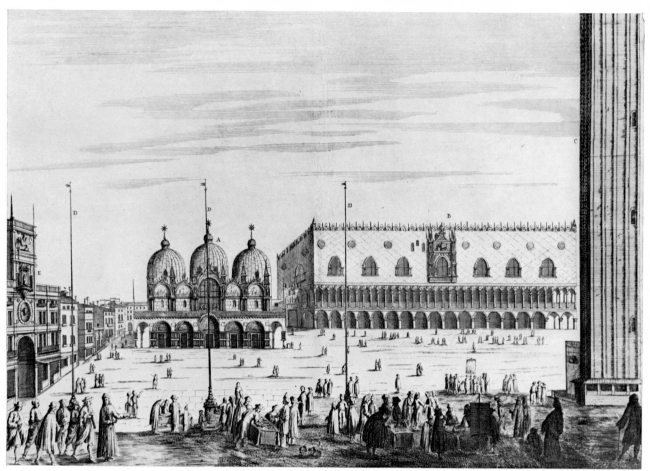

81 Filippo Vasconi, *The Piazza and the Piazzetta*.

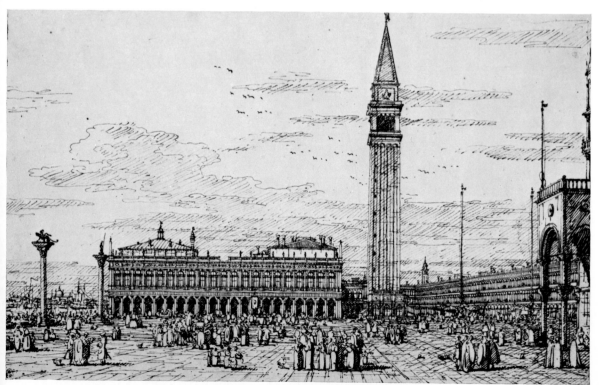

82 *The Piazzetta: looking West, with the Library and Campanile.* 23 × 37cm

83 Title-page of *Vedute da Antonio Canal.*

84 *Imaginary view of Venice.*

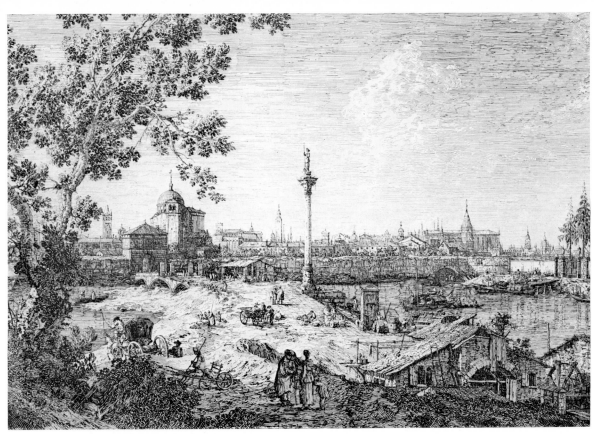

85 *Imaginary view of Padua.*

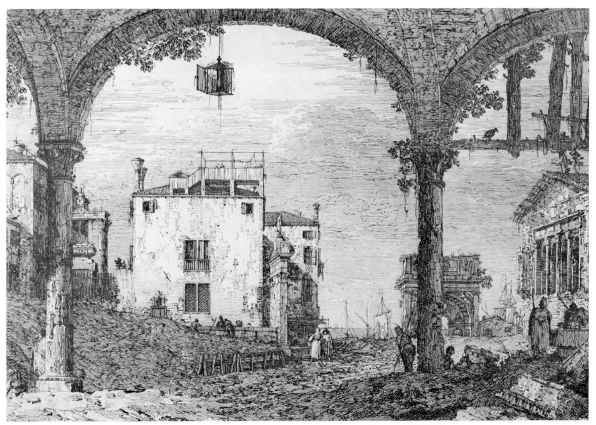

86 *The Portico with a lantern.*

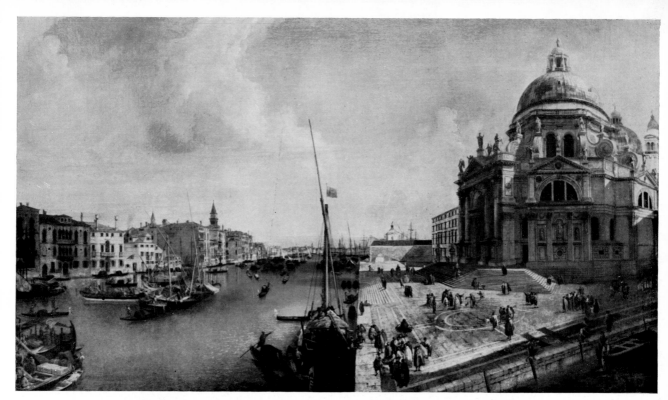

87 Attributed to Marieschi, *Entrance to the Grand Canal: looking East.* 124 × 213cm

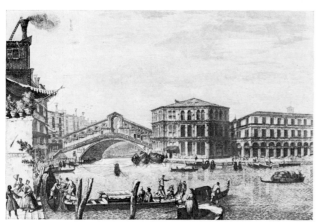 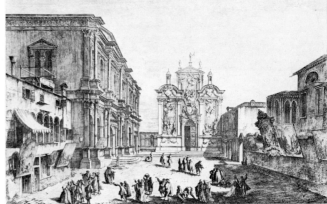

88 (*left*) Michele Marieschi, *The Rialto Bridge from the North.*

89 (*right*) Michele Marieschi, *Campo di S. Rocco.*

90 (*opposite*) *The Piazzetta: looking North, the Campanile under repair.* 42 × 29cm

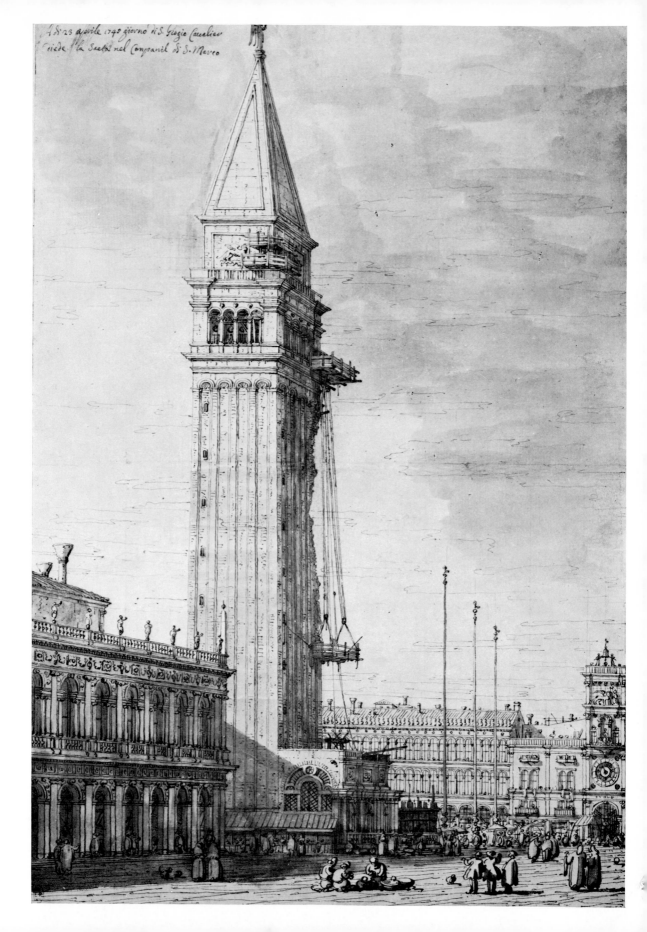

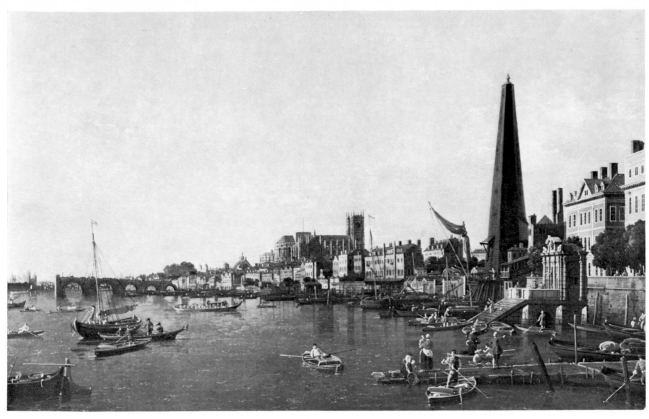

91 *London: the Thames, looking towards Westminster from near York Water Gate.* 48 × 81cm

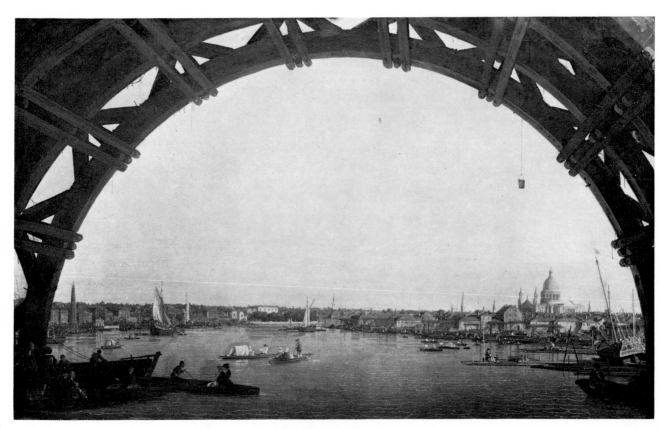

92 *London: seen through an arch of Westminster Bridge.* 57 × 95cm

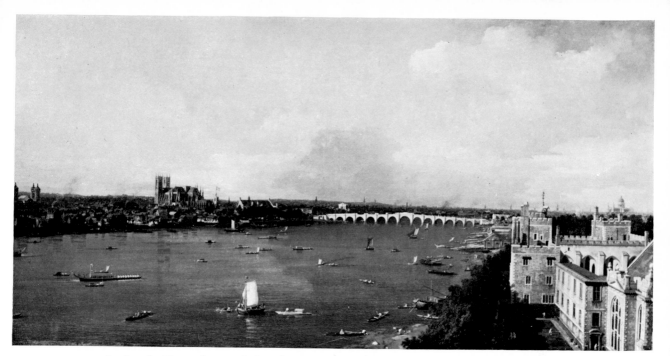

93 *London: the Thames from Lambeth, with Westminster Bridge.* 188 × 238cm

94 Detail of plate 93

95 Detail of plate 93

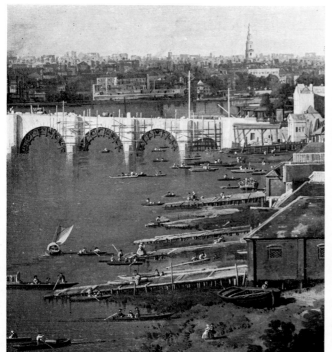

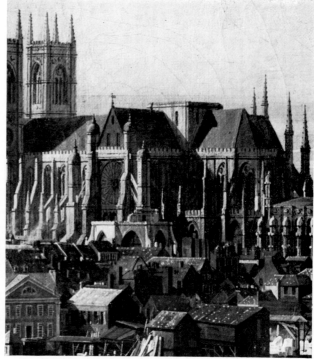

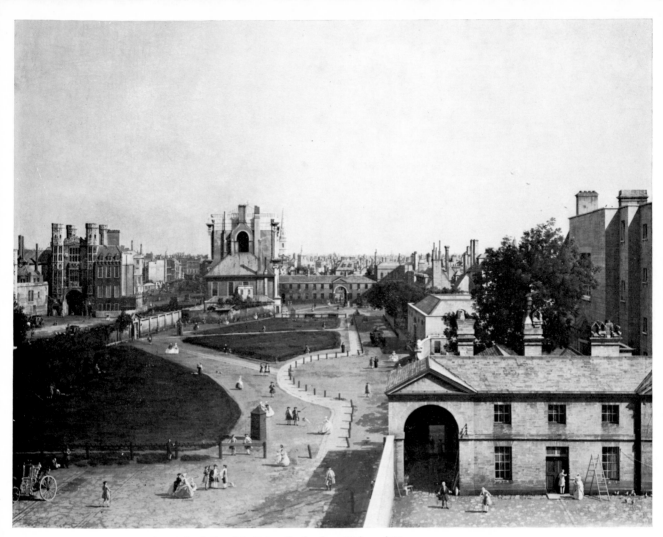

96 *London: Whitehall and the Privy Garden from Richmond House.* 109 × 119cm

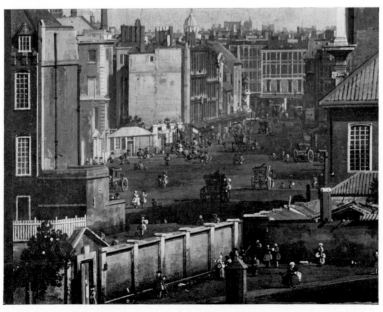

97 Detail of plate 96

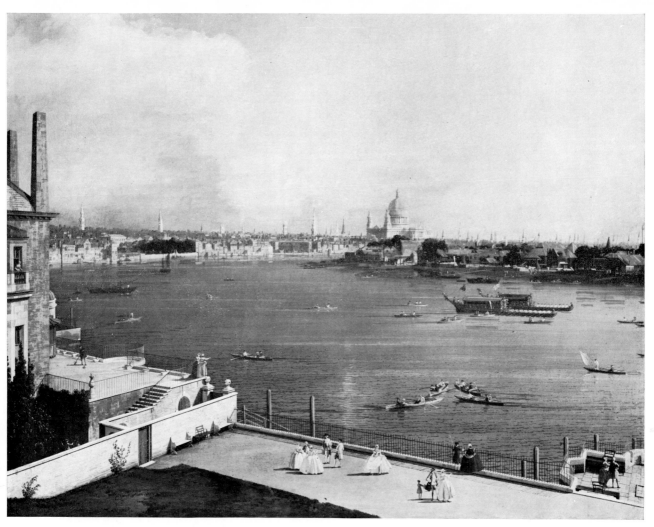

98 *London: the Thames and the City of London from Richmond House.* 105 × 117cm

99 Detail of plate 98

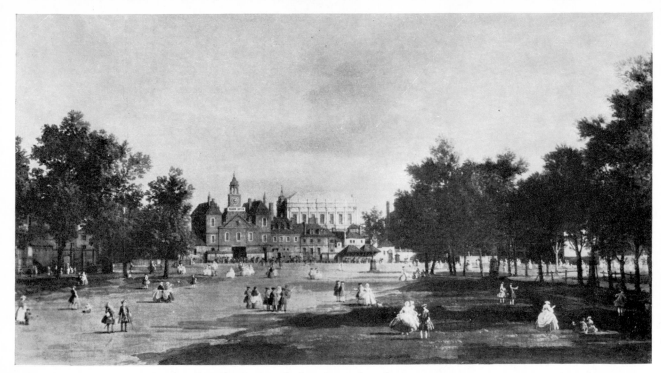

100 *London: the Old Horse Guards, from St James's Park.* 122 × 249cm

101 *London: the Thames from the terrace of Somerset House, the City in the distance.* 105 × 186cm

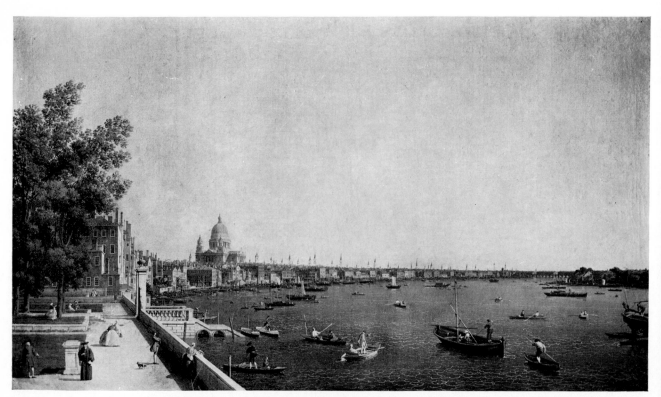

102 (*opposite*) Visentini after Canaletto, Detail of the *Grand Canal: looking North from near the Rialto Bridge.*

103 (*opposite*) Detail of the *Grand Canal: looking North from near the Rialto Bridge.*

104 (*opposite*) *Grand Canal: looking South-East from the Campo S. Sofia to the Rialto Bridge.* 119 × 185cm

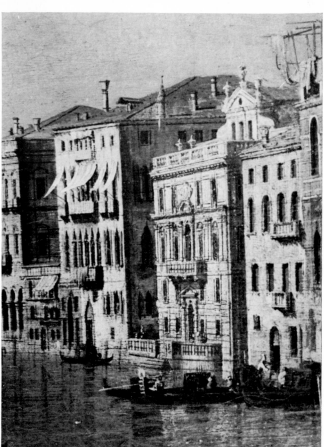
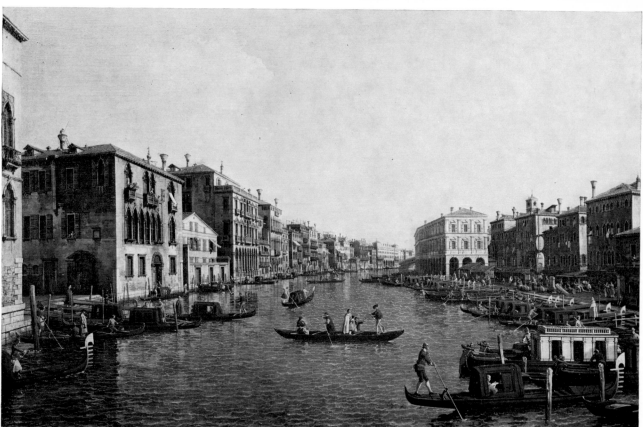

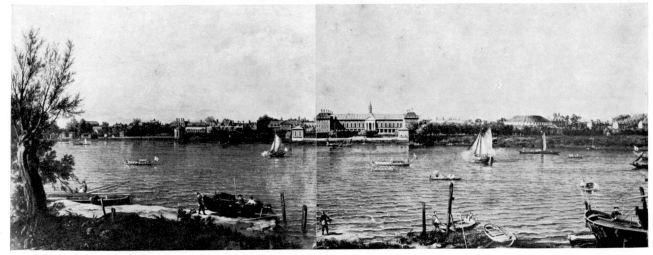

105 *London: Chelsea College with Ranelagh House and the Rotunda.* 90 × 200cm

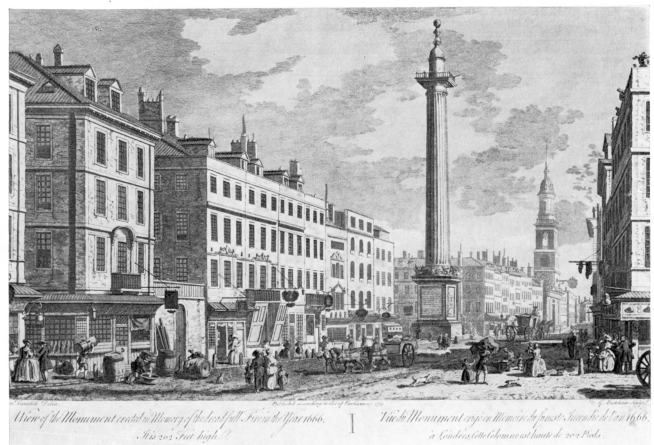

106 G. Bickham after Canaletto, *London: the Monument.*

almost twenty years earlier? However, the Duke had never been a Smith client (perhaps that was why he had so few Canalettos) so no direct approach was poss- ible. Smith therefore wrote to Owen McSwiney who had negotiated the sale of the original two paintings in Venice and had been back in London since the early 1730s, his earlier misfortunes well behind him. He in turn chose as intermediary Thomas Hill, the Duke's former tutor and now, apparently, on closer terms with him than McSwiney was. On 20 May 1746, surprisingly soon if Vertue's date for Canaletto's arrival was correct, Hill wrote to the Duke:

The only news I know to send you, is what I had this day from Swiney at the Duke of Montagu's, where we dined, & he, I think got almost drunk. Canales, alias Canaletti, is come over with a letter of recommendation from our old acquaintance the Consul of Venice to Mac in order to his introduction to your Grace, as a patron of the politer parts [arts?] or what the Italians understand by the name of *virtu*. I told him the best service I thought you could do him w^d be to let him draw a view of the river from y^r dining-room, which in my opinion would give him as much reputation as any of his Venetian prospects.

The Duke was presumably out of London at the time or would have called rather than written (the Duke of Montagu's house, where he had dined, was next door) so there was no immediate response. Instead, Canaletto set to work on his own drawings of the neighbourhood of these two houses and evidently managed to ensure that his activities were known because within a few months Vertue was writing another entry about him. It was in this that Vertue referred to Canaletto having already made himself easy in his fortune but he began by recording that 'Signor Cannelletti a Venetian painter of Views came to London—as he had done at Venice many nay multitudes of painting for English Noble and Gentlemen and great numbers bought by dealers & sold here gave him a desire to come to England . . .'

The reference to dealers having bought great numbers of Canaletto's paintings is interesting since there is no record of any of his work having gone through dealers' hands. One suspects the dealers had had no difficulty in meeting the demand for Canalettos without having to turn to the notoriously expensive artist himself and this is confirmed by a note made many years later by Edward Dayes. Dayes, a water-colour painter who was not born until 1763 so that he could only be repeating stories he had heard, wrote that 'the picture dealing tribe . . . hoped to drive him [Canaletto] from the country, and thereby to prevent him detecting the copies they had made from his works, which were in great repute'.

Vertue went on to note that Caneletto had come on the recommendation of Amigoni who had 'acquainted him with his Success here and also of the prospects he might make of Views on the Thames at London—of them he has begun some Views'.

If Canaletto's visit to England was a failure—and on the whole, it was—the

6—C • •

blame cannot be laid to bad timing. The demand which his work in Venice had built up, with Smith's help, was still there, or the dealers would not have employed hack copyists, and there was no competition. The Dutch artists who had introduced townscape painting to England in the seventeenth century had died out and no English had taken their place. Hogarth was not really a topographical artist. Paul Sandby's career had hardly begun. Samuel Scott was a marine artist who was only toying with topography at this time (if, indeed, he had begun: no one knows when Scott's gifts in this direction developed to the stage when he rivalled Canaletto himself).

Nor was there any shortage of subject. The Thames was even more the main thoroughfare of London than was the Grand Canal of Venice and, although the decorated barges did not rival the Bucintoro, they provided some colour, at any rate on Lord Mayor's Day. And the interest of the day centred on the completion of Westminster Bridge after centuries of obstruction by the watermen and publicans, supported by the City Corporation. It must have surprised Canaletto, who had seen four 200-year-old bridges in Rome and Verona that London's second bridge had only just been completed. It was not even yet carrying traffic although the architect, a Swiss named Charles Labelye, recorded that it was complete and capable of doing so by 20 July 1746. There was still stonework to be finished and the centrings of the arches to be removed but by 25 July 1747 all this work was done. However, a month or so earlier a 'gentle settlement' had been observed and, instead of the bridge being opened, some of the stonework had to be dismantled. Labelye noted that this was 'heartily rejoiced at by the Watermen, Ferrymen etc.' the 'etc.' no doubt being a reference to the English architects who had been vigorously criticizing Labelye's methods at every step. It was not until 18 November 1750 that the bridge was eventually opened to traffic.

As foreseen by Vertue, Canaletto concentrated for his first London work on the Thames and particularly on the area around the new bridge (plate 91). There was evidently a demand for views of the bridge in the course of being built and as he was too late to have seen this himself he appears to have used drawings, engravings or perhaps just descriptions of others. Any attempts to place these drawings and paintings in chronological sequence is therefore immediately frustrated. What is of greater interest is that one of the paintings, *London: seen through an arch of Westminster Bridge* (plate 92), was commissioned by Sir Hugh Smithson and that an engraving of it showing Sir Hugh as the owner was published as early as 1747. Canaletto had evidently begun with a great coup.

Sir Hugh Smithson's advancement was unusual even for the English nobility of the eighteenth century. A Yorkshire squire with no prospects, he had in 1741 married Elizabeth Seymour whose grandmother (twice widowed before she was seventeen) had been a Percy. There had long been a determination that the name of England's most illustrious medieval family should not be allowed to die

out, regardless of the lack of male heirs, and Lady Smithson's brother was in line to inherit, not only the Dukedom of Somerset through their grandfather, but the six oldest baronies in the kingdom, including that of Percy, through their grandmother, together with the four Percy seats, Northumberland House, London, Syon and Petworth Houses and Alnwick Castle. With the death of this brother in 1744 at the age of nineteen Sir Hugh Smithson's prospects had changed spectacularly. His wife was now heir to all the Percy fortunes and, following precedent, he would himself expect to become a Percy in due course. In the event this and more occurred. Before Canaletto left England a way had been found to enable Sir Hugh to inherit from his father-in-law the Earldom of Northumberland (although he had not even married a Percy, but a Seymour) and he was created, as a result of bullying the King, it was said, the first Duke of Northumberland. He had naturally changed his name to Percy so that the present Duke still bears the name which was already an ancient one when it was borne by his ancestor Sir Harry Hotspur.

Except for Sir Hugh Smithson's commission, nothing is known of the original buyers of the two dozen drawings and paintings by Canaletto which have survived and which show Westminster Bridge in various stages. If, as is probable, they were all done in the first year things must have been going well for Canaletto. He may even have landed a distinguished foreign tourist, as had been a matter of course ten or fifteen years earlier in Venice. Certainly Prince Lobkovice bought a pair of large Thames pictures (plates 93–95), now in Prague, but they cannot be traced back earlier than 1752; if the state of the bridge can be relied upon they were among the very earliest commissions.

Some time during this busy first year the Duke of Richmond must have responded to Tom Hill's recommendation that he should allow Canaletto into his dining-room. The Duke was now forty-five years old and had settled down to an uneventful family life, much involved with horses; he was generally well regarded and very different from that 'grotesque old rake', his father. He had but three more years to live.

Canaletto was now about to embark on the two masterpieces of his English visit and after making some preliminary drawings, two of which have survived, he began to paint, very probably with his easel set up in the house itself, the scenes before his eyes. Almost everyone knows *The Thames and the City of London from Richmond House* (plates 98–99) and *Whitehall and the Privy Garden, looking North* (plates 96–97) either from reproductions or in original. Few can ever see London again with quite the same eyes, or at any rate pass down Whitehall or the Embankment without remembering their luminous, pale colouring, their soft clouds or their sense of the charm and disorder of eighteenth-century London. A detail of the background of the Whitehall picture shows the statue of Charles I,

the Duke's great grandfather, where it stands today and a minute study of London life expressed in the twirls and blobs of which Canaletto had now become a master. In the Thames picture we can see St Paul's and the panorama of Wren's steeples in the background and the Duke's garden, with its owner using a stick, in the foreground. There is a State Barge on the river but the Duke must have had a moment of doubt when he compared the mannerism of its oarsmen to the festival pictures he must have seen or, indeed, to the figures in his own paintings of eighteen years earlier. Canaletto had learnt much since the days of the Duke's copper-plates, not all of it to the good.

There was to be at least another year during which it must have seemed to Canaletto that he had made the right decision in coming to England. Sir Hugh Smithson commissioned a picture of Windsor Castle; the Duke of Beaufort had a view of his house at Badminton, Gloucestershire, with another done from its terrace, and it would probably have been at the same time that Canaletto painted the four pictures for the Earl of Warwick of his castle in the adjoining county. Vertue recorded many of the commissions in his entry of June 1749 but he ended on an ominous note.

On the whole of him something is obscure or strange, he does not produce works so well done as those of Venice or other parts of Italy. which are in Collections here. [one cannot help wondering what works of 'other parts of Italy' were then in English collections] and done by him there. especially his figures in his works done here, are apparently much inferior to those done abroad. which are surprisingly well done & with great freedom & variety—his water and his skies at no time excellent or with natural freedom. & what he has done here his prospects of Trees woods or handling or pencilling of that part not various nor so skillful as might be expected. above all he is remarkable for reservedness and shyness in being seen at work, at any Time, or anywhere. which has much strengthened a conjecture that he is not the veritable Canaletti of Venice. whose works there have been bought at great prices. or that privately, he has some unknown assistant in makeing or filling up his peices of works with figures.

Evidently the great patrons had had their requirements met, the novelty of Canaletto's presence in England had worn off and the lesser patrons were not placing the orders expected of them. The whispering campaign set on foot by the dealers must also have had its effects. Above all, there was some substance in the charge that the work of the 'veritable Canaletti' of Venice had deteriorated; what the English apparently did not realize was that it had been deteriorating for years and that most of the pictures in England as a result of Smith's efforts marked the decline in varying degrees. It must have puzzled Canaletto that the kind of work so much in demand by the English in Venice during the 1730s was now being criticized, particularly after the unquestionable success of the Duke of Richmond's commission. He could hardly change his style at this stage but he could scotch the rumour of an imposter being at work and this he did by the unusual step of placing an advertisement in a London newspaper. 'Signor Canaleto', he an-

nounced, 'hereby invites any gentleman that will be pleased to come to his House, to see a picture done by him, being *A View of St James's Park*, which he hopes may in some Measure deserve their Approbation.' The picture would be on view in the house where he had his studio, belonging to a cabinet-maker in Silver Street, Golden Square (now Beak Street, where Canaletto's stay is marked by a plaque and where until recently there were the remains of a studio). The painting was probably *The Old Horse Guards from St James's Park* (plate 100) which must have been painted in or before 1749 when the building was demolished. If so, it was bought by Lord Radnor and later given by him to an ancestor of the Earl of Malmesbury, who still owns it, but there is no way of knowing whether Lord Radnor bought it following a visit to Silver Street or later on.

Vertue recorded Canaletto's advertisement verbatim in his diary and accounted for it by saying 'it may be supposed that his shyness of showing his works doing—or done. he has been told of—and therefore probably, he put this advertisement in the publick news papers'. He then explained that he now understood 'how this difficulty was spread about, that this Man was not the person so famd in Italy at Venice' and described the relationship between Canaletto and his nephew. He continued:

This young stripling by degrees came forward in his Proffession being taken notice of for his improvements he was called Cannaletti the young but in time getting some degree of merrit he being puffed up disobliged his uncle who turned him adrift. but well Imitating his uncles manner of painting became reputed and the name of Cannaletti was indifferently used by both uncle and nephew—from thence the uncle came to England and left the nephew at Venice so that this caused the report of two Cannelettis which was in this manner.

This may all have been true but Vertue said nothing of the source of his information. Bellotto was in fact using the name of Canaletto but, as has already been seen, he had been doing so for some time, apparently with full approval from his uncle. If it was true that he had been 'turned adrift' by Canaletto it seems strange that the story was told in London but never recorded by anyone in Venice. In the absence of any confirmation it must be regarded as pure gossip. In any case, the existence of another Canaletto somewhere else did nothing to explain the alleged inferiority of the work of the 'veritable' Canaletto in England.

Commissions generally may have fallen off but Sir Hugh Smithson remained loyal to Canaletto. He had already inherited the Percy house at Syon, just outside London, and on 2 July he wrote to his mother-in-law that he had commissioned Canaletto to paint it. He added, 'By the outlines upon the Canvass I think it will have a noble effect and he seems himself to be much pleas'd with the subject which I should think will suit his manner of painting perfectly well'. It was a dull house but a commission from Sir Hugh, who within a year was to become Earl of Northumberland, was not to be turned down lightly. Canaletto's advertisement

may have brought other work but nothing can be attributed with confidence to the months that followed its appearance and 1750 must have been a lean year.

Some time between September and November of that year Canaletto returned to Venice. Why did he go? How did he go? What did he do there? Did he intend to stay or to return to England? There are no firm answers. There seems to have been little enough work for him in England and he must have hoped for more in Venice; the war was over and the visitors could be expected to return. There is no evidence of any commission important enough to justify such a journey.

It was a formidable undertaking for any but the very rich or influential. Tobias Smollet some years later found the coaches uncomfortable, the roads bad and the inns appalling; the only two innkeepers he came across who were not idle and dissipated were demented. If Canaletto went overland it could not have taken him less than three weeks each way—three generations later it was noted that Trajan and Sir Robert Peel, travelling as fast as they could between Rome and London, took the same time. The journey would have cost him as much as he would have received for an important picture. He might have gone by sea to Genoa or Leghorn and then overland; this would no doubt have been the cheapest way and one could sail to Leghorn in two to three weeks if the winds were favourable. Even so, the journey across northern Italy was a considerable one and it must be rare indeed for an artist to travel so far twice and leave no record whatever of what he saw on the way.

There was a little business for him to do. He invested 2,150 ducats, about £360 sterling, in a building on the Zattere which belonged to the Scuola dei Luganegheri (the provision merchants' guild) and they leased part of the building back from him. The contract records that Canaletto was personally present at the signing and that, should he die intestate, the value of the property should go to two of his sisters. This, in the event, was what occurred on his death and the building was all he left except for 283 ducats in cash and his modest personal effects.

It could be argued that he went back to Venice to take with him his English earnings for investment but it does not seem very likely that almost his entire capital on death had been earned in three years of work in England and that he had no savings from his years of success in Venice. More probably the 2,150 ducats was the amount he had available for investment, including anything he was able to spare from his English earnings. It was not a lot for a successful artist who impressed so many of those he met as a man who thought a great deal about money.

While Canaletto was in Venice, P. A. Orlandi was preparing a dictionary of painters which was published in 1753. Under Canaletto's name he recorded that he had returned to Venice after a stay in London, adding that he had taken with him 'various sketches of the most noteworthy views and sites of that spacious city

which, it is to be hoped, he will at his leisure transfer to canvas'. Orlandi concluded the entry with the words 'Now he has again returned to London' so he evidently did not know whether the hope was realized.

Smith sold with his collection to George III, as well as several drawings of London, two paintings from the terrace of Somerset House, one looking down the river (plate 101) and one up, and there is no reason why these should not have been painted from two of the drawings during the 1750–1 visit. They do not look as if they were painted after Canaletto's final return to Venice when his work became even more stylized than it had been in England, but they may have been finished in London and taken to Venice at Smith's request.

And it might well have been during this visit that Smith gave Canaletto one of his most intriguing commissions, small though it was. Smith had for long been employing Visentini to build a new façade for a palace he had bought on the Grand Canal, now known as the Mangilli Valmarana, which can be seen looking north from the Rialto Bridge. Marieschi showed the work already in hand before his death in 1743 but it was not finished until 1751 when the diarist Pietro Gradenigo recorded that it was to be seen for the first time. Visentini's engraving for *Prospectus Magni Canalis . . .* of Canaletto's *Grand Canal: looking North from the Rialto Bridge* (plate 102) shows the palace with its old Gothic façade, as would be expected since it was published in 1735, before Smith owned it. More unexpectedly, the 1742 edition and even a third edition published in 1751 showed the same façade, although no one knew better than Visentini what it would look like when finished. Moreover, he had made an alteration to another view for the second edition which was of much less personal concern to Smith: a statue and balcony had been erected on the quay at the entrance to the Cannaregio after the first edition had been published and Visentini altered his drawing (which still survives) and his engraving so as to show the new state of the quay in 1742. Nevertheless, Smith's own house still appeared in the book as it was before the alterations had been started.

Most unexpectedly of all, Canaletto's painting (plate 103) from which the engraving had been made shows the house in all its fresh, neo-classical glory. The old façade had been painted over and the new one, done with different paint and technique, added in its place. If this was done by Canaletto, and it has every appearance of being his doing, the year 1751 seems the most probable time for the execution of the characteristic commission from Smith. Why he allowed the engraving to remain unaltered is inexplicable.

The moment chosen for the publication of the third edition of the engravings also requires explanation although none presents itself. The second edition, with its twenty-four additional plates, must have sold out, even though few commissions for paintings based on it had followed. Did Smith write to Canaletto in England saying he was reprinting the book and that this might be a propitious

moment for the artist to return and take advantage of the publicity that would ensue? The publication and Canaletto's presence in Venice seem unlikely to have been purely coincidental.

No commissions seem to have resulted from the re-issue and if Canaletto expected to find more work in Venice than there had been in England he must have been sadly disappointed. It is just possible that a commission for four paintings, including two moonlight scenes, from a German resident in Venice named Sigismund Streit had been the cause of his return; one of them (plate 104) shows Smith's house with its new façade so they could not have been painted before Canaletto had left Venice. They might date from much later, though, and we can but guess the reason for Canaletto's long, double journey from London.

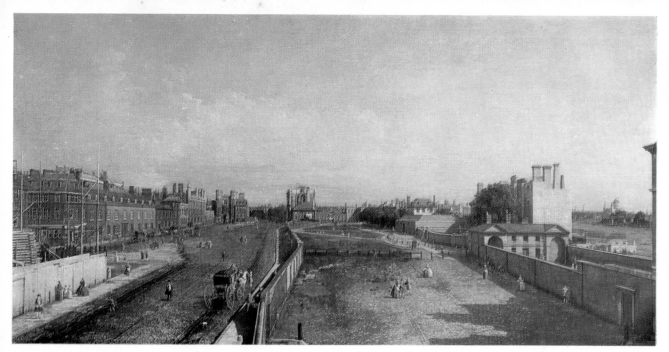

VIII *Whitehall and the Privy Garden looking North.* 118 × 273cm

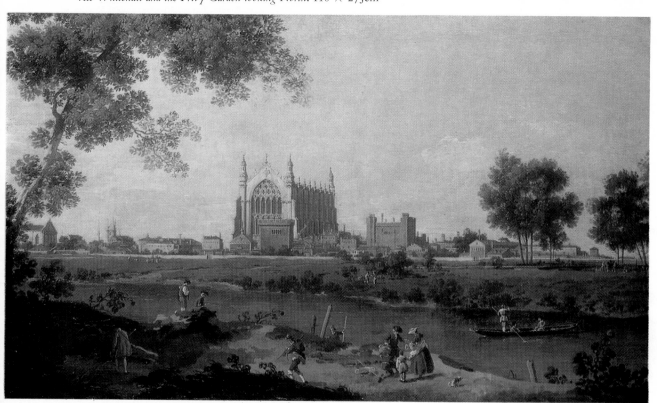

IX *Windsor: Eton College Chapel.* 61 × 107cm

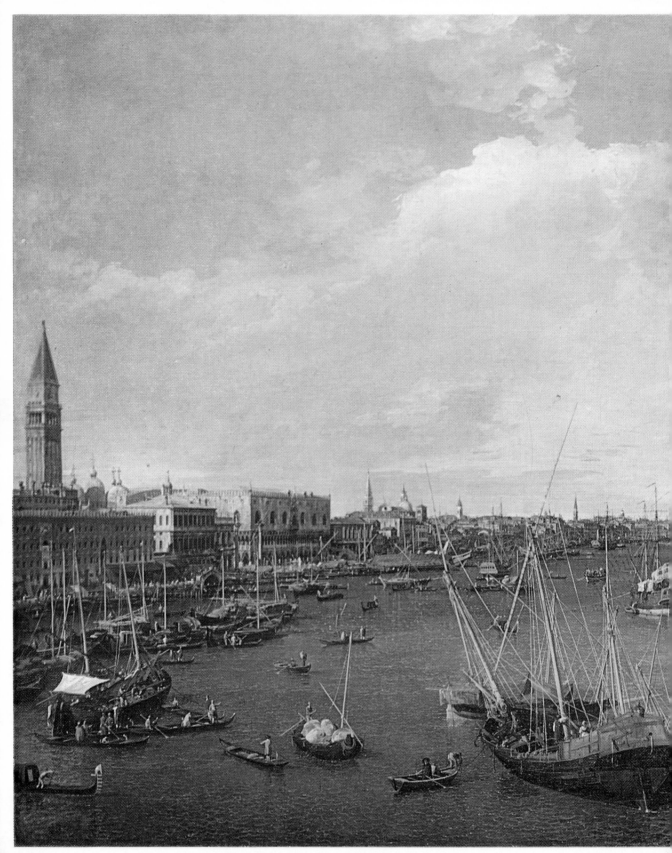

x *The Bacino di S. Marco: looking East.* 125 × 153cm

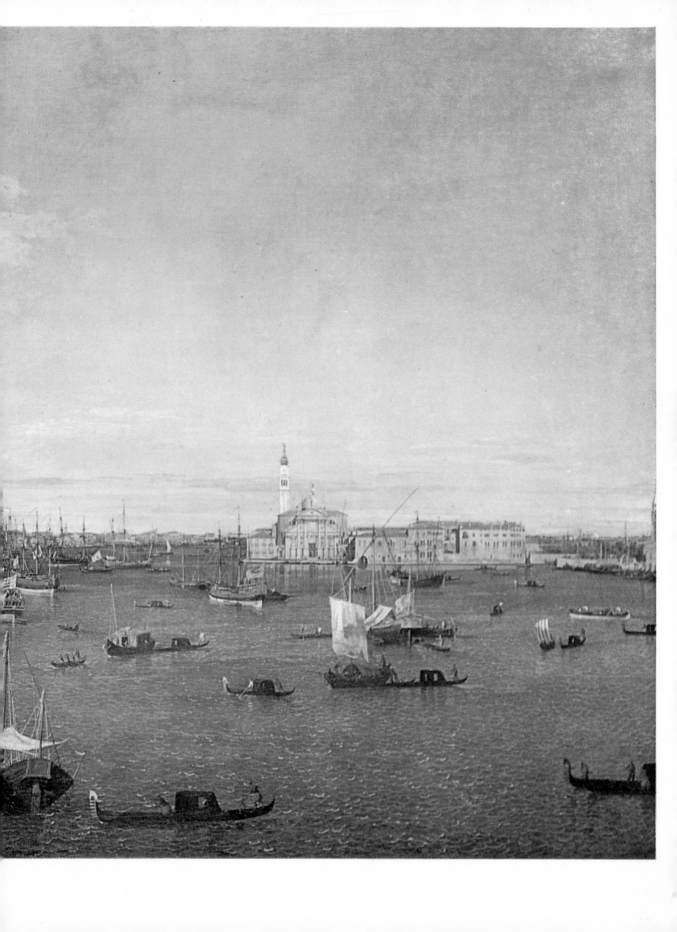

XI Francesco Guardi, *An architectural caprice*. 22 × 17cm

13

The last English patrons

'Now he has gone back to London'

Orlando in 1753

Whatever Canaletto's intentions may have been when he left England, he was back in the same lodgings in Silver Street by July 1751 and he announced his return by another advertisement in much the same terms as the first:

Signior **C A N A L L E T T O**
GIVES Notice, that he has painted the
Reprefentation of Chelfea-College, Ranelagh Houfe, and the
River Thames, which if any Gentlemen and others are pleas'd to favour
him with feeing the fame, he will attend at his Lodgings, at Mr. Vig-
gan's, in Silver-Street, Golden-Square, for fifteen Days from this
Day, the 31ft of July, from Eight o'Clock in the Morning to One in the
Afternoon, and from Three in the Afternoon to Six at Night, each Day.

Vertue duly recorded the advertisement, adding that the painting was valued as £60 or £70 and that Canaletto had 'made a Tour to his own country at Venice for some affairs there—in 8 months going and comeing'. This was Vertue's last reference to Canaletto and it ended on a sour note. *Chelsea College with Ranelagh House and the Rotunda* (plate 105) was thought to be 'not so well as some works of Canaletti formerly brought into England nor does it appear to be better than some painters in England can do'. The picture is no masterpiece but the only painter in England at the time who could possibly have done as well was Samuel Scott and for a long time his name was associated with it—or, rather, with part of it for it had a curious history. Whether the painting was sold from Silver Street or later is not known but at some time it was cut in two and the right-hand part appeared in a sale at Christie's in 1802 as by Canaletto; it later had various owners and ended by being appropriated by the Government of Cuba. The left-hand part first appeared in public in an exhibition in 1955 as by Samuel Scott and not until then was it recognized as being part of the original painting. Since this had been considerably more than two metres wide and only a metre high it is not altogether surprising that the early owner found it an awkward shape and cut it in two. Neither the shape nor the subject seem the best possible choice for a picture

painted in the hope of finding a buyer but the artist may have been stung by the earlier criticism of his representation of water and determined to show that he did not always rely on a monotonous series of wavy lines.

With *Whitehall and the Privy Garden looking North* (plates VIII and 107–8) Canaletto showed the extraordinary variation of quality that can be found in his work of the same period. It is much the same shape and size as the Chelsea picture yet the coarseness of touch has disappeared. His imagination must have been captured by the technical problems of designing a picture with a long wall receding almost just below his viewpoint. This viewpoint is well to the left of the Richmond pair (plates 96–98) farther back and lower down (the corner of Richmond House can be seen on the extreme right); there can be no doubt it was from a window of Lord Loudoun's house which was next to the Duke of Richmond's. Nor can there be any doubt that the picture was painted in the summer of 1751 or at the latest 1752; this has been demonstrated by records of the building work in connection with the construction of Parliament Street. This fine painting was said to have been bought in Venice in 1760 from Canaletto himself who had wished to keep it as a memento of his visit but the story was not told until a hundred years later and does not ring true. Against this, there is no other evidence as to who did buy the picture from Canaletto.

Some time in the following year, 1752, Sir Hugh Smithson, now the Earl of Northumberland, appeared yet again with a commission. Northumberland House at Charing Cross had just been altered and Canaletto was called in to paint it (plates 109–10). It looked out on to a scene which warmed the artist's heart. He had shown it in the far distance in the Duke of Richmond's *Whitehall* but now the blobs became figures, albeit rather stiff ones, and every detail is shown of the Mews Coffee House, Cannon's eating house, the Widow Bagnall's saddler's shop, the trunkmakers, the wax chandler, the jeweller, the hosier—all have been identified by those who delight in the topography of London.

It may have been at this time that the new Earl sent Canaletto off to Northumberland to paint his (or rather his wife's) medieval castle at Alnwick. Alnwick is a long way from London, though, at least nine days' journey each way, and there was only one painting and a replica. It seems more probable that an engraving or drawing was supplied—and it may also have been lent to Samuel Scott whose copy (either of Canaletto's painting or of the engraving) is dated 1752.

Apart from Northumberland House and the Whitehall paintings there were no street scenes of London on a par with the pictures of Venetian *campi*. Canaletto, or his patrons, preferred river scenes and their country houses. One other exception was a view down Fish Street Hill, one of London's busiest streets at the time since it led across London Bridge (later rebuilt farther west). Neither painting, if there ever was one, nor drawing is now known to exist but there was an engraving

inscribed 'Signʳ Canaleti Delin' which was published in 1752 (plate 106). It shows *The Monument* (to the Great Fire of 1666) and the church of St Magnus the Martyr which stands at the point where London Bridge began. Like most engravings after Canaletto's work, this was copied as early as 1759 and the copy was signed 'W. James'. This had a ludicrous result. The value of a painting is always increased by the attachment of a name, however little is known of the artist named, instead of the word 'school'. The name 'William James' is recorded as that of an exhibitor of pictures in London between 1761 and 1771 but no identifiable work of his has survived. The existence of the name James on the copy of the engraving has led in recent years to the creation of an artist, said to have been a pupil of Canaletto, whose works appear in sale rooms and galleries in ever increasing numbers. The attachment of the name to some pictures in the Royal collection many years ago gave it respectability and the denial by later cataloguers of any justification for the attribution has done nothing to dim it as that of an artist whose works can be identified and attributed just as if he was a known figure in the eighteenth-century art world.

The Monument is but one of several engravings after Canaletto's work which were published in London between 1751 and 1753. Except for an engraving after the Earl of Northumberland's painting of his newly-furbished house at Charing Cross these give Canaletto credit only for a drawing, the implication being that he was now working for engravers' publishers in the absence of commissions for paintings. After the initial impetus of his return from Venice the years 1752–3 seem to have been as lean as 1750.

On 28 July 1753 Pietro Gradenigo made his first reference to Canaletto. 'Antonio Canaletto,' he recorded, 'the celebrated Venetian painter of views returned from England to his native city.' It is a most perplexing entry. Gradenigo had begun his diary, at the age of fifty-three, in 1748 but he had made no reference to the artist's visit of 1750–1, when Canaletto had been in Venice for some six months. All contemporary writers on Canaletto refer to his stay in England being interrupted by a visit to Venice: none mentions two visits. There is confirmation of his presence in Venice in March 1751 when he signed a contract to buy the building on the Zattere but no record of anything he did there in 1753, either professionally or to do with his business affairs.

It has been suggested that Canaletto left London for good in 1753 and that Gradenigo was recording the end of his English period. However, he was certainly inscribing pictures in his own hand with the words 'Done in the year 1754 [or 1755] in London' and these were direct commissions from patrons who would not have allowed such inscriptions had the pictures been painted in Venice. If, therefore, he was in Venice in 1753 he undoubtedly returned to London in 1754.

A contemporary reference by a normally reliable writer cannot be ignored and

a second visit to Venice in 1753 has become part of Canaletto's life as recorded by all his modern biographers. It would be wrong, though, to dismiss the possibility that Gradenigo was referring to the earlier visit to Venice. The alternative is to accept the fact that Canaletto made a second arduous return journey within two years of going back to London, that Gradenigo did not know of, or did not think it worth recording, when he left Venice in 1753, and that neither the artist himself nor any of his patrons or friends left any trace of what he did in Venice while he was there.

Although the work Canaletto did in England in 1753–4 is, for him, unusually well documented, there is not a great deal of it. The principal commission, and one which might conceivably have taken him back to London *if* he went to Venice in 1753 and if he had intended to stay there permanently, was for six paintings for Thomas Hollis. Hollis was at the time a rich, eccentric and highly ascetic recluse of thirty-four with radical sympathies who had recently returned from some years travelling on the Continent. He had met Consul Smith in Venice but not Canaletto, to whom Smith probably gave him an introduction for use on his return to England.

Hollis received a mixed bag of paintings. *Ranelagh, interior of the Rotunda* was based on an engraving which had been published three years earlier and *St Paul's Cathedral* (plate 3) probably on another. A picture of Rome was based on an engraving not even by Canaletto and one of Westminster showed the bridge being built, which he had never seen. But among the six was the delicious *Old Walton Bridge* (plate 112) which has become one of Canaletto's most-loved pictures. It showed the wooden bridge as it had been in 1750, just after being built and was possibly also commissioned from a drawing. On the back of most of the paintings, according to labels added much later when they were relined, was an inscription reading 'made in the year 1754 in London for the first and last time with the greatest possible attention at the instance of Cavalier Hollis, my most esteemed patron—Antonio del Canal detto [called] il Canaletto'.

Canaletto must have read his undertaking not to repeat Hollis's *Old Walton Bridge* loosely, if not cynically. A year later he painted another picture of it for Samuel Dicker, a Member of Parliament whose house is shown among the trees in both paintings and who had paid for the building of the bridge. Later he made a drawing for an engraving of his picture and this he inscribed 'Drawn after my picture painted in London 1755 for Cavaliere Dickers'.

Hollis's six paintings and Dicker's one, with its related drawing, are not the sole evidence of Canaletto's presence in England in 1754–5. There was a commission for six paintings which descended to the Earls of Lovelace from a member of a family named King (which one is uncertain). One of these is signed and dated

AC 1754. The group vary in size but they are very similar in style and may well have been painted as decorations for a room. If one was painted in England it may be assumed that all were and the presence of Eton College Chapel in the dated picture makes it very improbable that that was painted anywhere but in England.

They must have formed a delightful group before they were dispersed in 1937. In the case of a pair of upright pictures particularly (plates 113–114) Canaletto seems to have included everything that gave him most pleasure, whether in England, Rome or Venice. Yet the dominant impression is of England, and of Surrey where the Kings lived. No longer could it be said that Canaletto saw only the Grand Canal in England, nor, after eight years' residence, would it be expected that he should. The paintings are indeed fine and characteristic examples of one of Canaletto's most interesting aspects, the painter of imaginary views.

It was an aspect of his imagination which was seen at its best in the etchings and at its least successful in Smith's overdoors and which Canaletto was probably exercising to a greater or less degree throughout his career. It will be remembered that the earliest paintings attributed to him, although without any firm evidence, were capriccios in the style of Marco Ricci and when, at the end of his career, he finally became a member of the Venice Academy it was a capriccio which he chose as his reception piece.

A way may be found one day of putting these capriccios into some kind of chronological sequence but this cannot be done with any confidence in the present state of knowledge of Canaletto's development. As with all his work, a mechanical style becomes evident in the late 1730s and if it seems more noticeable in the cappriccios than in other work this may well be because the proportion of capriccios to other work increased after 1740. Canaletto's lack of consistency adds to the problems. Not only did he differ from most other artists by progressing from broad, loose strokes to a tighter, harder technique, instead of the reverse; having once changed his style there is every reason to suppose that he was apt to revert to an old style for an occasional picture. Sometimes his imagination was caught and he took infinite pains over minute details; sometimes he was bored, or hurried, and allowed mannerism to take over. So, generally speaking, the capriccios cannot be dated. There is an occasional topographical clue but otherwise the capriccios must be enjoyed rather than used to plot the artist's progress; they were, after all, painted primarily to give pleasure.

When Canaletto inscribed his drawing of *Old Walton Bridge* to the effect that it had been drawn after his painting of 1755 he provided the last evidence of his presence in England. Nothing more is heard of him there and there is no reason to suppose he remained much longer. It is true that there is no evidence of his arrival in Venice (Gradenigo is silent on the subject) but after a few years there is plenty, so it may be said with confidence that Canaletto's English period began in 1746,

was interrupted in 1750–1 (and again in 1753 if Gradenigo is to be believed) and ended some time in or after 1755.

What was there to show for it? It is surprisingly little represented in English public galleries. Only two of Hollis's pictures, a view of *Greenwich Hospital* (plate 115) and the *Eton College Chapel* (plate IX), are on public exhibition, the last two probably painted at about the same time as those of Hollis. Those painted for Sir Hugh Smithson, the Dukes of Richmond and Beaufort, the Earls of Malmesbury and Warwick and the Dean of Westminster all belong still to their descendants or successors. Less than thirty drawings of the period have survived, and it is doubtful whether there ever were many more; some of these were done for engravers, some are *aides-mémoires* in a sketch-book and several were taken back to Venice and entered Smith's collection. There are not more than forty paintings of English subjects over the whole period if replica versions are excluded and here again there is no reason to suppose many have been lost. 'Studio' or 'school' versions present a problem since there never seems to have been enough work to justify Canaletto employing assistants. It is difficult therefore to find any attribution for an inferior version other than that of an unknown imitator or Canaletto himself when below par. Several of these seem too good for the one description and not good enough for the other but so little is known of the imitators and followers (as most of them were at pains to ensure should be the case) that there are no certainties. The mysterious Samuel Scott comes to mind. He often copied Canaletto's subjects, sometimes overtly and sometimes not. Until more is known about his activities after Canaletto's arrival in London nothing can be said about the relationship between the two artists; at present there is no evidence that they even met. Finally, on the subject of Canaletto's output in England, it will have been noted how high a proportion was produced during the first years; he must have been very under-employed for quite considerable periods later on. Against this, capriccios which might have been executed at any time between 1740 and 1760 have not been taken into account. There are at least two dozen of these, some of them in many versions of varying quality. If Canaletto had a 'factory' for producing such pictures in London the assessment of his activity there would be quite different. But there are no grounds whatever to support such a theory.

Canaletto's eight years in England were not a financial success. His savings in 1751 amounted to 2,150 ducats and that was what he died with seventeen years later, except for a trifling amount of cash and effects. If Vertue's valuation of £60–70 for the Chelsea picture is an indication of his prices he would not have earned much more than £3,000 over the whole period. He lived in modest circumstances both in London and Venice.

There remains the question of his artistic achievement. The Duke of Richmond's two paintings; *Northumberland House* and the later *Whitehall* fully justify the visit in terms of his heritage to posterity. A few of the Thames paintings such as those

of Prince Lobkovice and the pair, perhaps painted in Venice, which went to Smith, add much to our knowledge of what eighteenth-century London looked like to a Venetian with a pair of penetrating eyes. We must be grateful for these and it is improbable that he would have produced anything which would have enhanced his reputation more had he stayed in Venice. Nevertheless it seems unlikely that Canaletto himself could have looked back on those years with complete satisfaction.

14
The final years

'A calm mind and a happy genius'

A. M. Zanetti the younger

When he returned to Venice Canaletto was on his own almost for the first time in his career. The English noblemen had had enough of him or he would not have left London. Algarotti, always a disappointment but of whom there must always have been hopes, was living in Bologna and the elder Zanetti, a shadowy figure in Canaletto's life but certainly a valued patron at some time, was nearly eighty and had not long to live. Smith was much the same age and could no longer be relied on for help.

At about this time Smith's first wife had at last died and he had married the sister of John Murray who received the appointment of English Resident, the post which Smith had always coveted. If Lady Mary Wortley Montagu was to be believed Murray was a far more dangerous character than his predecessor Burges, against whom Lord March had been warned by his mother. 'Such a scandalous fellow,' she wrote about Murray, 'in every sense of the word, he is not to be trusted to change a sequin, despised by the Government for his smuggling, which was his original profession, and always surrounded by pimps and brokers, who are his privy councillors.' Nor was the loss of the Residency to one apparently so unqualified the only disappointment Smith had to suffer in his old age. The war had disrupted his business and he became disenchanted with the social life which had meant so much to him. He gave up his box at the theatre and talked of selling his collection and returning to England after visiting the principal towns of Italy which he had never seen. He was in no mood either to commission work from Canaletto or to find him new patrons.

It is therefore not surprising that Canaletto should have taken on anything which looked like providing him with a living, and without the stimulus of a patron to propose new subjects he was reduced to the repetition of old successes in new guises. *The Bucintoro returning to the Molo on Ascension Day* (plate 116) is just such an example. The festival pictures had always been large, generally between two and three metres wide, and painted with meticulous attention to the activities of the people who inhabited them (plates 53–54). The version now in the

Dulwich College Picture Gallery is barely one metre wide and the figures, although painted with skill and ease, are mechanical and lifeless. The coloured dots to represent the highlights had been increasing over the years and here they appear in abundance. There can be no doubt about the date. It is indeed one of the few festival paintings which can be dated with certainty since the Clocktower in the Piazza clearly has an upper storey which has not appeared in any earlier version. Gradenigo noted the removal of the scaffolding which had been erected for the modernization of the Clocktower on 2 March 1755 and in this case, unlike his reference to Canaletto's presence in Venice in 1753, there is no reason to doubt his accuracy. The picture must therefore have been painted after Canaletto's return from England and so must a fairly large group of pictures with exactly the same characteristics which are often thought to have been painted in the 1740s.

The etchings provided material for other paintings, and rich material they were; having conceived them, though, in terms of the needle Canaletto was unable to translate them into paint with any great success. At times his imagination deserted him to such an extent that he used well known old engravings of Rome for paintings, making quite minor alterations and even leaving the figures in their original positions but with their costumes brought up to date. A group of paintings of some of the better-known palaces and *scuole* were original to the extent that they had not been painted before but they are the work of a tired or dispirited man, unwilling or unable to exercise the extraordinary powers of composition which had served him so well in the past.

There were also some tiny canvases of the Piazza area which give the impression that they were done with an eye to the less well-off tourist who had supplanted the illustrious visitors of the past. A number of these were upright or square, as were several capriccios apparently designed for tourists to take away in their baggage or even carry around in their pockets. Then there was work for engravers, certainly three sets, each of six engravings, for Josef Wagner, a Swiss who had, settled in Venice, and his pupil and assistant, Fabio Berardi who was not born until 1728; Berardi's name appears as the engraver in many cases and, since he was not eighteen when Canaletto left Venice for London, it is extremely improbable that this work was done before the final return to Venice. Altogether some fifty paintings and twenty drawings have survived from this period, apart from engravers' drawings, so it is clear that Canaletto was by no means in retirement.

In 1757 Robert Adam travelled from Rome to the Dalmatian town he called Spalatro, more generally spelt Spalato and now known by its Yugoslavian name of Split. He was accompanied by the artist C.-L. Clérisseau and several draughts-men, the intention being to study and make drawings of the palace of the Emperor Diocletian. On the journey from Rome Adam, to his delight, met Algarotti in Bologna where, although retired, he was perhaps more sought after than ever.

7—C • •

Algarotti gave Adam a letter of introduction to Smith who, he assured him, would be helpful both in Venice and Spalato, and in Padua Adam met not only Smith but also John Murray, who had recently become Smith's brother-in-law, and Lady Mary Wortley Montagu. Lady Mary characteristically described the new Mrs Smith as 'a beauteous virgin of forty who after having refused all the peers in England she remained without a husband till the charms of that fine gentleman, Mr Smith, who is only eighty-two, determined her to change her mind' (Smith's exact age cannot be determined). Smith made many promises to Adam, none of which were carried out, and the party of artists proceeded to Dalmatia.

They returned to Venice towards the end of the year and Robert Adam left Clérisseau and the draughtsmen there to work on the drawings and prepare the plates for the book on Diocletian's Palace while he returned to England. We do not know whether Canaletto had been among the brilliant company Adam had met, nor do we know where the drawings were left. We do, though, know that Canaletto saw them because he was sufficiently interested in one, at any rate, to make a copy of it. It was certainly the original drawing, probably by Clérisseau, which he copied and not the engraving from it, which was not published until 1764, because Canaletto's drawing of *The Mausoleum of Diocletian* (plate 122) shows a polygonal building which is correct, whereas in the engraving the building appears to be square. The only other difference between Canaletto's drawing and the engraving is in some of the figures, although even these are placed in the same positions. Clérisseau's drawing, if it was Clérisseau's, has disappeared but there can be no doubt that it provided the original for Canaletto. On the way to Spalato Robert Adam and his party had stayed at Pola in Istria to see the celebrated Roman amphitheatre but, finding rivals there, had passed on after making a few drawings. The recent appearance of the drawing of Diocletian's palace explains two capriccios of Canaletto's based on buildings at Pola; the probability is that these were also the result of drawings Canaletto saw among Robert Adam's collection in Venice since there is no reason to suppose he ever went to Dalmatia himself.

Canaletto's drawing of Diocletian's Mausoleum is of small significance but it provides a curious sidelight. He must indeed have been short of subjects to have turned to those of a minor artist such as Clérisseau and there may well be some explanation of which we know nothing today.

Three years later, in 1760, Robert Adam's brother James arrived in Venice and found the work of preparing plates from the Spalato drawings was far from complete. He, too, met Smith who had just retired from the post of Consul (to which he returned for a few months in 1766). He was received at Smith's house in Mogliano 'with much flummery' and shown the collection. 'He ought to sell,' was James Adam's comment, 'if vanity would allow him, but he is literally eaten up with it.' He found Smith 'devilish poor and should he live a few years longer,

which he may do, will die a bankrupt'. Fortunately for the British Royal collection Smith knew this and a year later negotiations for the sale to George III began.

Just about this time, in 1759, Francesco Algarotti wrote a rather puzzling letter to a Bolognese artist named Prospero Pesci. Although he had neglected Canaletto in 1742–5 when he was buying for the King of Saxony, Algarotti seems to have owned a few of his paintings. A catalogue of his pictures found by his daughter some years after his death includes three views of Venice for which it seems unlikely Algarotti would have turned to anyone but Canaletto. These cannot be identified but in the letter to Pesci, Canaletto is mentioned by name in connection with a 'new kind of painting in which a site is ornamented with buildings taken from here and there, or just imagined'. He went on:

The first picture I had painted for me in such a manner was a view of our Rialto Bridge from the side facing north-east. Little or nothing was changed in the bend of the Canal, in the position of its banks or of the buildings situated along it. We only changed a good many of those buildings. You will know that the Rialto Bridge, with all its reputation, has no other virtue than that of being a great pile of stones, shaped into a big arch about a hundred feet wide, and on top of which it carries two rows of shops of the most heavy and squat architecture one can possibly imagine . . . For this reason, in place of the Rialto Bridge such as is seen today we put the bridge designed by Palladio for that same location and which is the most beautiful and decorated building it is possible to see.

After a detailed description of Palladio's bridge, which Algarotti could not believe was excelled by the design of Michelangelo, who had also entered the competition for the new bridge in 1554, and some deprecatory words about the Fondaco dei Tedeschi, which had already by then lost most of the frescoes by Titian and Giorgione, Algarotti continued:

Such a building, painted and given light by the brush of Canaletto, of which I made use, I cannot tell you the beautiful effect it makes, especially when it is reflected in the water underneath. To its right, in the place of the Fondaco, we put the Palazzo Chiericato by the same Palladio . . . and in the middle there stands the Basilica of Vicenza, known as the Palazzo della Ragione [both buildings are still standing in Vicenza] . . . Between the Basilica and the bridge our eye goes through and travels a long way over a view along the Canal at the other side of the same bridge . . .

There are several versions, none of them with a known early history, of a painting which corresponds to Algarotti's description except that it is in reverse, as if, perhaps, an engraving or engraver's drawing had been copied (plate 117). At least two of these versions have as pendant another picture showing Palladio's Bridge with an unidentifiable, circular building beside it (plate 118). None is certainly by Canaletto but the attribution would be a reasonable one in the case of those illustrated and at least two others.

But when were they painted and to what period was Algarotti referring when he wrote 'The first picture I had painted for me was . . .'? The idea of a painting

'in which a site is ornamented with buildings taken from here and there, or just imagined' was far from new in 1759. As long before as 1744, Smith had commissioned pictures of 'the most admired buildings at Venice, elegantly Historiz'd with Figures and adjacency to the Painter's Fancy' and in one of them (plate 75) Palladio's design for the Rialto Bridge was the subject, although without the Vicenza buildings added for Algarotti. Could Algarotti have been referring to a fifteen-year-old commission? In the absence of the painting, and none of the known versions has any real claim to have been Algarotti's, this seems to be a distinct possibility. If it ever appears it may bear the mark of a 1759 picture; this cannot be said of any of the known versions for which 1744 would be a more plausible date.

In 1760 another figure makes a reappearance. The Reverend Edward Hinchliffe published a book in 1856 about the Crewe family and told of his grandfather being in Venice in 1760 with John Crewe. He insisted that John Crewe had bought the Whitehall painting (plate VIII), which now belongs to the Duke of Buccleuch from Canaletto himself who 'had refused to sell it in England as he wished to keep it as a memento of his visit'. This is a difficult story to believe but Hinchliffe told another story of his grandfather's stay in Venice which is rather more acceptable, with reservations. The couple had

chanced to see a little man making a sketch of the Campanile in St. Mark's Place: Hinchliffe took the liberty—not an offensive one abroad, as I myself can testify—to look at what he was doing. Straightway he discovered a master-hand and hazarded the artist's name 'Canaletti'. The man looked up and replied '*mi conosce*'. Thereupon a conversation ensued, and Canaletti, pleased to find so enthusiastic a judge of drawing, invited Hinchliffe to his studio, who waited upon him there the following day, and inspected his paintings and drawings. The visit terminated most agreeably to the traveller. Having requested Canaletti to allow him to purchase the painting about to be made from the sketch he had seen the artist take, Canaletti not only agreed to this, but, in addition, presented him with the sketch itself, as a complimentary gift: and a very valuable one my grandfather esteemed it, and so did his eldest son, at whose death it became the property of the present Lord Crewe, by purchase, and is now at Crewe Hall.

An anecdote of a meeting with Canaletto, even one told a hundred years after the event, is a great rarity and Hinchliffe's engaging little story has been repeated many times. Unfortunately, whatever Canaletto may have been doing in the Piazza when discovered by Hinchliffe's grandfather, he was not making the drawing which became the property of Lord Crewe and now belongs to his descendant (plate 119). This, quite clearly, is no 'sketch of the Campanile' but a finished drawing produced in the studio. Perhaps the sketch has disappeared. Perhaps Canaletto allowed himself to be seen in the Piazza with a drawing for the reason artists are always to be seen where tourists congregate, in the hope, that is to say, of attracting custom. There would be nothing discreditable about this, sad

though one might feel that it should be necessary for the artist who was astounding all Venice thirty-five years earlier. It is some comfort to know that the ruse, if it was a ruse, succeeded and that the sale of a painting was effected as a result. Edward Hinchliffe's story is confirmed by the recent discovery that his father sold a painting (plate 120) in 1836 which is obviously closely related to Lord Crewe's drawing. And there is always the possibility that Canaletto really did find it necessary to make a sketch of the Campanile before embarking on the painting even though he was sixty-three years old and must have made hundreds of such sketches.

For his biographers Canaletto was irritatingly erratic in dating his pictures. Until 1742 he hardly ever did so and after 1744 he stopped for ten years when, during his last two years in England he dated the Hollis and Lovelace paintings. After the return to Venice he dated nothing until 1763, so providing his most difficult period for chronological arrangement. The single beacon he lit in 1763 is therefore of unusual interest.

It is probably Canaletto's last large picture of the Piazza and it was twenty years since he had painted the Venetian scene on such a scale. Over a metre in width, it shows the bright, newly furbished Clocktower on the right and, on the left, the north-west bay of St Mark's through which can be seen the column of St Theodore and a glimpse across the lagoon (plate 121). The Loggetta, at the foot of the Campanile, has the extension to the upper storey which was added in 1750 and which appears in no other Canaletto painting. More than fifty figures are seen, painted in the shorthand brushstrokes which are by now so familiar but with every point made: even their shoes can be seen to vary. The viewpoint, ostensibly from the Campo S. Basso, is quite imaginary; from no point could all that is shown be seen, however much the neck might be craned. As if to acknowledge that the picture is almost a capriccio the column of St Mark's is decorated with foliage. On the back of the canvas the artist wrote 'Io Antonio Canal, detto il Canalletto, fecit. 1763'. The spelling of his name bothered him no more than the conjugation of the verb fecit (but perhaps this is unjust since it is just possible that the Io stood for 'Giovanni', not for 'I', in which case the use of fecit would be correct). If he wanted to sum up his life work as a painter of Venice he could not have done better than with this picture. He has travelled from theatricality to a cool study in perspective, from sombre colours on a dark, reddish ground to sun-drenched buildings in a subdued atmosphere on a smooth, white ground— and, it must be admitted, from passion to serenity, if not complacency.

About the time Canaletto returned to Venice from England, the Venetian Academy was founded with a fixed number of thirty-six members. Canaletto was not one of them which is scarcely surprising; he had long been absent and may not yet have returned. It was an ineffective body and its members objected to being compelled

by the Government to put on shows in the Piazza on Ascension Day where the pictures were not allowed to be sold. All the same, it was an academy of sorts and Canaletto evidently wanted to be a member since he was a candidate in 1763 for one of the first three vacancies to occur. It must have been a mortifying experience for him to find that he was not elected and that a figure-painter named Pietro Gradizzi, soon to become a nonentity, was preferred to the man who had been one of Venice's most celebrated artists for forty years, The second choice was Francesco Pavona, an insignificant portrait-painter who had been away from Venice for as long as Canaletto himself. Francesco Zuccarelli was the only worthy choice and he later became President (and also a founder member of the Royal Academy in London).

In September of the same year, 1763, there was another vacancy and this time Canaletto was elected, still with four votes against him out of fourteen who voted. For his reception piece he might have been expected to choose a view of Venice on which his entire reputation had been built. He knew the opinion of his fellow academicians on view painting too well to be guilty of such tactlessness and after keeping them waiting almost two years he gave them in 1765 his *Capriccio: a colonnade opening on to the courtyard of a palace* (plate 123). Replicas of the painting abound and Canaletto himself may well have had a hand in some of them. On the other hand almost any competent craftsman could have copied it once the original had been painted. One cannot help wondering whether, if Canaletto had become an academician thirty years earlier, this is the kind of painter he might have become.

By this time the sale of Smith's collection to George III had been completed. Negotiations had been going on for several years but the hope expressed by James Adam that he would save himself from bankruptcy by selling had not been realized until 1762, two years after Smith's retirement from the consulship. His plans to return to England and sell his palace did not materialize and instead he became Consul again for a few months in 1766. Moreover, he either went on collecting after the sale or he did not sell all that he had. Six years after his death a sale of his 'remaining pictures and drawings' included fourteen views of Venice catalogued as Canalettos. Nevertheless, George III acquired about 500 paintings for the £20,000 he paid Smith, including more than 50 by Canaletto (and a Vermeer). The 140 Canaletto drawings were more than now exist anywhere outside the Royal collection and the price included the prints, books, gems and coins. Indeed, the books were valued at more than the paintings which, according to Lord Northampton, were not worth much 'There being few capital peices'.

Smith enjoyed twelve years of marriage to his second wife and died in 1770, two years after Canaletto. He was said to be ninety-six but might well have been ten or even more years younger.

★ ★ ★

The Academy reception piece was perhaps Canaletto's last painting. At about the time of his election he must have received a welcome commission for twelve large and elaborate drawings which were to be engraved by Giovanni Battista Brustoloni and published by Lodovico Furlinetto who had already been much involved with publishing engraved versions of his work. The subjects were to be twelve of the ceremonies and festivals which provided the Doge with his principal occupation throughout the year. Canaletto had seldom been at his best in festival scenes. He preferred showing his people at their everyday pursuits rather than the stiff, formal personages taking part in the ceremonies with blobs which represented the dutiful spectators in the background. It is highly unlikely that any paintings by Canaletto were ever done in spite of the word 'pinxit' which Furlinetto put after his name on the engravings. Francesco Guardi paid Canaletto the compliment of painting copies of the drawings (or of the engravings) and these at one time were thought to be by Canaletto.

Smith's last commission to Canaletto was probably an interior showing *S. Marco: a Service* (plate 124), possibly as a companion to a painting of a similar subject done at least thirty years earlier. It was not to be Canaletto's last interior. He went back to St Mark's when the Ducal Ceremonies and Festivals had been completed and drew what he carefully described underneath the drawing as 'the musicians who sing in the Ducal church of S. Marco in Venice' (plate 125). For once he had something more to say, something about himself. 'Aged 68', he added, 'Without spectacles, the year 1766'. The piercing eyes of the veritable Canaletto were still functioning, he seems to be announcing, and they needed none of the contraptions that other sixty-eight-year-old eyes needed to enable them to do so.

If anyone heeded the announcement and gave him a commission neither they nor Canaletto left any record of it. 'Brilliant and celebrated master, painter of the highest integrity and merit' had been the official citation on his election to the Academy and the last recorded fact of his life was neither drawing nor painting a picture but attending a meeting of the Academy in August 1767. Seven months later he fell ill with inflammation of the bladder and was dead within five days. There were twelve priests and candles at his funeral, as befitted the rank he claimed, and the funeral cost as much as Stefano Conti had paid him for his first pair of paintings. He would not have minded; there was no one but his two sisters to inherit his modest investment in the Zattere property, his 'small single bed with two overlays', his clothes, all described by his executors as 'old', or the twenty-eight unsold pictures he left. Was the Academy right in describing him as still 'celebrated'? His patrons had all died or turned their eyes towards the neo-classicists; Smith was alive but even he had given up collecting in his nineties. Whatever Canaletto may have been doing in the Piazza when Crewe and Hinch-liffe came across him, he was not acting as a celebrated master.

It is better to remember him as making everybody marvel with his picture of *SS. Giovanni e Paolo* outside the Scuola S. Rocco, as having 'more work than he doe in any reasonable time' in McSwiney's words, as being the prize Joseph Smith was able through his patience to dangle before the English dukes and as impressing the spoilt, influential·Sir Hugh Smithson with the 'noble effect' of his work.

It is better still to remember him as possessor of the vision and imagination which enabled him to savour and record Stefano Conti's and the Prince of Liechtenstein's views of Venice, those unknown patrons' masterpieces such as '*The Stonemason's Yard*', the delights of the Brenta, mid-Georgian Whitehall and the Thames and the magical cities which his needle etched on the wax. Perhaps Zanetti was right when he wrote of Canaletto's 'lucidity of colour and of brushwork, the effects of a calm mind and happy genius'.

15

Francesco Guardi

'A good pupil of the celebrated Canaletto'

 Pietro Gradenigo in 1764

No two artists, both highly regarded today, both working in similar fields in the same century, can have had careers which differ so startlingly as Canaletto and Francesco Guardi; nor did the esteem in which each was held for the century following their deaths have anything in common.

Canaletto was still in his twenties when, according to Alessandro Marchesini, his work was astounding everyone in Venice. Zaccaria Sagredo and the Imperial Ambassador were among his earliest patrons. Before he was thirty he had, in Owen McSwiney's opinion, more work than he could properly handle and two years later Smith was complaining of how he was so much followed by those who were ready to pay him his own price for his work. For the next ten years the demand for his pictures by the English nobility was so great that their quality deteriorated and imitators sprang up both in Venice and in London. War brought about a pause in this career of unbroken success which was soon resumed when he left Venice for England. After some years which brought a series of commissions from the leading English patrons there came another lull and he returned to Venice. There he was given academic recognition in spite of the prejudice against the kind of work which had made him so celebrated, and he continued drawing and painting, and selling all that he produced, until his death at the age of seventy-one. He may not have become rich but he certainly never knew poverty.

Canaletto's influence on other English artists has never been doubted and, if it was confined to English artists, that was because his work could scarcely be seen elsewhere. Samuel Scott was a marine artist until Canaletto arrived in London and would probably have remained one had he not decided to follow Canaletto in the art of townscape—which he did with immense skill. William Marlow became a pupil of Scott's immediately after Canaletto's return to Venice but he followed Canaletto's techniques more than those of his own master. Joseph Farington, another topographical artist, used the phrase 'Canaletti brick' in his notes to describe how he intended his finished drawing to look. Thomas Malton II, a contemporary of Farington, knew Sir George Beaumont when he owned '*The*

Stonemason's Yard' and taught both Turner and Thomas Girtin. Turner was an admirer, although not a follower, of Canaletto, but Girtin, whom Turner admired perhaps even more, owed a great deal to Canaletto, as did Richard Parkes Bonington, the most accomplished of them all, and his own friend and follower Thomas Shotter Boys. Boys carried on the tradition up to his death in 1874, a century after that of Canaletto and the year in which the Impressionists first appeared and everything changed in the world of topographical art.

Not only throughout that century but in the one leading up to the present day Canaletto's own reputation remained almost unchanged. This could be said of but a handful of artists since the Renaissance: there are many artists of far greater stature than Canaletto ever aspired to of whom it certainly could not be said. It is true that auction prices of 'Canalettos' fell in the middle of the nineteenth century after the Duke of Buccleuch had paid the enormous price of a thousand guineas★ for Canaletto's second *Whitehall* (plate VIII) painting in 1838 but this was because of the flood of imitators' work, produced both in England and abroad, which entered the market. The rare appearance of what the catalogues described as 'a capital piece in the master's early style' always resulted in lively competition among connoisseurs. By the 1890s Whistler's enthusiasm and even Ruskin's grudging acceptance gave Canaletto a fresh impetus. Stefano Conti's four pictures realized more than £25,000 in 1928 when fine paintings by Canaletto's great contemporary, G. B. Tiepolo, could be bought for less than half as much. In short, Canaletto has been far less subject to the caprices of fashion than most artists are in the centuries following their death. Occasionally a freak price has been paid, as in 1974 when a pair of pictures, twenty-three centimetres high, belonging to his final period realized £130,000, but in general the market price of a fine Canaletto has not greatly changed in terms of real money over the whole period.

The contrast with Francesco Guardi's case is truly remarkable. Guardi was almost unheard of during the first fifty years of his life. Even when he became a view-painter, producing vast quantities of pictures both real and imaginary (many more than Canaletto), he was completely neglected by contemporary writers and he died almost unnoticed in 1793 at the age of eighty-one. His patrons were Italian doctors, priests and secondary dealers; he was unknown to the English aristocracy who had taken Canaletto up when already celebrated in Venice. When, in 1782, Guardi was commissioned to record for the State the visit of Pope Pius VI to Venice he had reached the crowning moment of his career such as it was; yet he was paid ten sequins each for the four pictures, half Canaletto's price for his earliest views.

The late eighteenth-century English interest in neo-classicism, which later

★At about the same time the National Gallery was able to buy Jan van Eyck's *Arnolfini* portrait and Giovanni Bellini's portrait of *Doge Leonardo Loredan* for six hundred guineas each.

spread throughout Europe and even caused a temporary setback to the appreciation of Canaletto's work, prevented any possibility of Guardi's reputation gaining ground immediately after his death. Even so, it is astonishing to learn of an English tourist seeing 'a collection of Guadis [sic] pictures of Venice' in 1828 belonging to a dealer who had 'above a hundred of them—some very pretty— & he wishes to sell them all for £600 but he will not separate them'. As for his drawings, Count Teodoro Correr, the founder of the Museum in Venice, bought eighteen of them from Guardi's son, Giacomo, for less than half a sequin the lot and offered Giacomo 200 sequins for all he had left, running into thousands; Giacomo, however, wanted 300 sequins— £150 sterling.

It was not until the mid-nineteenth century that Guardi was 'discovered' and then in France, where Canaletto has never been seriously collected, rather than in England. English collectors owned, and showed at exhibitions, a number of Guardis but they were regarded as no more than souvenirs of Venice. In France the interest was in his capriccios and by the 1860s they were selling for over £100 each. Then the views were taken up and the price rose to almost £1,000 (still less than a good Canaletto), steadily increasing until £10,000 became quite common-place after the Second World War for a painting and £4,400 in 1951 for a drawing which had sold for £220 in 1891. In 1948 the publisher of the standard book on Guardi's drawings did not hesitate to observe on its jacket that 'once reckoned by many no more than an imitator of Canaletto, he [Guardi] is now generally pre-ferred to Canaletto himself'. This may well have been an over-statement at the time and it would certainly not be justified thirty years later but it is indicative of the extraordinary revolution in taste which has involved the reputation of one who was so obscure in his lifetime and for many years after his death.

The contrast with the stature of Canaletto, which scarcely changed from the early days of his career to 200 years after his death, does not end with the taste of collectors. Canaletto's influence on his contemporaries and, through them, his successors, was marked—particularly on the great school of English water-colour drawing which led to Bonington and his followers. No nineteenth-century artist seems to have taken any interest in Guardi's work, even if they knew of his existence. When he first came to notice in France the Impressionists were embark-ing on their adventure which had so profound an effect on art history and one might have expected Guardi's loose brush strokes and atmospheric painting to have caught their eye. None of them mentions him in their letters and none of them gives any indication in their own pictures that they had ever seen those of Francesco Guardi. The reason for this may appear when his work is studied (in the original, rather than in reproduction) and when the little that is known of his career has been briefly told.

Francesco Guardi was born in 1712, thirteen years after the birth of his brother,

Giovanni Antonio, called Gianantonio, who was therefore only two years younger than Canaletto. They were the sons of Domenico Guardi, an obscure figure-painter from Trent who had worked in Vienna and had moved to Venice in 1700. In 1716 Domenico died and the seventeen-year-old Gianantonio became the head of the studio and responsible for keeping the family which included another brother, Nicolo, and a sister Cecelia.

The head of a studio in eighteenth-century Venice, as in other European cities, was, so to speak, the head of a firm which was registered in his name on an official list, the *Fraglie*, and authorized to employ assistants and apprentices and produce and sell pictures. If one of the assistants wished to attach his own name to a picture it would have involved leaving the firm and starting on his own. When he was old enough Francesco joined his brother's firm and nothing whatever is heard of him as a painter until Gianantonio's death in 1760. A light momentarily falls on the family in 1719 when Cecelia married the young G. B. Tiepolo, who was to become the greatest Venetian painter of his age. The firm, or workshop, of Gianantonio Guardi, though, remained almost unrecorded in any surviving document.★

It is not altogether surprising since they were journeymen painters employed on such menial commissions as the copying of old masters from engravings for such patrons as Marshal von Schulenberg and a certain Count Giovanelli; the interest of the latter is that he referred in his will to copies executed by *the brothers* Guardi, thus confirming Francesco's presence in the workshop by 1731. Very occasionally Gianantonio signed a painting or altarpiece, never one of great merit, and in 1750 Francesco painted a signboard for a jeweller. Otherwise they practised their art, or craft, in obscurity although with respectability since in 1756 Gianantonio was elected to the newly-founded Academy; the fact that his brother-in-law, G. B. Tiepolo, was its first president may or may not have contributed to this honour which, it will be remembered, was denied to the celebrated Canaletto for another four years.

In 1760 Gianantonio died and Francesco, historically speaking, came to life for the first time. He had only recently married and was, as would be expected, enrolled in the *Fraglie* in his brother's place (not in the Academy for which he had to wait another twenty years).

At this moment there is no reason to suppose that Francesco had ever painted a view. An attempt has been made to establish some relationship between Francesco and Marieschi but it has failed to carry conviction. A vast amount of scholarship and connoisseurship has in fact been applied in recent years to the work of

★A rare, although unhelpful, reference comes from a surprising source. In 1742 the seventeen-year-old Giacomo Casanova, in flight from the seminary in which he had disgraced himself, writes: 'I went to supper with my brother Francesco, who was boarding in the house of the painter Guardi.' This, presumably, was Gianantonio whose own brother Francesco is not mentioned.

both the Guardi brothers but little agreement has been reached. This is exemplified in the case of the attractive decoration of the organ-loft of the church of Angelo Raffaele in Venice which shows scenes from *The Story of Tobit*. These have been plausibly demonstrated by different scholars to have been the work of Gianantonio, of Francesco and of the two working together. Even more remarkable is their dating which has been put at 1750 by some, 1785–90 (thus attributing them solely to Francesco, of course) by at least one, and various dates in between by others, all with apparently good reasons. One of the few aspects of Francesco's life on which there is general agreement, though, is that he was not a view painter until 1760, or at the very earliest 1755, that is to say when he was approaching the age of fifty.

In 1764 Pietro Gradenigo, whose diary has been quoted in other connections, recorded that

Francesco Guardi, painter of the parish of SS. Apostoli on the Fondamente Nuove, a good pupil of the celebrated Canaletto, having with the aid of the *camera ottica* painted two most successful pictures, fairly large canvases . . . on the commission of an English visitor, exhibited them this day under the colonnade of the Procuratie Nuove, and was universally applauded.

The reference to the *camera ottica* may be passed over in the hope that the reader by now reads into such a reference the suggestion that the pictures were so realistic that a camera *must* gave been used. The pictures, one of the Piazza and the other of the Rialto Bridge, cannot be identified with any degree of confidence and the 'English visitor' not at all. The interest of the entry lies in the fact that it is the first contemporary reference to Francesco and that he has by now become a view painter.

The description of Guardi, as it would now be reasonable to call him, as a 'good pupil' (*buon Scolaro*) of the *rinomato Canaletto* is capable of more than one explanation. There is no confirmation from any other source that Guardi ever entered Canaletto's studio and the phrase might be interpreted as 'good member of the Canaletto school'. On the other hand there is no reason why Guardi, having decided that view painting held out better prospects than figure painting, should not have gone to the Master himself for assistance. In favour of the suggestion it could be argued that Canaletto was approaching the end of his career, was well set-up financially and would welcome a successor, and that some, now indeterminable, form of collaboration might suit both parties. Against it lie the facts that Canaletto was still fairly active but does not seem to have had enough work to justify employing an assistant, that he was by no means a rich man and was willing to take on quite humble commissions from print sellers, and, above all, that it would have been almost impossible for the Canaletto of *c.* 1760 to teach Guardi the kind of painting with which he began his new career.

For Guardi indeed took Canaletto as his master but it was the Canaletto of forty years earlier, the free handler of loose brush strokes that he followed, not the

mannered painter of hard lines and calligraphic figures Canaletto had become in the 1740s and remained for the rest of his life. If Guardi had been Canaletto's pupil in the 1720s he might well have painted *The Piazza S. Marco* (plates 126–28) as he did. Comparison with the Prince of Liechtenstein's version (plate 15) suggests that the picture might almost have been painted by Canaletto himself—it was in fact attributed to Canaletto when it first entered the National Gallery, London, in 1846. It is hard to believe that Canaletto could have taught Guardi to paint in this way while he himself was painting in the style of John Crewe's *Piazza* (plate 120) and had been doing so for years.

Whether 'good pupil' or not, Canaletto must of course have exercised a profound influence on Guardi as must the fact that he had no apparent successor. The two artists must surely have known one another and Guardi must have seen Smith's collection. This was still in Venice in 1760 but Smith never owned a Guardi, perhaps another indication that his career as a view painter had hardly begun yet. Canaletto's subjects were available in original and in engravings and Guardi made free use of them as Canaletto had himself made use of those of Carlevaris. Gradenigo's description of Guardi seems therefore justified even though it should not be taken in its literal sense.

No painting or drawing of Guardi's can be securely dated with the exception of a few, painted towards the end of his career, commemorating events. There is an occasional clue based on topographical changes or on fashion but generally speaking any attempt to place his work in chronological order must depend on what the observer sees as a development of his style, often a controversial subject and particularly so in Guardi's case. The dates which follow are therefore necessarily tentative and the pictures selected for illustration are all to be seen in London so that the originals may be readily studied.

The Arsenal (plate 129) must, from its lack of assurance and the absence of Guardi's known characteristics, be one of his earliest view-paintings. It belongs to a group of which all are signed and which must have been painted after 1754 since one of them shows the *campanile* of S. Bartolomeo as it appeared only after that date. *The Piazza* of plate 126 shows Guardi still under Canaletto's influence, even though it is the influence of his earliest period, and it would be reasonable to date it between 1760 and 1765. The Guardi we all know is now beginning to develop and *The Dogana and S. Maria della Salute* (plate 130) of 1765–70 shows him almost at his prime. The brilliant *Doge's Palace and the Molo* (plate 131) may be dated about 1770, the beginning of a decade when Guardi, almost sixty years of age, was at the peak of his career. *The Rialto Bridge from the South* (plate 132) probably belongs to the end of this decade. Then comes another *Piazza* picture of the 1780s (plate 134) which represents the Guardi of a well-tried formula. By this time he had been painting views and capriccios for more than twenty years and

the picturesque has taken over completely. The *campanile* soars higher and slenderer than ever and the Piazza is wider and more splendid. The ragged figures, with the flecks of white paint to bind the composition together, are Guardi types rather than people—and the sun shines from the north, as it does in so many of his versions of the same subject. Yet the intention of presenting an harmonious and attractive picture of the Venice so many visitors thought they had seen has been fulfilled; everything and everybody seems to be in their proper place. His career was by no means finished. In 1782 he received the commission already mentioned to record the visit of Pope Pius VI to Venice, for which he was paid ten sequins for each painting by Pietro Edwards who held the post of Inspector-General of the Republic's collections. In the same year he had another commission for six pictures, most of which have disappeared, to mark the visit of a Russian Archduke who travelled as 'Count of the North'; Guardi was clearly the leading artist of the kind in Venice, in spite of the trifling fees paid. In 1789 he recorded a fire at S. Marcuola in both drawings and paintings and the following year he commemorated the wedding of the Duc de Polignac. This was thirty years after his brother's death and two years before his own.

Canaletto's capriccios were a by-product of his views and represent a small part of his total output. Guardi, on the other hand, is perhaps more thought of as a painter and draughtsman of capriccios than of views. The facility he soon developed after Gianantonio's death was even more appropriate to the ruined arch covered in weeds than to the solid buildings of Venice which he made appear to lie upon the water. Tempting though his capriccios proved to the copyists who have added greatly to their number, the quantity Guardi himself produced must have been prodigious. Occasionally there was a small masterpiece such as the one based on the courtyard of the Doge's Palace which would have been painted about 1770 (plate XI). The *Ruins on the Seashore* (plate 133) with its figures often described as 'treasure seekers' but more probably digging for eels, comes some five or ten years later.

Guardi did relatively little work for engravers and a smaller proportion of his drawings seem intended as independent works of art than in Canaletto's case. But the drawings are to be numbered in thousands as against Canaletto's few hundred as may be judged from the enormous quantity still in Giacomo's hands in 1829. Most of them were probably produced for Guardi's own pleasure or as studies for paintings and their nervous, fleeting line reflects Guardi's quality of insubstantiality and evanescence often as effectively as the paintings themselves. As with his paintings, Guardi did not hesitate to copy Canaletto's subjects for his drawings; and drawings from Canaletto's etchings *but in reverse* indicate the possibility that he may have had access to Canaletto's original drawings for those etchings. As would be expected Guardi drew less and less out of doors as he grew

older. The range of his subjects for drawing was in fact so great that the comfort of the studio would be appropriate for the large majority of his work. Imitators, who copied Guardi's drawings in order to learn from him, and forgers, who copied them with intent to deceive, seem to have had the impression that Guardi's magic was easily transferable: nothing could be further from the truth.

In spite of Guardi's dominating position in his own field he was not only denied reasonable financial reward. The Venice Academy did not regard him as serious enough a painter to invite him to join them until 1884 when he was seventy-two years old—Tiepolo had left Venice in 1760 and died in 1770 so that Francesco was denied the brother-in-law's influence that may have assisted Gianantonio's election in the Academy's early days. When at last the honour came the Academicians made it clear how little they understood of what Guardi had been doing for almost thirty years by describing him as a 'painter of perspective views'. He died six years later, on 1 January 1793, his life having spanned the best part of the Venetian Republic's final century; four years later it fell to Napoleon.

Canaletto's admirers tend to dismiss Francesco Guardi as a skilful decorator, a manipulator of colours and patterns into harmonious designs. It is true that the nobility of a '*Stonemason's Yard*' was beyond his reach and that he was incapable of organizing a panorama on the scale of Lord Carlisle's *Bacino*; he composed hardly any original views himself, preferring to rely on the paintings and engravings of his predecessors. Nevertheless, his power of subtly evoking the shimmer and luminosity of the Venetian scene, the association of water and building material and sunlight that transports every visitor—these qualities should not be under-rated. He was certainly not the painter of perspective views the Academy described: most of his buildings were incapable of standing up on their own. But until very recently visitors saw Venice almost entirely from the water and even today, when they have become accustomed to walking through its streets, many do not see it as a city of static architecture. They see movement all around them, buildings reflected in dappled water which is itself in turn reflected on the arches of the bridges and the fabric of palaces. They *see* the picturesque and Guardi recalls what they have seen with consummate ability.

He is, or was at some period, sometimes described as a forerunner of Impression-ism, an idea doubtless based on his loose brush-strokes and effective capture of certain tricks of light. This is no place to consider what Impressionism was, either to its admirers or to the Impressionists, to each of whom it was certainly some-thing different. They may be said to have had, at any rate, two things in common —a total unconcern with Guardi's work and an addictive pursuit of truth and reality. Francesco Guardi set himself a number of aims when he embarked on his long career as a view-painter and he achieved most of them. But realism was not what he sought or gained.

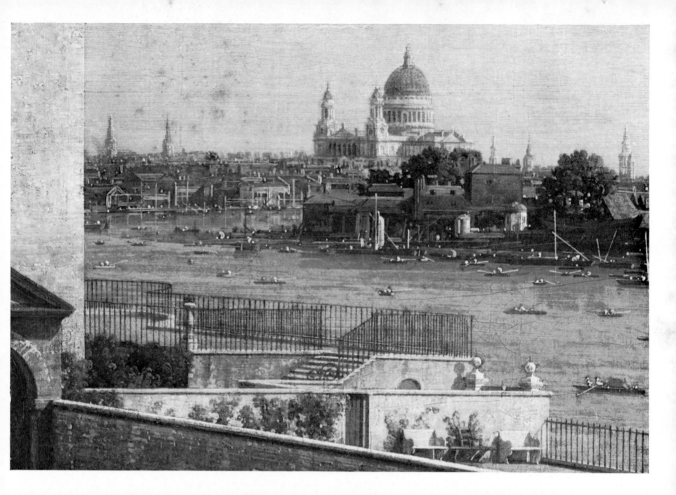

107 and 108 Details of plate VIII

109 *London: Northumberland House.* 84 × 137cm

110 Detail of plate 109

111 *London: St Paul's Cathedral.* 51 × 61cm

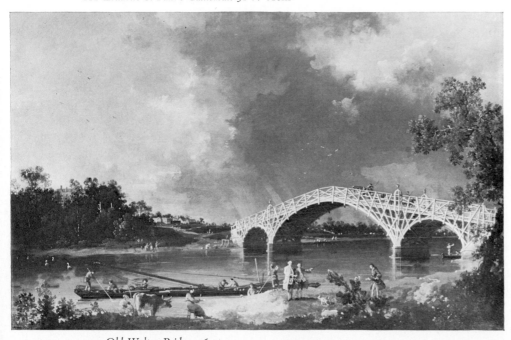

112 *Old Walton Bridge.* 46 × 75cm

113 *Capriccio: river landscape with reminiscences of England.* 132 × 106cm

114 *Capriccio: river landscape with a column and reminiscences of England.* 132 × 104cm

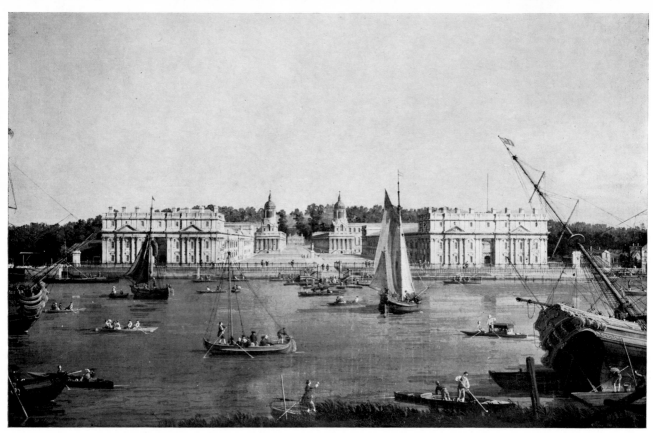

115 *London: Greenwich Hospital from the North Bank of the Thames.* 66 × 112cm

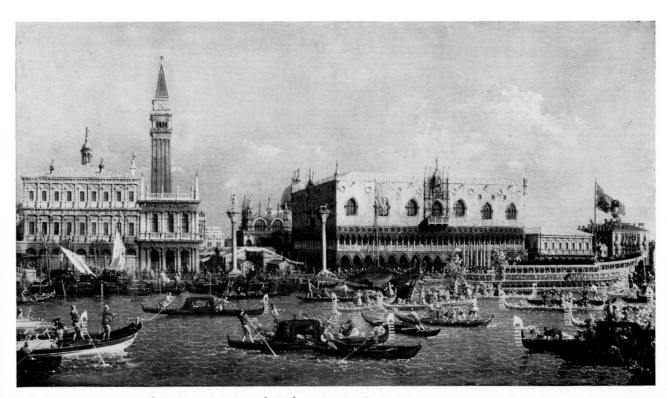

116 *The Bucintoro returning to the Molo on Ascension Day.* 56 × 100cm

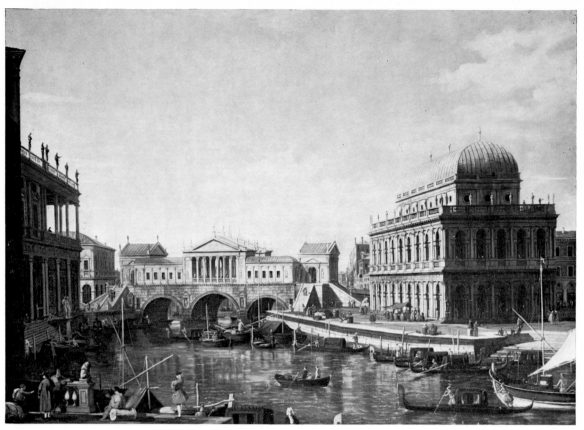

117 *Capriccio: a Palladian design for the Rialto Bridge, with buildings at Vicenza.* 60 × 82cm

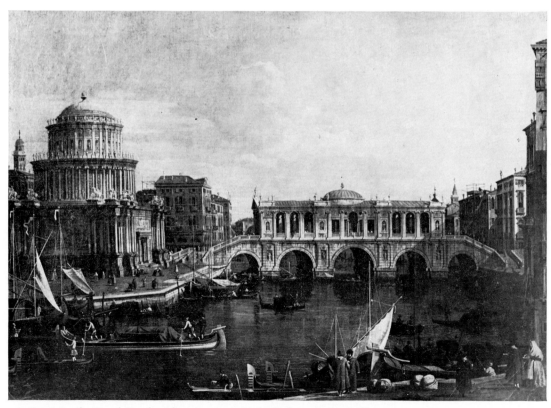

118 *Capriccio: the Grand Canal, with an imaginary Rialto Bridge and other buildings.* 60 × 85cm

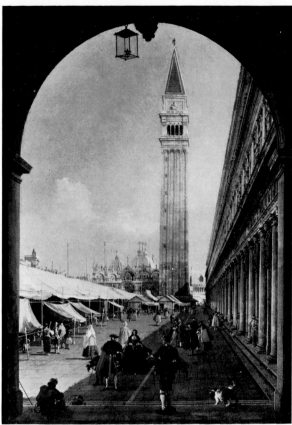

119 (*above left*) *Piazza S. Marco: looking East.* 40 × 25cm

120 (*above right*) *Piazza S. Marco: looking East from the South-West corner.* 69 × 60cm

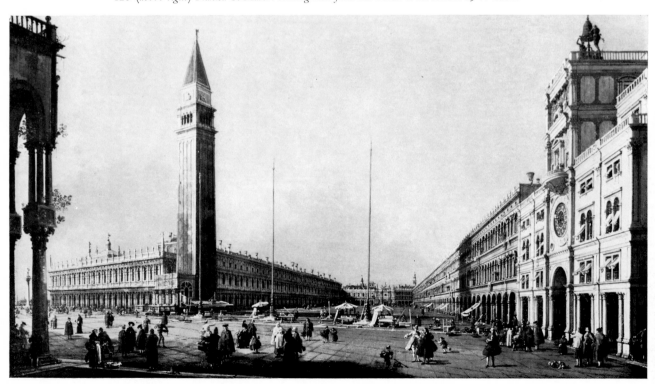

121 *Piazza S. Marco: looking South and West.* 57 × 102cm

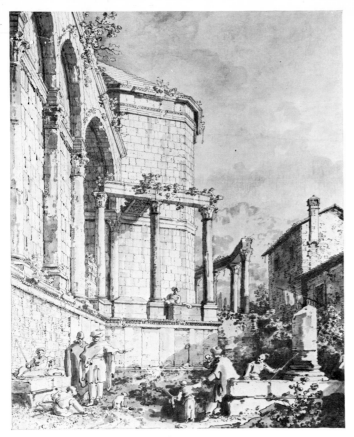

122 (*above left*) *Spalatro: the Mausoleum of Diocletian.* 42 × 35cm

123 (*above right*) *Capriccio: a colonnade opening on to the courtyard of a palace.* 131 × 93cm

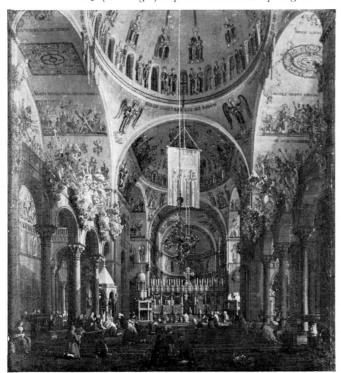

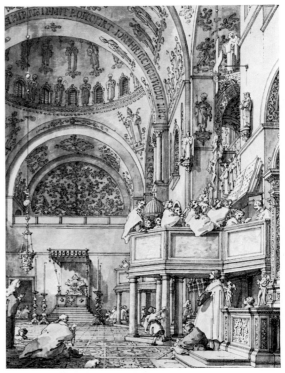

124 (*above left*) *S. Marco: a Service.* 30 × 20cm

125 (*above right*) *S. Marco: the Crossing, with musicians singing.* 36 × 27cm

126 Francesco Guardi, *Piazza S. Marco.* 72 × 119cm

127 and 128 Details of plate 126

129 Guardi, *The Arsenal*. 62 × 97cm

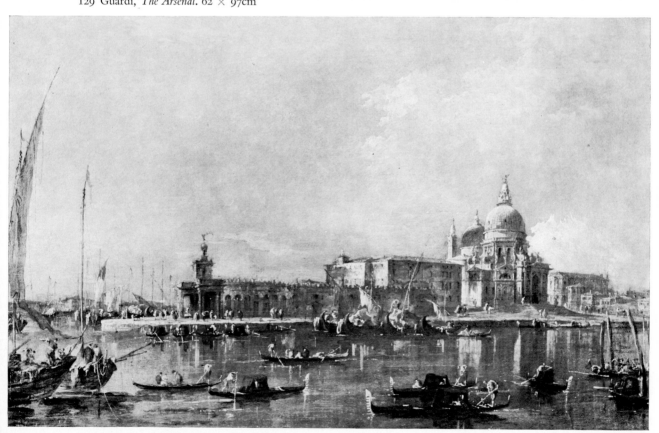

130 Guardi, *The Dogana and S. Maria della Salute*. 36 × 56cm

131 Guardi, *The Doge's Palace and the Molo*. 58 × 76cm

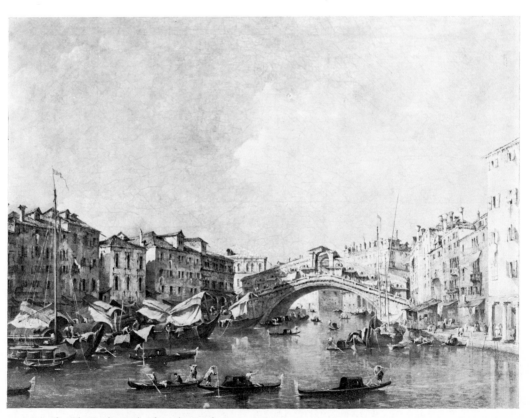

132 Guardi, *The Rialto Bridge from the South*. 71 × 94cm

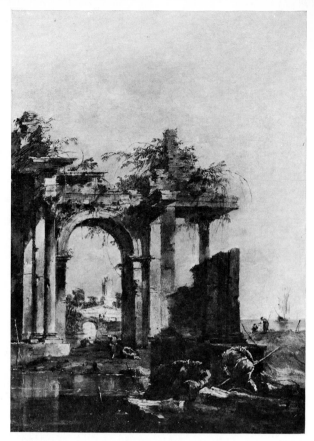

133 Guardi, *Caprice with ruins on the seashore.* 37 × 26cm

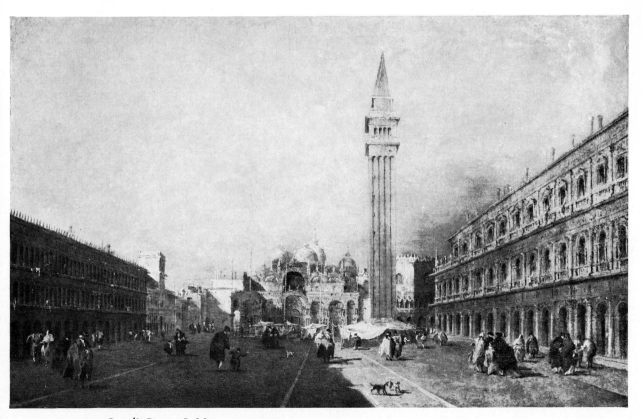

134 Guardi, *Piazza S. Marco.* 35 × 53cm

135 Visentini and Zuccarelli, *Burlington House*. 80 × 131cm

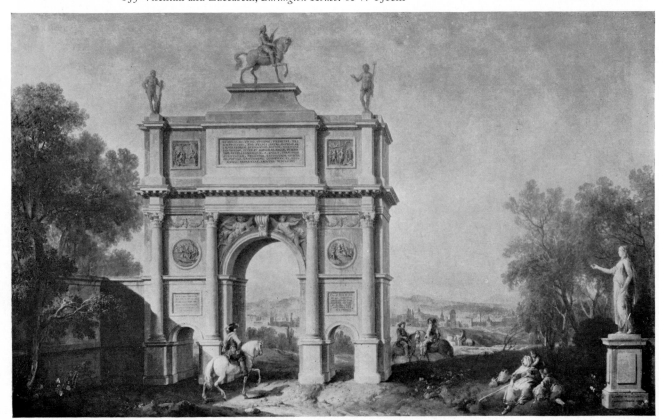

136 Visentini and Zuccarelli, *Triumphal Arch to George II*. 81 × 131cm

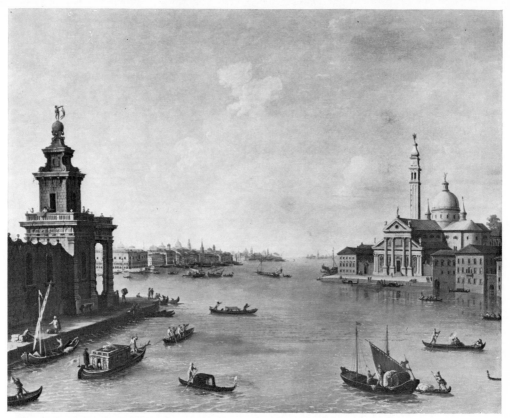

137 Antonio Joli, *The Bacino, with the Dogana and S. Giorgio Maggiore.* 82 × 100cm

138 Francesco Battaglioli, *Architectural capriccio.*

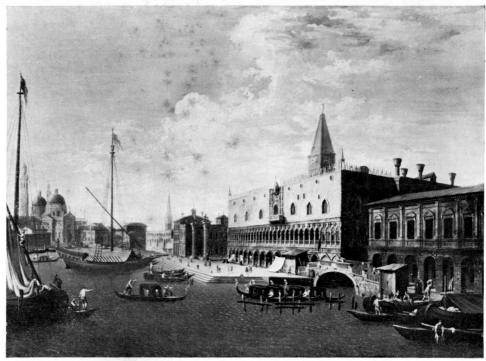

139 Giuseppe Moretti, *Capriccio with the Library, Venice.*

140 Jacopo Fabris, *The Molo: looking West.* 76 × 100cm

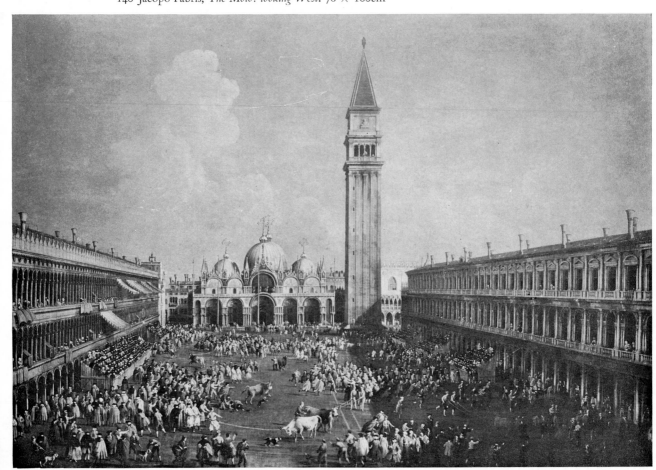

141 Giambattista Cimaroli and Canaletto, *A Bull-fight in the Piazza.* 99 × 73cm

16

The 'School'

'There are no more view painters of repute'

Pietro Edwards in 1804

In 1804 the sculptor Antonio Canova wrote from Rome to Pietro Edwards asking for some views of Venice to be bought and sent to him. Edwards, who will be remembered as having commissioned Guardi to paint pictures of the Pope's visit on behalf of the State, replied that this was very difficult. There were no longer any by Canaletto and the same applied to his nephew Bellotto, although Bellotto had done nothing special and had for the most part copied his uncle's work. Nothing by Marieschi could be found either, or only a few pieces which were turning black. Of Visentini, Joli and Battaglioli there were only capriccios, entirely imaginary or based on views on the mainland. There remained Guardi, very inaccurate but spirited, and even he was in great demand since nothing better could be found. However, Guardi was known to have had to work hard to make a living and he had bought defective canvases with wretched priming; moreover, to save time he had bought very oily colours. Whoever bought his pictures must resign himself to losing them in a short time; Edwards could not guarantee they would last more than ten years. Still, he was trying to deal on two although he could not agree with the seller on the price. They were pretty and no more. He promised to continue his efforts and perhaps he might dig out a few satisfactory pieces. 'What a pity it is,' he ended 'even this branch of our tree of painting is drying up in Venice. There are no more view painters of repute.'

Edwards hardly sounds a reliable agent. There must have been plenty of Guardis around in 1804, since the future Lord Dover was able to find over a hundred going for six pounds each twenty-four years later. And, however little Guardi paid for his materials, he knew well how to make his pictures last, as two centuries experience of them has provied. 'Pretty [*graziosetti*] but no more' might have been a fair description of all that Edwards was able to find, but a little diligence would surely have produced a few views of his native city of sufficient merit to satisfy Canova's need. It was certainly true that Canalettos were unobtainable: there never had been any to speak of left over for Italian buyers. Nor had there ever been more than a handful of Venice views by Bellotto who had

8—C * *

finally left Venice sixty years earlier, no doubt taking with him anything that happened to be unsold. As for Marieschi, we know that a few years earlier, in 1789, there were pictures the experts were prepared to ascribe to his school; Francesco Guardi was one of the experts called upon for an opinion and evidently thought he knew enough of Marieschi's work to express one. From the number of Marieschi-type views still to be found in Italy one would have expected a good many to be available in Venice in 1804 although Edwards would not have been serving Canova well had he bought any but the most exceptional of these.

Edwards's choice of the three painters by whom he would have hoped to find views is interesting. There were evidently still some pure capriccios, or capriccios based on mainland scenes [*vedute alterate di terrafirma*] to be found by Visentini, Joli and Battaglioli but these were not what Canova wanted. It seems very doubtful in fact whether these artists had ever painted the kind of view Canova was looking for and they had been born between eighty and 120 years earlier.

Visentini was the oldest, having been born before 1690, and, although he lived to be nearly a hundred, and could do competently almost anything he turned his hand to, there is no reason to suppose he ever attempted view painting. He was virtually a member of Smith's staff for the greater part of his life and Smith, who had the greatest view painter in the world at his disposal, would not have encouraged Visentini to follow Canaletto further than in copying his work for the engraver, and in engraving the copies himself. As a painter his speciality was perspective, which he taught at the Venice Academy from 1772 to 1778, and architectural details by him can no doubt be seen in many landscapes in which other artists painted the figures and other parts and for which they took the credit, if credit was given to anybody. In some cases he shared the commission with others, including a set of frescoes at the Villa Valmarana, Vicenza, for which Tiepolo's son, Gian Domenico, painted the figures. He has already been seen as the architect of Smith's new house on the Grand Canal and in 1746 Smith employed him to work with Zuccarelli on a series of capriccios based on English Palladian buildings (plate 135). Smith did not consider it necessary to send Visentini to England for this purpose and the fact that he was working from engravings is fairly noticeable. A *Triumphal Arch to King George II* (plate 136) was added to the set, perhaps part of the 'flummery' which James Adam found to be one of Smith's many weaknesses. Owen McSwiney had done well with his 'tombs', and favour at the English Court could do no harm to Smith's prospects. No painting of Venice exists which is today attributed to Visentini, but Joseph Farington, the English landscape and topographical painter, seems to have seen one. Writing in 1797, after a visit to James Wyatt the architect, who had studied under Visentini as a young man, Farington wrote: 'This picture was so much in the style of

Canaletto and Marieski, that if they were younger it must be concluded that they formed themselves in his [Visentini's] manner.' The idea is an intriguing one but there are no grounds for it at all.

Antonio Joli was not much younger than Visentini and Canaletto, having been born in 1700 at Modena. After a period in Rome, working with Pannini, he went to Venice where he stayed almost without interruption until 1746, the year Canaletto left for England. According to Gradenigo, Joli then set out on a journey which took him to Germany, to London while Canaletto was still there, and to Madrid. He was back in Venice by 1754 and, with Visentini, was one of the founder members of the Academy. In 1762 he went to Naples where he died in 1777. Joli was certainly a follower of Canaletto, although a not very accomplished one, and there are Venice views which must be attributed to him as well as some of London based frankly on Canaletto's work (plate 137). A merchant named Heidegger furnished his house in Richmond with a series of panels containing views of various places and these have been attributed to Joli. Contemporary references to him are rare and Vertue made no mention of his stay in London. Walpole, many years later in his recollections of the times of George II, wrote that Antonio Joli, 'I think a Venetian, was in England in this reign and painted views with historic figures in the manner of Paolo Pannini . . . at Joli's house I saw one of these pictures, in which were assembled as many blunders and improprieties as could be well contained in that compass'. Whether or not Joli was a sufficiently weighty figure to justify Walpole's sourness years later, Venice views played a small part in his life and it is not surprising that Edwards was unable to find any in Venice in 1804. He might have been more fortunate in London, where they still quite often appear, but they are a poor substitute for the real thing.

Edwards was right to describe Francesco Battaglioli as a painter of 'invenzioni di capriccio' but it is hard to understand why he should have been considered as even possibly able to provide the views Canova was looking for. He was born about 1722 in Modena, Joli's birthplace, and scarcely anything is known about his life or even the date of his death. He appears as a member of the Academy in 1772 and he succeeded Visentini as their professor of perspective. He specialized in painting buildings of almost every period, classical ruins, fountains and columns, grouped together with considerable ability, and he signed and dated two views of Aranjuez in 1756, although there is no record of a visit to Spain. On the other hand he did not sign his reception piece given to the Academy, so often the only truly authenticated work of an obscure painter, with the result that the architectural perspective bearing his name there is no more than an 'attributed Battaglioli'. (It hangs in the same room as Canova's own reception piece given in 1779.) The *Architectural Capriccio* illustrated in plate 138 is characteristic of the kind of picture now attributed generally to Battaglioli and its skill and charm are self-evident. It is, however, hard to believe that it was once attributed to Canaletto, as it was, or

that Pietro Edwards would have hoped to find a Battaglioli which would revive memories of Venice in Canova's mind.

Contemporary, or near contemporary, references to Canaletto's followers and rivals are so rare that a letter such as Edwards's, dealing with view-painting exclusively, demands special attention. So shadowy are the figures of these minor practitioners of what was at the time at best a minor, and at worst a degrading art, that they flit into the *Fraglie*, and later into the Academy, are paid for an altar-piece here and there, die and leave no other records of their existence beyond works which bear no name until one is attached to them by art historians working in the fog. Giuseppe Moretti emerges to the extent that his reception piece for the Academy, although unsigned, is firmly identifiable (plate 139) and that he was mentioned by Algarotti. 'In this picture,' wrote Algarotti of one of Moretti's views, 'the author has imitated the manner of Canaletto to perfection' and the artist would probably not have been displeased by the words.

Apart from some perspective panels on the ceiling of the church of S. Toma in Venice, the Academy piece is Moretti's only known work; Algarotti's picture has disappeared. But the *Architectural Capriccio* is enough to establish Moretti as nearest to Canaletto in feeling for both architecture and figure painting of all the unknown imitators whose works crowd the scene. The view is of Sansovino's Library as it might be seen from a largely imaginary portico of the Doge's Palace and Moretti must have been very confident to deposit the picture on his election in 1772, only four years after Canaletto's own death.

Moretti was a name in the art world over a long period, beginning with Faustino Moretti, a seventeenth-century painter of Bologna, and continuing up to Dionisio Moretti who drew a continuous series of sixty engravings of the Grand Canal which was published in 1828, brought up to date and republished, without acknowledgement to Moretti, by Ongania in the 1890s, and which remained in print until quite recently. There was also a Giuseppe Maria Moretti who died in Bologna in 1746 and whose signature is found on woodcuts. More difficult to separate from Giuseppe Moretti is his brother Giambattista whose name appears in the *Fraglie* between 1732 and 1744 and who must be assumed to have worked with Giuseppe. There are a number of engravings after Canaletto signed 'Jo [or Giov.] Battista Moretti' and a few original compositions on which 'del' is added. Two of these follow the moonlit scenes Canaletto painted for Sigismund Streit, and this led to the set of four Streit pictures being attributed to Moretti at one time. The relationship between the brothers has still to be un-ravelled but it is safe to assume that Giuseppe at any rate was an original painter in his own right and it is certain that he taught perspective at the Academy in 1782. He probably died soon after that date but although he is said to have been born in Val Canonica, near Brescia, there is no evidence as to when. If his age

during Canaletto's busy period of the 1730s were known he might well be re-garded as a possible assistant in Canaletto's studio; without this knowledge it is impossible to judge how he, almost alone among the painters active after Cana-letto's death, came to be a true follower.

Giovanni Battista Cimaroli will be remembered as Canaletto's only recorded collaborator and as sharing with him the first mention of Canaletto's existence as an artist. This was in connection with Owen McSwiney's 'tomb' paintings of Lord Somers and Archbishop Tillotson for which, McSwiney wrote to the future Duke of Richmond in 1722, the perspective and landscape were painted by Canaletto and Cimaroli (plates 24–25). Cimaroli was born near Brescia, probably at about the same time as Canaletto, and went to Venice as a young man some time before Canaletto's return from Rome. After McSwiney gave up art dealing Cimaroli seems to have been taken up by Smith who obtained many commissions for him from English buyers; Smith himself owned only five landscapes by him, three of which are now in the Royal collection.

If Cimaroli's strength as an artist lay in the painting of architecture, McSwiney would not, one supposes, have called on two artists for the non-figure parts of his first two 'tombs'. It is more reasonable to suppose that Canaletto's architecture had caught McSwiney's eye but that he had more confidence in Cimaroli's foliage, just as he relied on Piazzetta in one case and Pittoni in the other for the figures. It is therefore somewhat surprising to find Count Tessin, the Swedish diplomat who was certain Canaletto was 'engaged to work only for' Smith, writing home in 1736 that 'Cimaroli paints in the same style as Canaletto, the view-painter, but has not yet reached the top of the ladder'. Cimaroli, added Tessin, had been spoilt by the English who imagined his smallest pictures to be worth thirty sequins—'not at all the same as our ideas'. The only view-painting, in the sense we under-stand the word, with a firm claim to participation by Cimaroli is a *Bull-fight in the Piazza S. Marco* (plate 140) which has borne the attribution 'Canaletti and Chimeroli' since 1761 when it was already in an English collection. Canaletto was still alive at this time and, of course, famous in England. Cimaroli had probably, although not certainly, died a few years earlier and, although known in England, was far from celebrated. It seems therefore highly improbable that the attribution would have been made unless it had been justified, but the association is a puzzling one. Canaletto was perfectly capable of painting both architecture and figures without assistance and both would have been better done, one feels, had he avoided outside help. It may have been that the prospect of painting such a vast array in such minute detail daunted him and that, having laid the design on the canvas and finished the more important parts, he left Cimaroli to complete the picture. But if Cimaroli was the assistant rather than the partner in this case, how many more pictures are there in which he also played a part? Canaletto

would not normally have employed him, as other painters did, to put in the figures since he was better able to people his canvases than Cimaroli. On the whole it seems safer to regard Cimaroli as an imitator who was occasionally, as in the case of the *Bull-fight*, called into the Canaletto studio to assist, and to accept the possibility that some of the better imitations that exist are by his hand—always provided that Count Tessin was right and that Cimaroli was a view-painter at all.

There are very few other artists of Canaletto's own generation, or practising during his lifetime, who need to be considered in a survey of Venetian view-painting. There is no reason to suppose that painters of scenery and architectural perspectives such as Pietro Gaspari, who joined the Academy in the same year as Moretti, Battaglioli and Visentini, or Antonio Diziani, really a landscape painter, were concerned with topography, or with reality in any form. Both have had views attributed to them, in Diziani's case a whole series of festival pictures, now in Berlin, but the attributions cannot be regarded as more than suggestions. Gianfrancesco Costa taught architecture in the Academy from 1767 to 1772, published a treatise on perspective, designed scenery for opera productions and, like Canaletto at one time, was employed by Joseph Wagner the publisher of engravings, but he is remembered for his series of 120 engravings, *Le Delizie del Fiume Brenta*, published 1750–62 in two volumes. These are of great topographical interest but Costa was incapable of portraying the delights of the Brenta which rely a great deal on atmosphere and light. In any event, there is no certainty that he ever painted a canvas at all. Finally, there is Jacopo, or Giacomo, Fabris who occasionally followed the exceedingly rare practice among view-painters of signing his pictures. He was born in Venice a few years before Canaletto and had German parentage. He can be traced on various occasions in Germany and finally in Copenhagen, where he died in 1761. He signed a few pictures of Rome, directly traceable to engravings, and a few more of Venice. For the latter he does not seem to have followed published engravings, such as those of Carlevaris or Canaletto, directly but he would not have needed a very vivid imagination to turn available material into such a picture as plate 141. A follower of the followers, perhaps, who found no reason to return to the city of his birth in order to paint pictures of it.

Briefly though all these artists have been discussed there is not a great deal more known about them than the facts mentioned. All were born before the first quarter of the eighteenth century was ended and, since all worked in Venice (except, perhaps, Fabris), all could have known Canaletto personally. With the exception of Giuseppe Moretti, Francesco Guardi at the outset of his view-painting career, and possibly Joli after his visit to London, Canaletto seems to have had

little or no influence on any of them. Bellotto and Marieschi were of course in a class apart but both had disappeared from the scene in their thirties, Bellotto for other fields and Marieschi by death. The generation that followed these men grew up in a world where neo-classicism was the vogue and nothing that Canaletto had to teach them was of much use if they were to appeal to the tastes of collectors in the second half of the century. In England, as has been noted, the situation was different and Canaletto certainly influenced the great school of topographical artists, particularly in water-colour, that began its development soon after he had left the country. But although Edwards wrote sadly that even the view-painting branch of the great tree of painting had dried up in Venice, if he meant by this a school of Canaletto followers, such a thing seems never to have existed.

This does not, of course, mean that no one except Guardi painted views of Venice after 1768. The name of Francesco Tironi, who was born about 1750, occasionally appears in catalogues; he may have been a painter although all that is known of him is a number of drawings of the islands of the lagoon, some of which were engraved. Bernardino Bisson (1762–1844) imitated Canaletto with some skill—but he was equally capable of imitating Marco Ricci, Tiepolo and Guardi and did so whenever the occasion demanded. Vincenzo Chilone was born in 1758 and when the Pope and the 'Count of the North' visited Venice in 1782 he, like Guardi, recieved a commission to record the scenes. His main interest to posterity is that he later wrote an unusually frank autobiography telling what life in the workshop of another artist meant. It was not until his master died, wrote Chilone, that he came into possession of his own name and efforts; before that his master took both the money and the glory. A friend of his, Giuseppe Borsato, born in 1770, also fell into the hands of a master who exploited him, according to Chilone. Borsato did not record his own experiences but an Englishwoman who visited Venice in 1816 wrote in her diary: 'Borsato paints views of Venice in the style of Canaletto, the perspective is excellent but he wants that breadth of touch which distinguishes the works of the great artist.' A perceptive criticism of the little that is known of Borsato's view painting. The diarist continued: 'Gardi [sic] the son of the painter of that name does views in distemper and in the same style.' This was Giacomo Guardi who was born in 1768 and whom we have already met selling his father's drawings for a few pence. True, there were no doubt a good many of his own among them since he did not hesitate to put his father's name on his own work if it would help him to sell it. He is remembered principally, though, for the thousands of little gouaches which he must have produced, judging from the number which still appear constantly in the salerooms, each with a description on the back followed by his name and address for the benefit of those who wanted to order more. The last Venetian artist with any claim to be a view-painter born in the eighteenth century was Giovanni Migliara (1785–1837). By the time his career

began it was the nineteenth century and by the time it ended he was able to show steam-boats in the lagoon.

It would be more reasonable to see these later artists as forerunners of the Romantic painters than as followers of Carlevaris and Canaletto. The Venice that Canaletto knew met its end in 1797 with the arrival of Napoleon but for many years before that there had been little to paint, few to paint what there was and hardly anyone with a taste for what had once set all Venice wondering and admiring. With the departure of Napoleon and the arrival of the Austrians Venice began a new life. She had lost her independence but still had more to offer the tourist than any other city on his route. She fitted well into the romantic tastes of her new visitors: she had always been able to adapt herself to the visitors' requirements. As for views of Venice, they were soon in demand again as they had been for so long. 'This is the end of Art', said Turner on seeing his first daguerreotype (adding 'I am glad I have had my day'): but he was quite wrong. The Venice that had stirred Gentile Bellini and Canaletto delighted not only the visitors with their sketch-pads, canvases and cameras. It inspired Manet, Whistler, Monet and Renoir as well. No one seems able to enter the lagoon without desiring to record as best they can something of the splendours of Venice.

Bibliography and source notes

Abbreviations

A.V.	*Arte veneta*
B.M.	*Burlington Magazine*
Constable	W. G. Constable, *Canaletto*, Clarendon Press, Oxford, revised edition 1976
Levey, 1964	Michael Levey, *The later Italian pictures in the collection of H.M. The Queen*, Phaidon Press, Oxford, 1964
Levey, 1971	Michael Levey, *National Gallery catalogue: The 17h and 18th century Italian schools*, The National Gallery, London, 1971
Haskell P.P.	Francis Haskell, *Patrons and Painters*, Chatto & Windus, London, 1963; New York, 1971
Pallucchini, 1960	*La pittura veneziano del Settecento*, Venice/Rome, 1960
Parker	K. T. (Sir Karl) Parker, *The Drawings of Antonio Canaletto . . . at Windsor Castle*, Phaidon Press, Oxford, 1948
Pignatti	Terisio Pignatti, *Canaletto, selected drawings*, English edition, Pennsylvania State University Press, 1970
Watson	F. J. B. (Sir Francis) Watson, *Canaletto*, Elek Books, London, 2nd edition 1954
Works	*The Works of John Ruskin*, edited by E. T. Cook and Alexander Wedderburn, W. H. Allen, London, ending 1912

My debt to Sir Francis Watson, the late W. G. Constable, Professor Terisio Pignatti, Professor Francis Haskell, Sir Karl Parker and Mr Michael Levey for their original researches is but inadequately expressed by the references to their work in these source notes. Their books and articles have been constantly by my side.

References to the works of authors already quoted by Constable under the appropriate entry in his catalogue are often omitted from these source notes.

Numbers in brackets indicate the first page number of the article or section referred to.

CHAPTER 1: TOWNSCAPE PAINTING

For Stefano Conti, see Francis Haskell in B.M., 1956 (296) and also in P.P. (226). For Carlevaris, see Aldo Rizzi, *Luca Carlevarijs*, 1967. For Vanvitelli, see G. Briganti, *Gaspar Van Wittel*, 1966. For townscape painters, see J. G. Links, *Townscape Painting and Drawing*, 1972.

CHAPTER 2: ROME

The contemporaries who refer, briefly, to Canaletto in their writings are: P. J. Mariette in *Abécédario*, first published in Paris, 1851–60; P. A. Orlandi in *Abecedario Pittorico*, Venice, 1753 and A. M. Zanetti in *Della Pittura Veneziana*, 1771 and 1792.
For works attributed to Canaletto's Roman period see Antonio Morassi in A. V., 1963 (143) and 1966 (207) and Rodolfo Pallucchini in A.V., 1973 (155) in which he summarizes previous writings and reproduces a further fourteen paintings he attributes to the period.

CHAPTER 3: STEFANO CONTI'S COMMISSION

Chapter 3 relies mainly on Haskell's two works cited in the note to Chapter 1 above and on Canaletto's letters quoted in full in Constable (171).

CHAPTER 4: PICTURES FOR PALACES

For the Smith-Sagredo connection, see Anthony Blunt and E. Croft Murray, *Venetian Drawings of the XVII and XVIII Centuries in the Royal Collection*, 1957. For dating of the Liechtenstein paintings see Pallucchini, 1960 (100), Michael Levey in B.M., 1966 (67) and 1962 (333).
Ruskin quoted from Works vol. X (12)

CHAPTER 5: THE FIRST ENGLISH PATRONS

Owen McSwiney's letters are from transcripts published in Constable (171) except that of 27 September 1730 which is unpublished and for which I am indebted to Francis Haskell. For the 2nd Duke of Richmond, see Earl of March, *A Duke and his Friends*, 1911. For McSwiney's 'tomb paintings', see F. J. B. Watson in B.M., 1953 (362) and Haskell in P.P. (291). For John Conduitt, see Francis Haskell in *Texas Quarterly*, 1967 (218).

CHAPTER 6: THE END OF THE BEGINNING

For Smith generally, see Parker, 1948 (9); Constable, 1976 (16); Haskell P.P. (299) and Frances Vivian's *Il Console Smith*, 1971. For Hill and Egerton, see W. H. Chaloner's *The Egertons in Italy and the Netherlands* in the *Bulletin* of the John Rylands Library, March 1950 (157). For Joseph Baudin, see Watson in B.M., 1954 (291), (351) and 1967 (410); Links in B.M., 1967 (405) and Morassi in B.M., 1955 (349).

CHAPTER 7: THE BEGINNING OF THE END

For Visentini's engravings, see Levey in B.M., 1962 (333) and Levey, 1964 (57); Links in *Bolletino dei Musei Civici Veneziani*, 1969 (3) and *Views of Venice by Canaletto*, Dover Publications, 1971. For *Dolo on the Brenta*, see Watson, in B.M., 1966 (532) and 1967 (97). For Canaletto paintings in the National Gallery, London, see Levey, 1971 (17). For *S. Cristoforo* . . . see Watson (16) and Levey, 1964 (66) (where it is called *View towards Murano*).

CHAPTER 8: THE ENGLISH COME TO CANALETTO

For the 4th Duke of Bedford, see J. H. Wiffen's *History . . . of the House of Russell*, 1833 and, for his wealth, Giorgiana Blakiston in *Lord William Russell and his Times*(433). For detailed examination of Smith's, now the Queen's, collection of drawings, see Parker which is unlikely to be superseded. For Canaletto's drawings generally, see Pignatti, with reproductions in facsimile, and Vittorio Moschini's *Drawings by Canaletto*, English edition, Dover Publications, 1969. For the Venice Academy sketch-book, see Terisio Pignatti's *Il Quaderno del Canaletto*, 1958, text volume; the second volume reproduces almost all the sketches. They are also discussed in Decio Giosefi's *Il quaderno . . . e l'impio della camera ottica*, Trieste, 1959.

CHAPTER 9: JOURNEY WITH A PUPIL

The definitive work on Bellotto is Stefan Kozakiewicz's *Bernardo Bellotto*, English edition, Paul Elek, 1971. This supersedes H. A. Fritzsche's *Bernardo Bellotto gennant Canaletto*, 1936 which, however, includes a chapter on the use of the camera obscura. P. A. Guarienti made additions to Orlandi, 1753, already cited.

CHAPTER 10: BELLOTTO, ROME AND MARIESCHI

For Canaletto and Rome, see Constable (29), summing up the arguments, and Levey, 1964, which deals with all Smith's Canaletto paintings now in the Royal collection. For Marieschi, see F. Mauroner in *Print Collector's Quarterly*, April 1940 and Antonio Morassi's catalogue of Galleria Lorenzelli, Bergamo, 1961. See also Morassi in W. Suida's *Festschrift*, London, 1959 (338) and Middedor's *Festschrift*, London, 1966. The Louvre *Salute* attribution to Marieschi is discussed in the catalogue of *I Vedutisti Veneziani del Settecento*, Venice, 1967, under no. 122, Constable, under his no. 169, dissenting. Ruskin's comments are in *Works*, 12, 468 and 13, 498. The dispute settled by the Academy is described by Watson, 1954, (12) quoting G. Fogolari in *L'Arte*, 1932 (383).

CHAPTER 11: FIXING THE CAMERA IMAGE

The following is a select bibliography dealing with the use of the camera obscura by Canaletto and, in some cases, other artists:
Francesco Algarotti, *An essay on painting*, English translation, London, 1764.
H. A. Fritzsche, op. cit. under chapter 9.
Decio Giosefi, op. cit. under chapter 8.
B. A. R. Carter, reviewing Giosefi in B. M., 1960 (399).
Terisio Pignatti, op. cit. under chapter 8, and *Canaletto e la camera ottica* in *Rappresentazione artistica . . . nel 'Secolo dei lumi'*, Florence, 1970.
B. W. F. van Riemedijk in Bredius's *Festschrift*, 1915.

On Vermeer:
Charles Seymour in *Art Bulletin*, 1964 (323).
H. Schwartz in *Pantheon*, May-June, 1966 (493).
Daniel A. Fink in *Art Bulletin*, 1964 (493).
L. Gowing in *Vermeer*, 1952 (69).
Hyatt Major in Metropolitan Museum *Bulletin*, 1946 (20).
L. Goldscheider in *Vermeer*, 1958 (25).

CHAPTER 12: CANALETTO GOES TO THE ENGLISH

Pioneer works on the etchings are:
A. De Vesme, *Le Peintre-graveur italien*, 1906, amended by H. A. Fritzsche in *Die graphischen Künste*, 1906, (447).
R. Pallucchini and G. F. Guarnati, *Le acqueforti del Canaletto*, 1945.
These have been partly superseded by Ruth Bromberg's *Canaletto's Etchings*, 1974.
See also the chapter on the etchings in Constable, with small reproductions, and full-size reproductions in facsimile published by Brandon Press, London, with notes, 1975.
Vertue's *Notebooks* were published by the Walpole Society, the passages dealing with Canaletto in vol. iii, 1933–34. They had been quoted by Hilda F. Finberg in *Canaletto in England*, Walpole Society, 1920–21 (21) and 1921–22 (supplement). Additional material is summarized in Constable (32) and under entry nos. 408–450 (paintings) and 730–760 (drawings).
For the views of Whitehall, see John Hayes in B.M. 1958 (341) and F. J. B. Watson in B.M., 1950 (316).

CHAPTER 13: THE LAST ENGLISH PATRONS

For travel to the Continent, see Thomas Seccombe's introduction to Smollett's *Travels*, 1907. For the alteration to Smith's painting, see Levey in B.M., 1962 (333) and Levey, 1964 (no. 391). For Streit's pictures, see Constable (no. 242) and *Venedig im 18. Jahrundert*, Gemäldegalerie, Berlin-Dahlem, 1974, with bibliography. Gradenigo's diaries, edited by Lina Livan were published as *Notizie d'Arte . . .*, 1942, Venice, and reviewed by Watson in B.M., 1948.

CHAPTER 14: THE FINAL YEARS

For Wagner and Berardi, see Constable (under *Engravings*).
For Robert Adam's journey, see John Fleming in *Architectural Review*, 1958 (103) also his *Robert Adam and his Circle*, 1962 (234). For Algarotti's letter to Pesci, see Haskell, P.P. (357); the letter is quoted in full in Giovanni Bottari's *Raccolta di lettere sulla Pittura . . .*, Milan, 1822.
For Hinchliffe, see E. Hinchliffe, Barthomley, 1856 (53) and Watson in A.V., 1955 (254). The painting referred to is Constable no. 19. For art exhibitions and the Venice Academy, see F. Haskell and M. Levey in A.V., 1958 (179).
The Ducal Ceremonies have been reproduced, with an introduction by Terisio Pignatti, by the *Cassa di Risparmio*, Venice, in *Le Dodici Feste Ducali*, 1972.

CHAPTER 15: FRANCESCO GUARDI

For a full Guardi bibliography up to 1965, see catalogue of the *Mostra dei Guardi* by Pietro Zampetti, Venice, 1965. Since that date Antonio Morassi's *L'opera completa di Antonio e Francesco Guardi*,

Alfieri, Venice, 1973, has been published as well as a much shorter, popular work with the same title (omitting Antonio) by Rizzoli, Milan, 1974. The present chapter relies principally on the following:

Francis Haskell's *Francesco Guardi as Vedutista* . . . in *Journal of the Warburg and Courtauld Institutes*, 1960 (256).

Problemi Guardeschi, Venice (*Comune*), 1965, particularly Francis Haskell's contribution. Antonio Morassi in *The Connoisseur*, 1963 (150), as well as in Suida's *Festschrift* already cited under Chapter 10.

Lecture by F. J. B. Watson, March 1966, reprinted in the *Journal* of the Royal Society of Arts. Denis Mahon in B. M., 1968 (69) and, for the Venetian Guilds, Michelangelo Murari in B.M., 1960 (421). Dating of the paintings in the National Gallery, London, follow Levey, 1971.

CHAPTER 16: THE 'SCHOOL'

This chapter relies largely on the papers collected by W. G. Constable for a projected work on Canaletto's followers. Pietro Edwards's letter is quoted in full by Haskell in the work cited under Chapter 15. For the *Bull-fight in the Piazza*, see Watson in B.M., 1953 (206). Pallucchini, 1960, covers the minor Venetian painters as well as the major ones.

Index

Page numbers are in roman; plate numbers are italicized

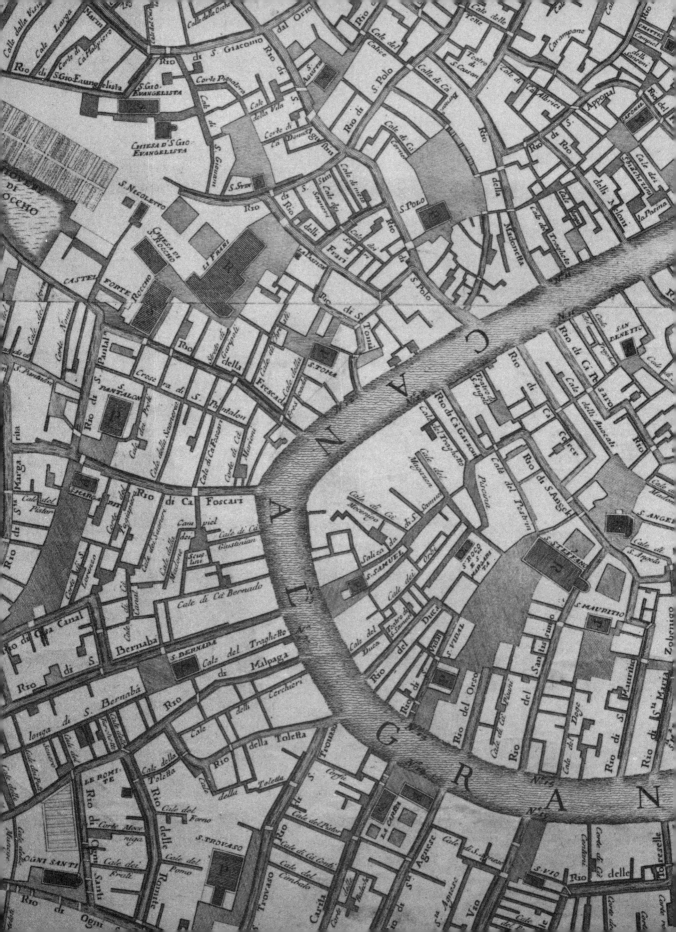